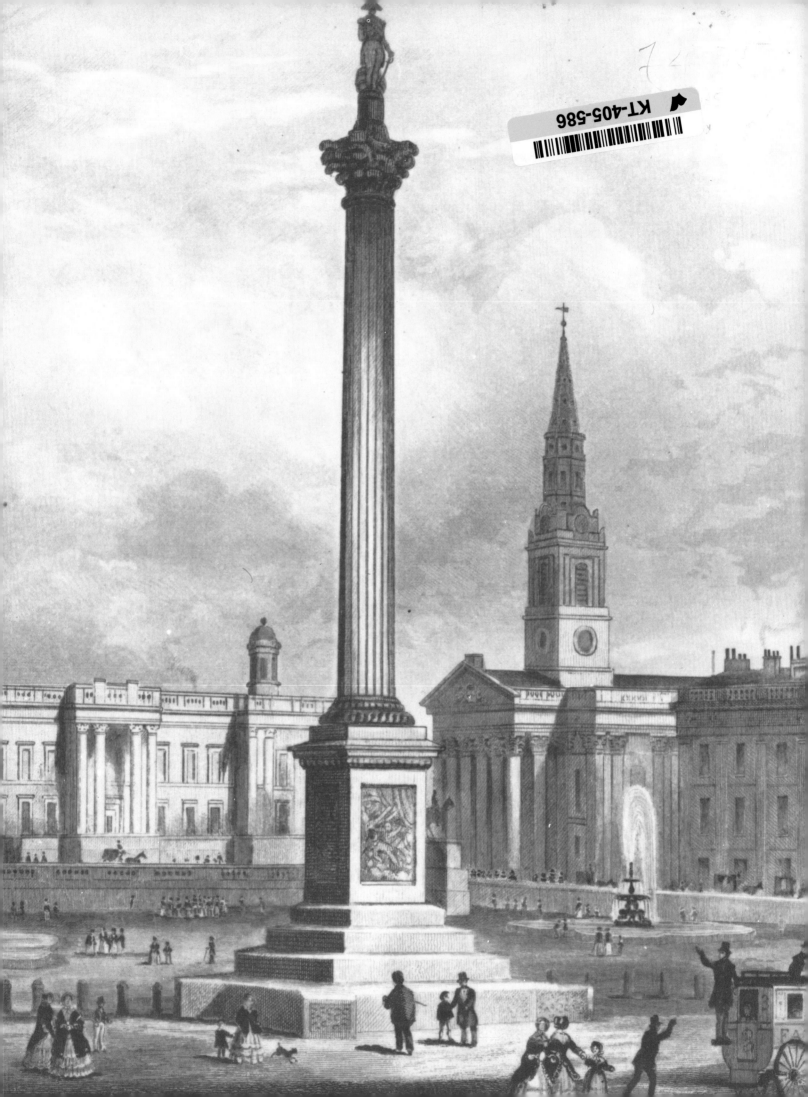

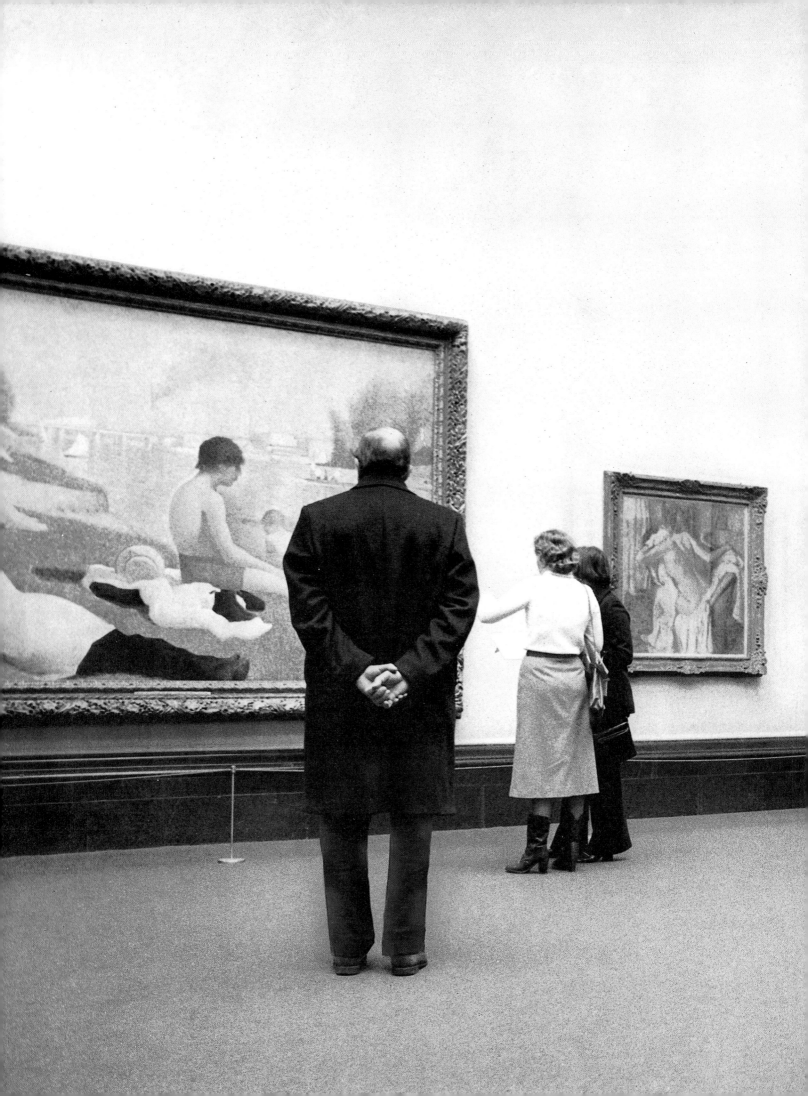

The NATIONAL GALLERY London

Michael Wilson

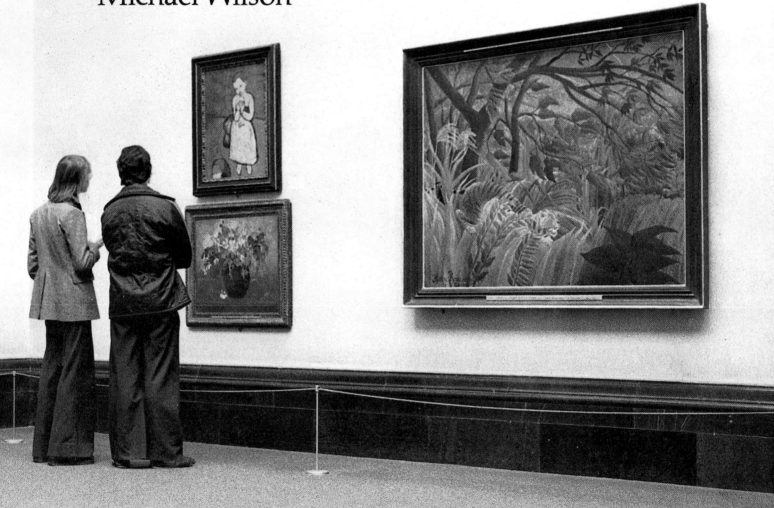

ORBIS PUBLISHING·London

Contents

© Orbis Publishing Limited, London 1977
Printed and bound in Spain by Graficromo, S.A. — Córdoba
Reprinted 1981
ISBN 0 85613 314 0

Picture acknowledgments
Title page, page 15: John Parker. Page 8: Victoria and Albert Museum. All other pictures reproduced by courtesy of the Trustees of the National Gallery, London

Foreword

Most museums and galleries nowadays are eager to rid themselves of the old-fashioned associations of forbidding dreariness and weariness which used to be conjured up by such institutions. They almost compete in their anxiety to offer amenities to attract visitors— publications, educational activities, exhibitions and other events. But the real attraction, the ultimate amenity, must always be the collection itself. And there the National Gallery can boast of an attraction of world-wide appeal.

A good idea of its character and what it contains will be gained from this book. Many of its masterpieces are famous and familiar, but some of these are to be seen freshly and reproduced very much better here since recent cleaning. It is important to realize, too, that the collection is far from being a static one. Masterpieces can still be acquired when circumstances are favourable, and the character of this collection of representative European painting from its beginnings in Italy up to about 1900 is all the time—we hope—gradually evolving. In very recent years great paintings have been bought by Titian (page 78) and Rembrandt (page 99) and Stubbs (page 116)—all painters already to be seen in the National Gallery. But examples have also been added of painters not previously represented, like 'Douanier' Rousseau (page 134) and Gustav Klimt (page 136). As it happens, the last two artists, born well into the 19th century, strike a more 'modern' note and serve as a reminder that, as our century advances, so must the bounds of the National Gallery's collection.

It will never be complete or totally representative, and nobody of sense or sensitivity would wish it to be so. Its character has been built up in just over 150 years, from an original nucleus of 38 pictures to today's total of about 2050—still a very small quantity compared with comparable great national collections in other countries. As for its quality, Michael Wilson's succinct and perceptive notes—along with his excellent choice of plates—reveal the sheer range of riches which those who are privileged to experience them daily know can never pall. There is always something new to be discovered in these forever accessible paintings, and in that novelty, perhaps, lies the secret of the perpetual pleasure they give.

Michael Levey

Director of the National Gallery

The Gallery – Past and Present

So familiar is the notion of a museum that a visitor to the National Gallery may be excused for accepting it as a foundation as ancient as Parliament or the Monarchy. It is easy to forget that, comparatively speaking, it is a recent innovation. The fact that most of London's museums have only been in existence for a century or so is usually overlooked. It was in the 19th century, above all, that the curious process of the secularization of art took place; altarpieces and portraits, for example, found themselves sharing the same wall-space and became regarded primarily as works of art, rather than images of sacred events or actual people who once existed.

Above: *England's first National Gallery—the house at 100 Pall Mall which housed the collections of John Julius Angerstein and was opened to the public in May 1824.*

The National Gallery is only a little over 150 years old, although the pictures that it contains represent European painting from the 13th century up to the beginning of the present century. The building occupies the whole of the northern side of Trafalgar Square, commanding a view down Whitehall to the Houses of Parliament. It is one of London's most famous landmarks, and few would guess, from the gallery's present aspect, the humble circumstances in which it arose in 1824. Most of Europe's great galleries have been created out of royal collections and owe their greatest treasures to the long-established patronage of former monarchs. The Louvre arose when revolution made the French royal collection public in 1793; in 1809 the French invasion of Spain led to the creation of the Prado. The National Gallery originated in 1824 with the purchase by the Government of 38 pictures from the Angerstein collection, and the gallery was first opened to the public in Angerstein's house, an unexceptional 18th-century terraced house in Pall Mall. For some, the comparison with the Louvre in Paris was an affront to national pride, but in retrospect it is all the more astonishing that today's world-famous collection could have been constructed from so modest a beginning in so brief a period.

It was during the latter half of the 18th century that serious proposals for the creation of a national gallery of paintings began to be put forward. The Royal Academy had been founded in 1769 and it was John Wilkes, a friend of the academy's first president, Sir Joshua Reynolds, who proposed in the House of Commons in 1777 that a collection of pictures then for sale be bought by the nation.

However insistent and convincing the arguments for a national gallery, it yet required a crisis to induce the Government to take practical measures to create one. In 1823 two collectors, Sir George Beaumont, the friend of Constable and patron of Wordsworth, and the Rev. Holwell Carr, had already promised their pictures to the nation if a suitable gallery was provided to accept them. The Government had taken no heed of their offer. In the same year it was learned that by Angerstein's will his famous collection would be dispersed, and that it was on offer to the Prince of Orange for £70,000. The alarm was sounded, so familiar in recent years, that the nation's art treasures were in danger of exportation.

The collection in question was outstanding, as Sir Thomas Lawrence, Court Painter and President of the Royal Academy, was acutely aware. John Julius Angerstein had arrived in London from his native S. Petersburg around the middle of the previous century at the age of 14. He later made his fortune in the city and began to collect paintings. His gallery of pictures achieved fame not only on account of its treasures, but through the prestige and distinction of its instigator. His influence was felt in Parliament, while socially he was accepted in the highest circles, being entertained by royalty. Lawrence himself, as a young man, had benefited from Angerstein's generosity and later repaid this debt by advising his patron on the purchase of pictures and superintending his collection. So after Angerstein's death, Lawrence urged that the collection should be offered to the nation. George Agar Ellis—later Lord Dover—warned Parliament that unless action was taken, the superb group of pictures, including the Bouillon Claudes which Angerstein had acquired in 1803, would be forever lost to the nation, adding that Sir George Beaumont had already promised his pictures as soon as room could be found for them.

Lord Liverpool's Government was still struggling to overcome the effects of a long and costly war, but when the Austrian Government repaid two loans made during the war in 1795 and 1797, the Treasury found itself unexpectedly rich. Accordingly, on 2 April 1824, the House of Commons voted £60,000 for the purchase, preservation and exhibition of the pictures. Thirty-eight paintings from the Angerstein collection

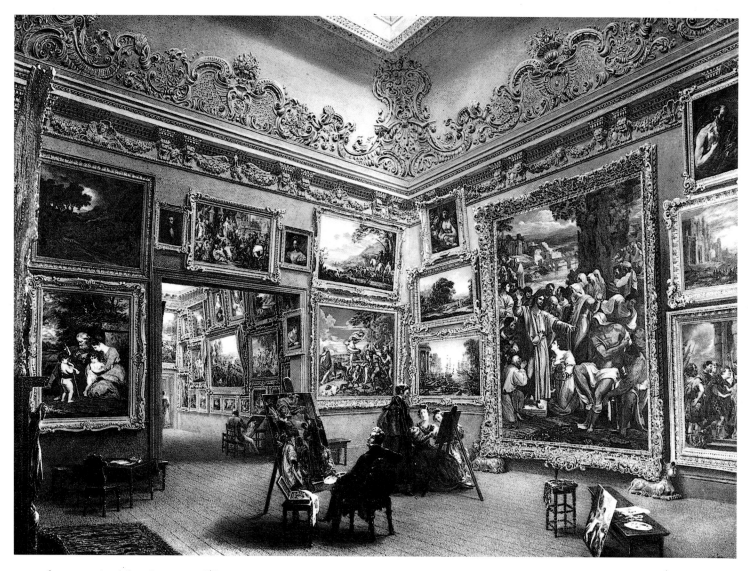

were thus acquired for the sum of £57,000.

The lease of Angerstein's house was acquired with the pictures, and the new National Gallery opened its doors to the public at 100 Pall Mall on 10 May 1824. The collection included the huge altarpiece of *The Raising of Lazarus* (Page 73) which Sebastiano del Piombo had executed in rivalry with Raphael, and which is catalogued as number 1 in the National Gallery inventory. The gallery otherwise consisted chiefly of 17th-century pictures, including works by Rubens, Rembrandt, Van Dyck, Poussin and Claude. There were also works by Reynolds and Hogarth—including the *Marriage à la Mode* series—to represent the British school. Sir George Beaumont's pictures joined these in 1826, when, in fulfilment of his promise, he handed his collection over to the nation. This included two Rembrandts, Rubens's *Château de Steen*, four Claudes, a Canaletto and two landscapes by Richard Wilson. So attached was Sir George to Claude's small *Landscape with Hagar and the Angel* that it was returned to him for his lifetime and only took its place in the gallery in 1828, after his death. In 1831 the Rev. Holwell Carr's bequest added to these Tintoretto's *S. George and the Dragon* and Rembrandt's *Woman Bathing*, as well as other notable paintings.

The very rapid growth of the collection in its first years is thus greatly due to the generosity of these two men. However, the Treasury, upon which the gallery was totally dependent for its funds, succeeded from the beginning in purchasing some exceptional pictures. In 1825 it bought Correggio's *The Madonna of the Basket* (Page 68) and in 1826,

Above: *A view of the interior of the National Gallery at 100 Pall Mall, from a water-colour by Frederic MacKenzie (1787–1854) made before the gallery's move in May 1834.*

Poussin's *Bacchanalian Revel* (Page 93) and Titian's *Bacchus and Ariadne* (Page 78), one of the three great mythologies he painted for the Duke of Ferrara.

Little is known of the circumstances of these purchases, because for many years no official records were kept of the gallery's business. When the gallery was founded a keeper had been appointed to administer the building, and later, in 1824, a 'committee of six gentlemen' was nominated to supervise the collection. But the business of purchasing pictures was conducted on an *ad hoc* basis, as these gentlemen—who included Sir George Beaumont and Sir Thomas Lawrence—recommended particular purchases to the Treasury. It does not seem that a specific policy for the acquisition of pictures or the management of the building had been formulated. The gallery had arisen as the result of the pressure placed on the Government at a moment of crisis; another crisis was required before the gallery achieved a proper constitution in 1855.

Until then acquisitions were made according to vague assumptions about the quality and value of old masters. The predominant taste of the trustees was conventional and leaned towards the recognized masters of the High Renaissance and the 17th century. Sir Robert Peel (Prime Minister from 1834–5), who became a trustee in 1827, opposed the purchase of

early Italian works, regarding them as 'curiosities'. Not until 1848, when Lorenzo Monaco's two groups of Saints were presented to the gallery, did it possess an example of painting earlier than the Renaissance.

Given these circumstances and the haphazard administration of the gallery, some of the early acquisitions are all the more astonishing: in 1834, two more paintings by Correggio, *Mercury instructing Cupid with Venus* (Page 67) and *Ecce Homo*; in 1842, Jan van Eyck's *Arnolfini Marriage* (Page 48) (purchased for a mere £630); and in 1844, Giovanni Bellini's *Doge Leonardo Loredan* (Page 40) (for 600 guineas). In these two cases at least, as the prices show, the gallery proved itself to be in advance of popular taste.

But while the collection expanded, the gallery's premises did not. It was very soon discovered that the quarters in Pall Mall could not properly accommodate either the growing collection or the public that came to view its pictures. Visitors complained of the heat and dirt, and the trustees protested to the Treasury. In 1832 William Wilkins's plans for a new gallery on the site of the King's Mews, along the north side of Trafalgar Square, were approved, and in the following year building began. However, in January 1834 the trustees were warned that 100 Pall Mall was in danger of imminent collapse. The foundations of the western wall, exposed by the demolition of the adjoining building for the construction of the Carlton Club, were on crumbling ground. Again a crisis precipitated sudden action, and immediately the gallery moved to no less unsuitable premises at 105 Pall Mall.

Nevertheless, there the collection had to stay until Wilkins's building was complete. Even the new site was not ideal. Although it extended the whole length of the northern side of Trafalgar Square, it was so shallow as to allow for only one range of top-lit rooms, with offices and living quarters for the keeper beneath. Wilkins was required to preserve the view of the portico of St. Martin in the Fields from Pall Mall, and so could not extend his building southwards. The long frontage posed problems of design also, and these Wilkins solved by breaking the facade with a central portico and dome and two flanking pavilions, features suggested by William Kent's building, the King's Mews, which had been demolished in 1830–31. In these he incorporated capitals and bases from Carlton House, which had also been recently demolished. Although the interior of the gallery has since been considerably remodelled, Wilkins's facade remains almost unchanged.

The building was completed in 1837, and on 31 March 1838 Queen Victoria came to inspect the pictures in their new accommodation. On 9 April the gallery was re-opened to the public at Trafalgar Square. Conceived in a severe classic style and conspicuously sited, the new building brought the gallery greater prestige after the cramped, make-shift premises it had until then occupied. But in effect it offered little more than an imposing facade. The eastern half of the building was allotted to the Royal Academy, which remained there until 1869, and less than ten years after the opening of the new gallery, the trustees were entreating the Treasury to enlarge the premises.

Well they might, for by 1847 the state of the gallery was causing a public outcry. In July the gallery accepted Robert Vernon's large collection of British pictures as a gift, but owing to the shortage of space at Trafalgar Square, they had to remain in Vernon's house until 1849 when they were moved temporarily to Marlborough House. The gallery was also dirty and ill-ventilated. Critics complained that it was 'a refuge for the idle and unwashed'. But more impassioned criticism was directed against the administration of the collection. The trustees were attacked for their purchasing policy, for their constant preference for works of the Bolognese school at the expense of earlier masters, and for their cleaning of important pictures which, it was claimed, had thus been ruined. In fairness it should be remembered that these critics were so accustomed to seeing pictures darkened by successive layers of dirt and varnish, by the filth that was accepted as the characteristic 'tone' of an Old Master, that exposed paint shocked their sensibilities. The pictures in question, which included Rubens's *Peace and War* and Titian's *Bacchus and Ariadne,* can be seen in the gallery today and are unspoiled. In January 1847, a letter appeared in *The Times* from the young Ruskin which eloquently voices the popular opinion:

> I returned to England in the one last trust that though her National Gallery was an European jest, her art a shadow, and her connoisseurship an hypocrisy, though she knew neither how to cherish nor how to choose, and lay exposed to the cheats of every vendor of old canvas, yet that such good pictures as through chance or oversight may find their way beneath that preposterous portico, and into those melancholy and miserable rooms, were at least to be vindicated thenceforward from the mercy of republican, priest or painter, safe alike from musketry, monkery, and manipulation.

His hopes were disappointed. He admits the necessity of cleaning, but continues:

> None of the varnishes should be attacked; whatever the medium used, nothing but soot and dust should be taken away, and that chiefly by delicate and patient friction; and, in order to protract as long as possible the necessity even for this, all the important pictures should at once be put under glass.

He too attacks the gallery's purchase of Bolognese pictures:

> The principles of selection which have been acted upon in the various purchases made in the course of the last five or six years have been as extraordinary as unjustifiable . . . What vestige of apology remains for the cumbering of our walls with pictures that have no single virtue, no colour, no drawing, no character, no history, no thought?,

when, the writer stresses, the gallery possesses

> no Perugino (for the attribution to him of the wretched panel which now bears his name is a mere insult), no Angelico, no Fra Bartolomeo, no Albertinelli, no Ghirlandajo, no Verrocchio, no Lorenzo di Credi (what should I more say, for the time would fail me?).

That the gallery now possesses such a wonderful collection of 15th- and 16th-century Italian pictures—unequalled outside Italy—is due very largely to the efforts of one man, Sir Charles Lock Eastlake, who became the gallery's first director in 1855. In 1853, when the gallery re-opened after its six-week vacation (during which time nine paintings had been cleaned), the outcry of 1847 again arose with renewed vigour. This time the public uproar resulted in a Government inquiry. A Select Committee was appointed to investigate the affairs of the gallery. Although the chief indictment against the gallery, for its policy of picture cleaning, was ill-founded, the resulting inquiry gave the gallery the revised constitution it so desperately needed. In 1855, a director was appointed with sole responsibility for the purchase of pictures, and for the first time an annual purchase grant was established, which in

1855 was set at £10,000. Under the director was appointed a keeper to look after the gallery staff, to compile catalogues for the public and to draw up the minutes of the board meetings. And so, in one move, the old administration was swept away and a coherent organization established; a new era was inaugurated of broadened, considered expansion.

The director, Sir Charles Lock Eastlake, had previously served as keeper and at the time was also president of the Royal Academy. In the year of his appointment he undertook the first of his Italian journeys, accompanied by his wife Elizabeth, to acquire works of art. In 1855 he returned with paintings by Botticelli, Mantegna, Veronese and Bellini; in 1856 with *The Martyrdom of S. Sebastian* (Page 43) by the brothers Pollaiuolo, and the Perugino triptych (Page 45); and in 1857 he purchased a masterpiece by Veronese, *The Family of Darius before Alexander* (Page 80). Later that year he succeeded in purchasing 22 works from the Lombardi-Baldi collection including Uccello's *Battle of San Romano* (Page 25), while in 1861, *The Baptism of Christ* by Piero della Francesca (Page 29), an artist then scarcely known, was bought for the astonishing sum of £241.

In 1865 Eastlake died. During his period of office, the gallery acquired, often for sums never to be matched, a representative selection of the finest Italian paintings. It had also seen the foundation of its German collection: in 1861, after the Prince Consort's death, Queen Victoria presented to the nation, in fulfilment of his wishes, 20 pictures, chiefly by German and Flemish artists.

So extraordinary a coup of great works in so short a period was never to be repeated. Eastlake's immediate successors, Sir William Boxall and Sir Frederick Burton, were responsible for the acquisition of such pictures as Michelangelo's *Entombment* (Page 71)—one of his very rare easel works—Raphael's *Ansidei Madonna* (Page 65), Holbein's '*The Ambassadors*' (Page 60) and Velázquez's full-length portrait of Philip IV (Page 90), but as competition increased among nations for great works, prices rose and the sort of opportunities Eastlake had seized with such alacrity arose with decreasing frequency.

Eastlake's successors, however, inherited the problem of displaying the growing collection. The Vernon gift of British pictures and Turner's bequest, which materialized in 1856, had already put such pressure on the gallery that in 1858

Below: *The gallery's new home in Trafalgar Square, as seen in an 1886 painting by Guiseppi Gabrielli. Right: The northern extension, opened in 1975 in order to provide more room for the paintings and up-to-date educational facilities and special exhibition galleries.*

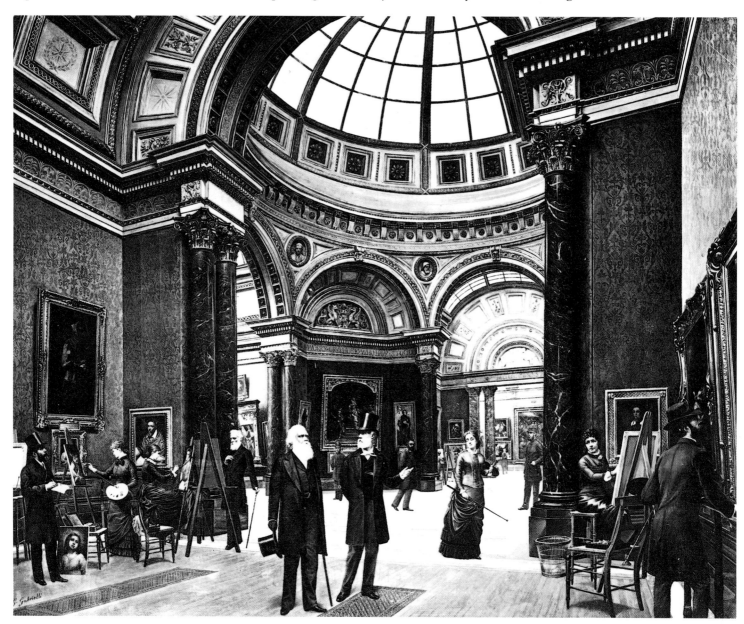

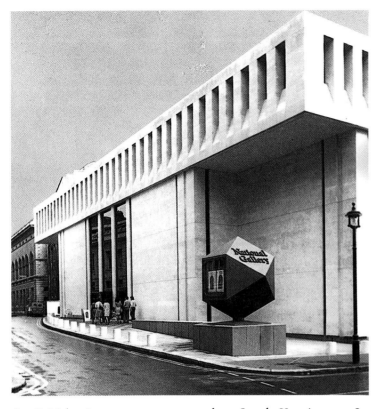

the British pictures were removed to South Kensington. In 1869 the Royal Academy at last vacated the east part of the building, but in 1871, 77 pictures (55 of them Dutch) were purchased from the Peel collection, and in 1875 the Wynn Ellis bequest brought a further 95 pictures, mostly Dutch, into the collection. E. M. Barry had already made drawings for a grandoise reconstruction of the whole gallery. In 1872 the foundations for a new wing, designed by him and comprising the present eastern dome and seven extra rooms, were laid. It was opened in 1877, the year of the Queen's Golden Jubilee, and the British pictures returned from South Kensington. In 1886 the central spine of rooms and the new vestibule, designed by Sir John Taylor, were opened, but the trustees made it at once clear to the Treasury that the additional space was not sufficient and the new rooms could only be regarded as a temporary alleviation of their difficulties. But not until 1911 were the five rooms in the west, which balance Barry's wing, completed, after a fire had made it imperative that S. George's Barracks and other buildings that hemmed in the gallery to the north-west should be demolished.

A reversal of policy in 1894 gave the responsibility for acquisitions once again to the trustees, leaving the director in an advisory capacity. This arrangement remains unchanged today. Three years later, in 1897, the Tate Gallery opened at Millbank for the British paintings and modern foreign collection (such as it then was), although a small selection of the finest British pictures remained at Trafalgar Square and still does. The collection at the Tate remained vested in the trustees of the National Gallery until 1954, when the National and Tate Galleries Act made the Tate Gallery an independent institution.

The new gallery allowed space at Trafalgar Square for the many new pictures which entered the collection in the early years of this century, above all through the bequests of George Salting (1910), Sir Austen Henry Layard (1916), and Dr. Ludwig Mond (1924). The National Gallery was also destined to receive Sir Hugh Lane's collection of late 19th-century French pictures, bequeathed in 1915. But the trustees showed so little interest in the paintings, which included Renoir's *The Umbrellas* (Page 132) and smaller works by Manet and Degas, that Sir Hugh Lane, in an unwitnessed codicil to his will, left them to the city of Dublin. Their ownership was later strongly contested, and in 1959 it was agreed to divide the collection for a period of 20 years between London and Dublin, exchanging the two parts every five years. Today, as a result of the trustees' indifference in 1915, the pictures are still subjected to periodical journeys between the two countries. Such lack of appreciation is hardly of credit to the gallery, and in part explains why this part of the collection is still comparatively thin. However, in 1923, Samuel Courtauld donated a sum of £50,000 specifically for the acquisition of modern foreign pictures, and works purchased from this fund have included paintings by Manet, Renoir, Degas and Van Gogh.

A body to which the gallery has been repeatedly indebted for its generosity is the National Art Collections Fund, founded in 1903 to aid the national collections at times of difficulty. In 1905 the fund helped to save *The Rokeby Venus* (Page 89) from exportation with a donation of £45,000, and it was instrumental in 1909 in saving Holbein's *Duchess of Milan* (Page 61). In 1929 it contributed to the purchase of 'The Wilton Diptych' (Pages 18–19) and it continues today to play a part in many of the gallery's acquisitions.

The present century has been a period of considerable internal change, seeing the establishment of a number of new specialized departments within the gallery. In 1915 an official publications stall was established to sell postcards and prints, and with it a photography section. The conservation and scientific departments arose largely as a result of experience gained during the Second World War, when the collection was evacuated and stored at Manod quarry in Wales, leaving the gallery as a venue for concerts and recitals. A consultant restorer and a scientific adviser had been appointed in 1934, but only after the war were permanent departments created.

Observation of the pictures during their exile in Wales also provided a basis for subsequent air-conditioning programmes. A constant relative humidity is highly desirable for most pictures—especially delicate panel paintings. In the humid, stable atmosphere of the quarry, the pictures were found to require almost no conservation treatment. In 1950 the first exhibition room was installed with full air-conditioning, to be followed in 1956 by a suite of rooms in the west part of the gallery. The proportion of air-conditioned space was greatly increased with the opening in 1964 of the new reserve galleries (now the lower-floor galleries) below the main floor, which enabled the whole collection—including pictures by lesser artists, studio works and copies—to be on public display. In 1975 the opening of the northern extension gave the gallery 13 new, fully air-conditioned exhibition rooms, a much enlarged lower gallery, a cinema, a historical gallery and other public rooms.

At present the history of the gallery's physical expansion concludes with this major achievement. The gallery must continue to expand as the collection grows, but the new extension has allowed all the paintings in the collection to be rehung in less cramped conditions. With this the gallery has been able to go a long way towards giving every picture its rightful space, thus creating the kind of environment that the gallery's many masterpieces require if they are to give maximum pleasure to the millions of visitors that now see them annually.

Today's collection of paintings at the National Gallery is, in effect, our inheritance from past benefactors and administrators. It has been shaped by earlier policies. It is the accumulated result of past judgments, and the very quality of the vast majority of the paintings is a reflection of the discerning taste with which it has been formed.

But the process of building a collection of paintings knows no end. As few remain in private hands, it may be the case that masterpieces by the world's most admired artists are unlikely to appear on the market. But great paintings can still be acquired and there remain, as there always will, gaps to fill, for every age expresses its own character not only in the art it produces, but in the art of the past it discovers or rediscovers. Looking at pictures and understanding them is not a science subject to laws. If it is not to become sterile and self-defeating, it must be a matter of highly personal sympathies and enthusiasms. Changes in our own society affect the way we see the past. A changing perspective can result in an artist emerging from obscurity to be valued as highly as many that are better-known. As we have seen, past eras have had notorious blind-spots. Until the 19th century, early Italian and Netherlandish art was completely overshadowed by the art of the High Renaissance and the 17th century. In England, establishments like the gallery were very slow in this century to recognize the importance of the Impressionists. It is perhaps in more recent fields that most discoveries await to be made. It is here that the collection is most likely to grow. In 1972 the gallery purchased its first picture by 'Le Douanier' Rousseau, while the Gustav Klimt purchased in 1976 is the first work by the artist to enter a British collection.

As the price of art works has increased so has the gallery's purchase grant, allotted annually by the Treasury. In 1975 it rose from £480,000 to £990,000. But great pictures are still lost, like, for example, Velázquez's *Portrait of Juan de Pareja* which was sold to America for the record price of £2.31 million. Titian's *Death of Actaeon* was only saved from a similar fate by an enormous public subscription and a special government grant. However, significant tax concessions nowadays apply if a private owner chooses to sell directly to a national collection. No Capital Gains Tax is charged on such a sale, so that it is possible for a museum or gallery to pay approximately the equivalent net amount that the owner would have received after public sale at a much higher figure. And the owner actually receives slightly more than he would have done from a public sale, so that the arrangement works to the advantage of both parties. In recent years a number of important paintings, including Velázquez's *Immaculate Conception,* Parmigianino's *Mystic Marriage of S. Catherine* and Rembrandt's *Portrait of Hendrickje Stoffels* have been purchased by private treaty in this way.

But despite its importance, the acquisition of new pictures accounts for only a small part of the gallery's activities. Every painting is a complex and often fragile construction, composed in most cases of several layers of different materials. These materials are subject to change with time, and unless necessary preventive and curative measures are taken, paintings can deteriorate and the pleasure they afford be lost for future generations. It is part of the gallery's responsibility to conserve the nation's pictures, and it was for this purpose that the conservation department was founded in 1946. It now occupies three studios above the principal floor and workshops for relining, panel-treatment and woodwork in the basement. It is responsible for the cleaning of the gallery's pictures, a

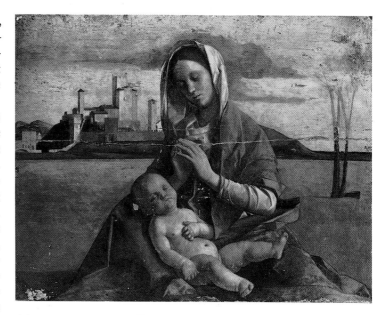

Above: *Giovanni Bellini's* Madonna of the Meadow *(see page 41), viewed from the back of the first layer of paint without the artist's later additions.*

process which in a collection of over 2,000 pictures will continue indefinitely, and for their regular inspection, so that any requiring essential conservation treatment can receive immediate attention.

Apart from a small number of frescoes, pastels and drawings, the majority of the pictures in the collection fall into two categories: paintings in oil or tempera on wooden panels, many of which are 15th-century or earlier, and oil paintings on canvas. Wooden panels are particularly sensitive to variations in atmospheric conditions. Changes in humidity cause the cells of wood to expand or contract, but since, in a painting, the front of the panel is sealed and protected by the paint, it is the back that responds most acutely to such variations. Therefore, if not kept in a stable atmosphere, pictures of this sort warp, and may crack. Previously, battens of various sorts were attached to the back of panel paintings to try and prevent the movement of the wood. The results were nearly always disastrous, for a panel constricted in this way would crack, perhaps in more than one place, at the weakest points. Modern practice prefers to remove all restrictions and allow the wood to move, but a water-impervious layer, such as beeswax, may be applied to the back to seal in the moisture so that the panel cannot dry out. If the panel is very weak it can be strengthened with balsa wood, a material flexible enough to move with the panel. But if it is so damaged that it threatens the paint surface itself, it may be removed from the layer and the picture 'transferred'—that is, mounted on to a new support. This normally consists of a synthetic board backed by expanded honeycomb paper, which is at once strong, light and very stable. Both the panel and the ground were removed from the back of Bellini's *The Madonna of the Meadow* (Page 41), so that during treatment it was possible to see the reverse side of the very first layer of paint.

Paintings on canvas do not respond so acutely to changes of humidity, but canvas is a less resilient support, and its flexibility can result in serious cracking of the paint surface. 'Craquelure'—a network of fine cracks—is a feature common to most old paintings, but as a canvas deteriorates and slackens, the paint can break up and fall away. For this reason most old pictures need to be 'lined'—to have a new canvas

stuck on to the back of the old one. This method of treatment is itself very old, and sometimes the lining has to be replaced and the picture relined. The flaking paint can then usually be dealt with from the front. Small quantities of adhesive are allowed to seep under the surface and the loose parts are gently ironed back.

The front of a painting may also be disfigured by old, discoloured varnish and by earlier attempts at restoration. In the past the touching-up of paint losses was generally undertaken in a fairly liberal manner, and in removing these and retouching again only to the area of damage, more of the original paint can be recovered. The oil and resin paints used in the past tend to darken, so that the aesthetic gain in replacing these retouchings is very great. Thick discoloured varnish may not only disguise the true colour of the painting, giving it the deceptive golden tone that the 19th century expected from an Old Master; it may also threaten the condition of the paint beneath. If a thick layer of varnish flakes, it may actually pull the paint away from the ground. The gains from cleaning are thus twofold: it helps to prolong the life of the picture, and it enables us to see what the artist painted as he intended it to be seen. But it should be emphasized that thorough tests are made before and during treatment. Photographs are taken at every stage and no work is undertaken without the consultation of the chief restorer and the keepers'staff. The resins used for retouching and the final varnish are selected so as not to discolour appreciably with time, and to be easily removable should the need arise.

Photography plays an important part in the work of the conservation department, and this is undertaken by a specialized photographic unit inside the gallery. Originally founded with the publications department in 1915, it provides prints and transparencies of gallery pictures for public sale, but the provision of technical photographs for research and conservation purposes has become an essential part of the department's duties. With X-radiography, ultra-violet fluorescence and infra-red photography, it is possible to penetrate the surface of paintings and reveal aspects of their make-up that are invisible to the eye. It may be rare that masterpieces are discovered under other paintings, but frequently changes are discovered. Corrections in the composition may be evident, as for example in Correggio's *Mercury instructing Cupid with Venus* (Page 67), where the poses of Venus and Mercury have changed considerably. In the absence of firmer proof, such changes serve as a strong indication that the picture is the artist's original, and not a later version by him or a copyist. Some pictures in the gallery, like Pittoni's *The Nativity with God the Father and the Holy Ghost* (Page 109), have been 'improved' by past owners and offensive details painted out. These too can be revealed by photographic means.

X-radiography penetrates deeper than other types of technical photography. In effect the picture becomes transparent and the stretcher, the nails holding the canvas, and the weave of the canvas as well as the layers of paint appear. Infra-red photography is particularly useful for paintings of earlier date. When the paint is thinly applied over a careful drawing—as in many early Netherlandish pictures—photographic film sensitive to infra-red radiation can record in great detail the stages of the artist's work concealed by the final layer of paint.

While the conservation department, with the contribution of photography, undertakes the necessary repair work on old pictures the scientific department aims to establish con-

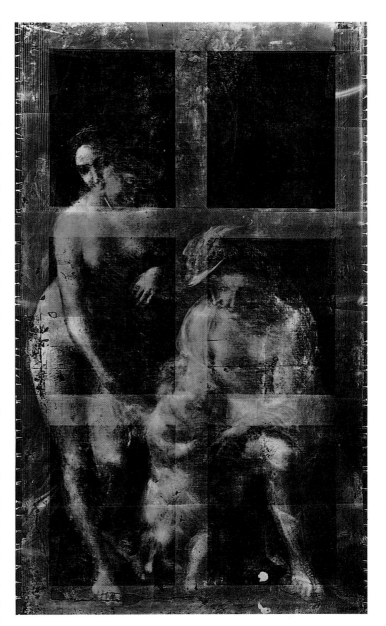

Above: *An x-ray photograph of Correggio's* Mercury instructing Cupid with Venus *(see page 67), revealing the original poses of the figures.*

ditions in which the need for conservation is reduced to a minimum. To do so requires an understanding of how and why pictures deteriorate, but the problem is by no means simple. Light causes some pigments to change and weakens the binding medium of the paint, but light is needed so that the pictures can be seen and enjoyed. Air pollution attacks the paint surface, but visitors to a gallery bring in dirt and upset the stable environment pictures require. So a compromise has to be reached. Before a rational programme of preventive conservation can be established, more needs to be known about how materials react to different environmental conditions and at what rate they change. Tests have been undertaken on various media and pigments, but changes in colour may occur so gradually that the eye does not register the difference. Accurate means are required of measuring and recording colour so that changes can be noted. The department now possesses a specially constructed spectrophotometer which can measure and record colour in a chosen area of a painting. This evidence can be compared with later readings and the rate of change calculated. The data can then be

related to environmental conditions, records of which are also taken, so that the specific causes of colour changes can be determined.

In the meantime, conditions in the greater part of the gallery are regulated so as to protect the pictures as much as possible. In most of the rooms there operates a system of temperature and humidity control—essential to the preservation of wood panels—and the same air-conditioning system cleans the air of dust and damaging gases. Throughout the gallery special filters in the ceiling remove all the ultra-violet radiation, and over the 13 new exhibition rooms in the northern extension there are motorized shutters which automatically control the amount of light entering the gallery throughout the year. Direct sunlight is shut out and the walls are flooded with light sufficient to illumine the pictures without endangering them.

Most of the visitors to the gallery are probably unaware of the work entailed behind the scenes in maintaining such a valuable collection of rare and ancient works of art. And this is perhaps as it should be. People come to enjoy the paintings, and while every reasonable precaution should be taken to ensure their protection, the paintings must remain accessible. It is a further responsibility of the gallery to present the collection in a way that augments the qualities of the pictures.

Often large in scale and grandiose in conception, the art gallery tends to suffer from its association in many people's minds with notions of 'Victorian' ostentation and moral and intellectual prudery—if it is not taken for granted as yet another piece of urban architecture as familiar and graceless as the town hall or railway station. If it is to succeed in attracting the public, the art gallery has to overcome an immense weight of resistance, an inherited prejudice that regards the gallery as only another dull institution, more lifeless than most because more cluttered with relics of the past. And both the public and the arts suffer from this misconception. Works of the imagination are discarded as mere archeological specimens, as incomprehensible as inscriptions in an unknown language, or as luxuries, rare and precious objects irrelevant to everyday life. And the public remains blithely indifferent to one of the greatest of possible pleasures, especially in England where a love of the visual arts has seldom been encouraged in schools. To the popular imagination art is best kept at a distance, and if it is taken at all seriously, is regarded as difficult and even suspect—the product of deranged minds.

Until recently, galleries may have done little to combat this lack of comprehension; in their own indifference to the public, they may even have contributed to it. Painting is put across as a subject for esoteric study and not as a pleasurable experience at all. From the lack of response to outside circumstances and to change, it would not have been unfair to have assumed that the custodians of our treasures were as lifeless as our galleries. But today, largely due to the influence of the media, more people than ever before are aware of the possible means of presenting material, of involving an audience, and of educating without alienating. And the public grows to expect every means to be utilized. Part of a gallery's function must be to make its collection accessible to the public, physically and intellectually—to remove as many of the obstacles to pleasurable appreciation as possible. And among these obstacles must be numbered the popular prejudices regarding art and museums, and the stultifying aura of institutionalism which can still surround galleries.

The task is very great, especially when the shortage of public funds prohibits or delays necessary improvements. The National Gallery can boast that virtually the whole of its collection of paintings is on public display. While the finest works are shown on the principal floor, lesser paintings can be seen in the lower floor galleries. Shortage of space will perhaps always be an obstacle to the happy presentation of the gallery's pictures, but other problems are more intrinsic. Among the exhibits are many altarpieces, originally painted for specific purposes or sites. There are some diptychs and triptychs which need to be viewed from both sides, and there are frescoes and ceiling decorations which were originally executed as parts of architectural schemes. All these call for individual treatment, and where possible the gallery attempts to suggest something of the original function of the work. The 'Wilton Diptych' and a number of the early Netherlandish and German panels with paintings on both sides are shown on free-standing display units, and some of the Italian altarpieces are isolated from other exhibits in niches designed especially for them.

But there are other considerations to be borne in mind, apart from historical authenticity. If some of the altarpieces were exhibited as they were originally intended, it would be impossible for the visitor to see them at all clearly. Some people criticize the clinical aspect of the modern gallery, the bland neutrality of architecture and decoration, and undoubtedly it is true that a gallery should provide sympathetic surround-

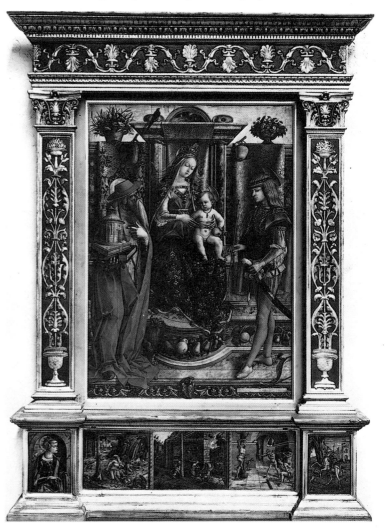

Above: *Crivelli's* Madonna della Rondine, *acquired by the gallery complete with its original frame—a rare example of a painting which retains its historic setting.*

ings for its pictures. But such criticism seems sometimes to betray a lack of feeling for the pictures themselves. In the attempt to recreate the period setting of a particular picture, there is a danger of giving too great an importance to historical authenticity. A painting can thus be reduced to the status of an archeological specimen. The process becomes self-defeating. The painting becomes less accessible to the modern spectator, more submerged in historical paraphernalia. A painting may be great in spite of, and not because of, its origins. Originally designed to fulfil a very limited function, to record, perhaps, the features of someone long forgotten or perhaps as part of the decoration of a church or a palace, a painting may offer very much more for the imagination, and this quality places it apart from the vast majority of works of its kind. It has meaning outside its original circumstances and for people living perhaps centuries later. It is this factor which distinguishes an art gallery from an historical museum. The exhibits are there for people to find present pleasure in them.

This said, it must be added that sympathetic surroundings can aid the expression of a picture. The frame, above all, is of great importance, enclosing the image and affecting the way we see it. The particular character of a painting can be emphasized by a period frame, and a considerable number, including Jan van Eyck's *Man in a Turban*, Crivelli's *The Virgin and Child with SS. Jerome and Sebastian*, and Ingres's *Madame Moitessier* survive in their original frames. The gallery has its own workshop where frames can be adapted and new ones constructed to suit specific pictures in the collection.

Wall coverings and carpets are carefully selected so as to complement in colour and texture the pictures to be exhibited in particular rooms. Pieces of furniture, such as the Renaissance chests known as *cassoni*, are sometimes incorporated in a display, and the French 17th-century paintings are exhibited with Roman sculpture loaned from the British Museum—not to simulate a 17th-century gallery, but to link visually the paintings of Poussin and his contemporaries with the antique art that inspired them.

Paintings are not always self-explanatory, and for the visitor confronted with examples of Western art from the 13th century to the 19th, some guidance is desirable. But information on the walls can detract from the pictures, and so in the individual rooms the gallery provides 'bats' with printed information that the visitor can carry around with him.

The gallery also has its own publication department which operates on the lines of an independent trading company. Profits from the sale of postcards, photographs, colour slides etc. help to subsidize the other activities of the photographic department, and to cover the cost of non-profitable publications such as the detailed catalogues of the National Gallery collection. The series began publication with *The Netherlandish School* by Martin Davies in 1945 and now covers the whole collection in eleven volumes. Here can be found detailed information covering the attribution, subject matter, size, condition, dating, copies and versions, and past history of virtually every picture in the collection.

But the catalogues, with their specialist information, are of greatest use to students of the subject. A recent series of booklets, entitled *Themes and Painters*, offers comment on pictures in the gallery, and aims at a wider audience. Artists represented in the collection, such as Rubens, Velázquez, Reynolds and Gainsborough, and themes, like the nude, and architecture in painting, have been taken as subjects for brief essays.

Above: *Children explore the media and techniques of painting in the education department's new Colour Workshop to gain practical understanding of art.*

The same idea—to throw more light on the gallery's pictures—lies behind the exhibition programme. The gallery holds regular, small, 'Painting in Focus' exhibitions, each based on a single masterpiece in the collection. By removing a painting from the usual gallery context and exhibiting it with related material—drawings, photographs of paintings, and so on—the gallery hopes to stimulate new awareness of the qualities that make it a unique object. The results can be both refreshing and astonishing. Since the new extension opened in 1975, providing much-needed extra accommodation, the gallery has also embarked on a series of major exhibitions, combining pictures from the collection with loans. The opening of the extension was marked by 'The Rival of Nature', an exhibition of Renaissance art. This was followed in 1976 by 'Art in 17th-century Holland', an exhibition comprising not only paintings, many borrowed from both public and private collections, but also sculpture, furniture, silver and china.

The exhibitions are organized by the keepers' staff, the members of which take responsibility for the various schools of painting in the collection. But the planning of the exhibition programme falls within the province of the recently established education department, a small group inside the gallery with a rapidly growing role. The gallery has long had its own lecturer. However, today, the education department can offer a far wider range of attractions, from lectures, both in the rooms and in the gallery's lecture theatre, to poetry readings, play-readings, films and audio-visual presentations, produced by the gallery and shown in its own cinema, 'The Moving Picture Room'. While a certain proportion of these activities are designed with an adult audience in mind, the department makes particular efforts to attract a younger

public. It has its own schools officer to promote interest in the gallery among teachers and children.

Over the past few years special activities have been organized for children during school holidays: quizzes, films and drawing competitions to encourage them to look thoughtfully at a small number of pictures. School groups are shown the gallery, and in the recently opened colour workshop children can experiment with different media—oil paint, egg tempera, fresco, etc.—under the supervision of an artist. In this way the process of looking at pictures is complemented by practical experience with paints. And this may help to convey that the paintings in the gallery were once created in such ways by living men, that they are very different from colour reproduction, and they are much more than famous and valuable objects.

Although the National Gallery continues, when the opportunity arises, to acquire new works, a new emphasis is now being placed on how they are displayed, and on the means by which they can become important to more people. As it stands, the collection of paintings at Trafalgar Square is undoubtedly one of the richest in the world, and it is imperative that the gallery makes every effort to ensure that these paintings—a selection of which are illustrated on the following pages—continue to give pleasure to as many as possible. To judge by attendance figures in recent years its efforts have not been in vain. In 1975, the annual total of visitors topped the two million mark for the first time. Included in the scheme for the air-conditioning of the eastern part of the gallery, due to commence in 1977, are plans for more public facilities, incorporating a new restaurant and a second lecture theatre to seat over 200. Cuts in public spending add to the difficulties involved in adapting the gallery to modern needs. But no government should underestimate the importance of an institution so rich in the finest works of the imagination. New facilities make possible new activities, more ways of benefiting from the lasting pleasures that paintings can afford.

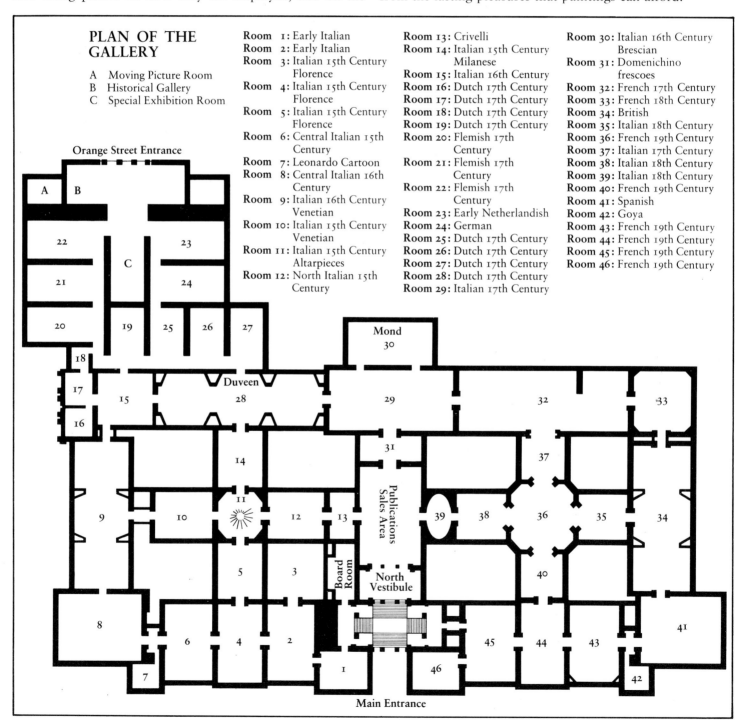

PLAN OF THE GALLERY

A Moving Picture Room
B Historical Gallery
C Special Exhibition Room

Room 1: Early Italian
Room 2: Early Italian
Room 3: Italian 15th Century Florence
Room 4: Italian 15th Century Florence
Room 5: Italian 15th Century Florence
Room 6: Central Italian 15th Century
Room 7: Leonardo Cartoon
Room 8: Central Italian 16th Century
Room 9: Italian 16th Century Venetian
Room 10: Italian 15th Century Venetian
Room 11: Italian 15th Century Altarpieces
Room 12: North Italian 15th Century

Room 13: Crivelli
Room 14: Italian 15th Century Milanese
Room 15: Italian 16th Century
Room 16: Dutch 17th Century
Room 17: Dutch 17th Century
Room 18: Dutch 17th Century
Room 19: Dutch 17th Century
Room 20: Flemish 17th Century
Room 21: Flemish 17th Century
Room 22: Flemish 17th Century
Room 23: Early Netherlandish
Room 24: German
Room 25: Dutch 17th Century
Room 26: Dutch 17th Century
Room 27: Dutch 17th Century
Room 28: Dutch 17th Century
Room 29: Italian 17th Century

Room 30: Italian 16th Century Brescian
Room 31: Domenichino frescoes
Room 32: French 17th Century
Room 33: French 18th Century
Room 34: British
Room 35: Italian 18th Century
Room 36: French 19th Century
Room 37: Italian 17th Century
Room 38: Italian 18th Century
Room 39: Italian 18th Century
Room 40: French 19th Century
Room 41: Spanish
Room 42: Goya
Room 43: French 19th Century
Room 44: French 19th Century
Room 45: French 19th Century
Room 46: French 19th Century

The Wilton Diptych

FRENCH (?) SCHOOL c. 1395 or later *Richard II presented to the Virgin and Child by his Patron Saints ('The Wilton Diptych')* Pages 18–19

This diptych owes its name to the fact that for over two centuries before its purchase by the gallery in 1929, it belonged to the Earls of Pembroke at Wilton House, Wiltshire. It was in the collection of Charles I in 1639–40, but nothing certain is known of its purpose or early history, although it is generally thought to be of French origin. The left panel shows Richard II, King of England from 1377–99, kneeling in a bare earthly landscape, with his patron saints, S. Edmund, King and Martyr (with an arrow), S. Edward the Confessor, the former Patron of England (with a ring), and S. John the Baptist (holding a lamb). In the right panel the Virgin and Child appear surrounded by angels in a heavenly landscape where flowers bloom in profusion. The angels wear Richard's own device, the White Hart (which also appears on the reverse of the diptych) and, like him, collars of broom-pods, associated particularly with Charles VI of France, whose daughter, Isabella, Richard married in 1396. The diptych may commemorate this new alliance with France, or it may have been executed after the King's death in 1400 to show him about to be received into heaven.

Early Italian Painting

DUCCIO Siena, active 1278, died 1319 *The Transfiguration* Page 20

Unlike Giotto in Florence, the artists of Siena did not break abruptly with the traditions of Byzantine painting. Duccio, the greatest artist working in Siena at the beginning of the 14th century, without entirely renouncing the old forms, nevertheless instils them with new life. Three of his panels in the National Gallery, *The Transfiguration, The Annunciation*, and *Jesus opening the Eyes of the Man born Blind*, originally formed part of the predella of his huge *Maestà*, an altarpiece which he executed between 1308 and 1311 for Siena Cathedral. The figures in *The Transfiguration*—Christ at the centre, the prophets Moses and Elijah to each side, and the apostles Peter, John and James below—are arranged symmetrically in a formal pattern. The background is gilded and Christ's robes, as in Byzantine icons, are streaked with gold. But within this highly stylized format, Duccio introduces novel features: the figures seem to move naturally, each is individually characterized, and the apostles, with heads thrown back at the spectacle, raise their arms in awe and astonishment.

DON LORENZO MONACO Florentine school, c.1372–c.1422 *The Coronation of the Virgin*
Page 21

This panel is the central portion of an altarpiece which at some time was cut into three panels. When it was purchased in 1902 it was again united with the two flanking panels of adoring angels, bequeathed to the gallery in 1848—the first primitive Italian pictures in the collection. In 1390 Lorenzo Monaco, who came from Siena, entered the Camoldolese monastery of S. Maria degli Angeli at Florence, for which, in 1414, he produced a very similar altarpiece of the same subject, now in the Uffizi. The altarpiece seen here was probably painted in imitation of one in the Uffizi for the Camoldolese monastery of S. Benedetto Fuori della Porta a Pinti, outside Florence. The sweet colouring, the delicate patterning of the throne and draperies, and the flowing linear design are typical of the International Gothic style and strongly influenced the work of Fra Angelico, who may have trained under Lorenzo.

SASSETTA Sienese school, 1392(?)–1450 *S. Francis renounces his Earthly Father* Page 22

This panel, and six others in the Gallery, once formed part of the altarpiece commissioned from Sassetta for the church of S. Francesco, Sansepolcro in 1437 and delivered in 1444. As if in sympathy with his subject—the story of S. Francis of Assisi (1182–1226), the founder of the Franciscan Order—Sassetta describes events with a simplicity and a poetic charm which confidently ignore the new discoveries made by artists in Florence. In Siena, his birthplace, the stylized and decorative forms of gothic painting lingered long into the 15th century. Here the details of tiled floors and clothes are lovingly painted, but are made to conform to a flattened, linear design. Diminutive, gesturing figures inhabit fanciful buildings too small for them. Like actors in a medieval mystery play, they are arranged to present the narrative of his story with the utmost clarity. The young S. Francis has thrown off his clothes, rejecting his earthly father and worldly possessions, recognizing no other father but God. To the left, the outraged father with swirling cloak is held back, while to the right, the bishop covers the naked saint with his pallium.

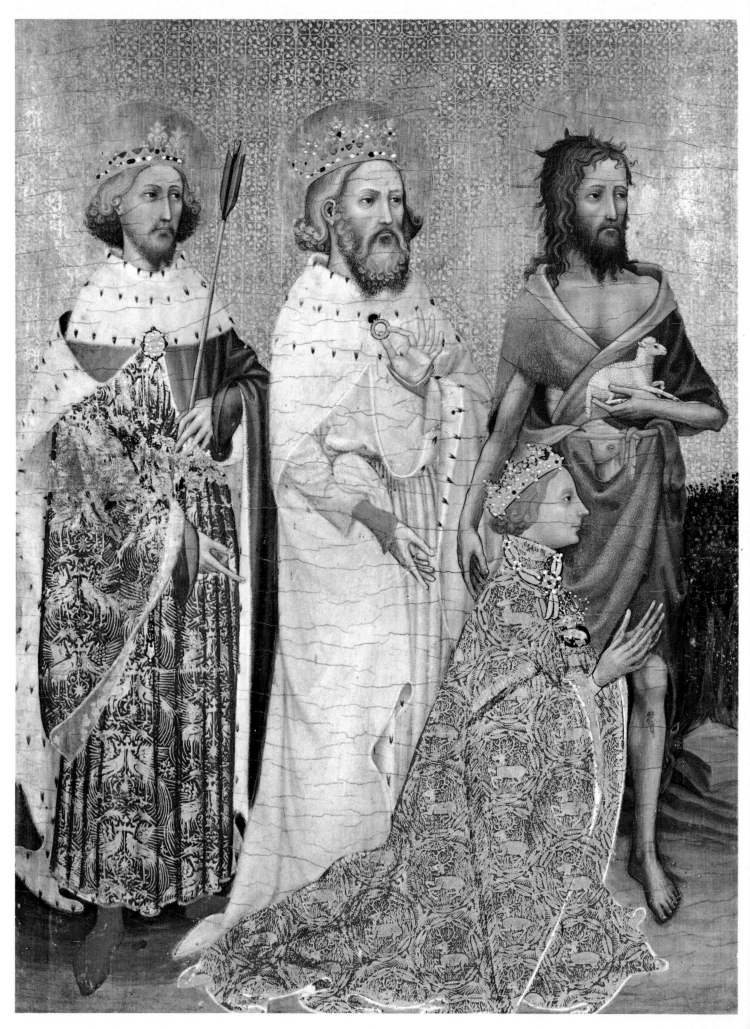

FRENCH(?) SCHOOL
*Richard II presented
to the Virgin and
Child by his Patron
Saints
('The Wilton Diptych')*
(details)
Oak, 45 × 29 cm

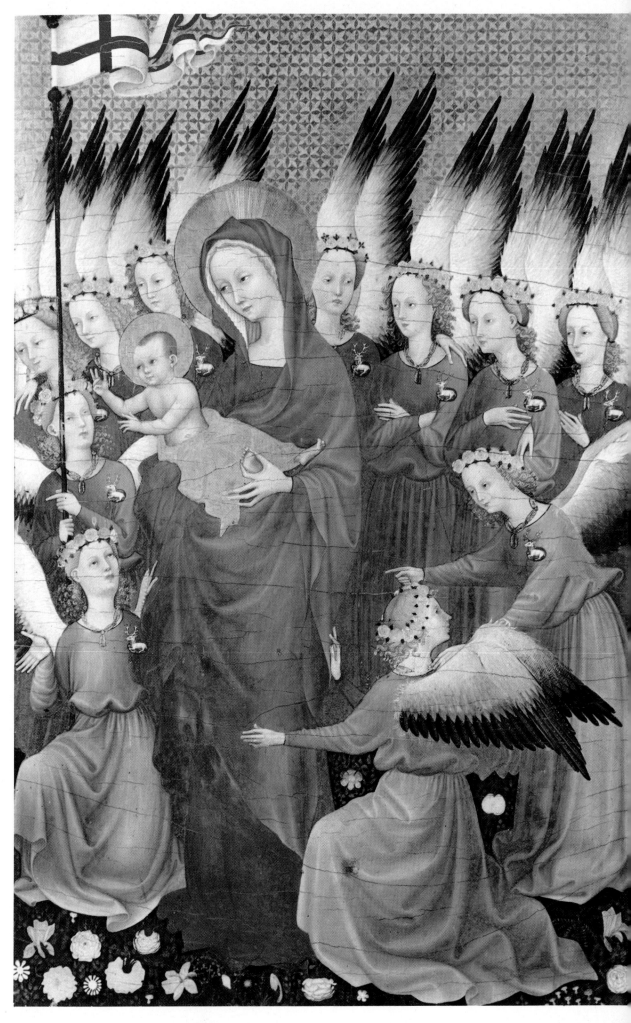

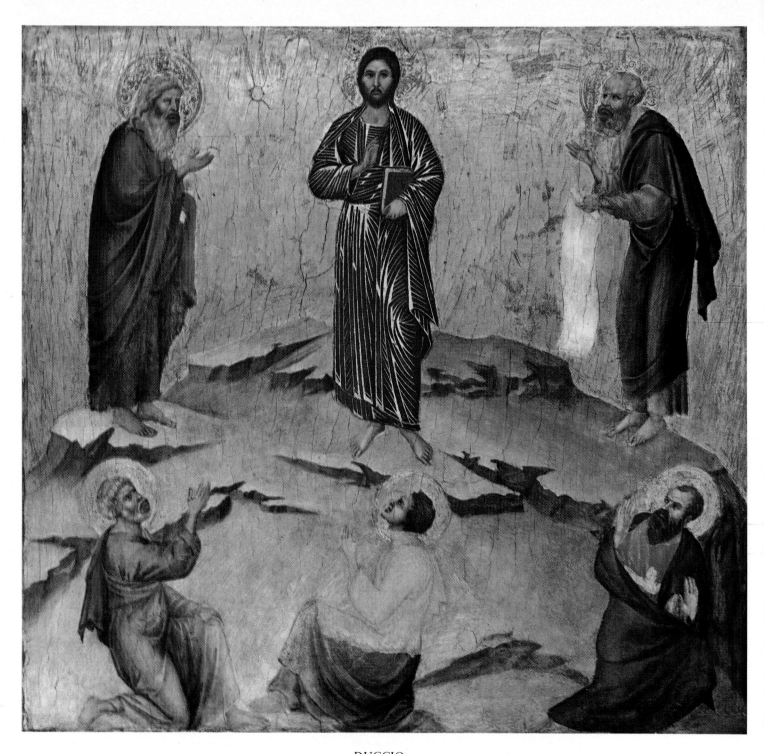

DUCCIO
The Transfiguration
Wood, 44 × 46 cm

Right
DON LORENZO MONACO
The Coronation of the Virgin
Wood, 217 × 100 cm

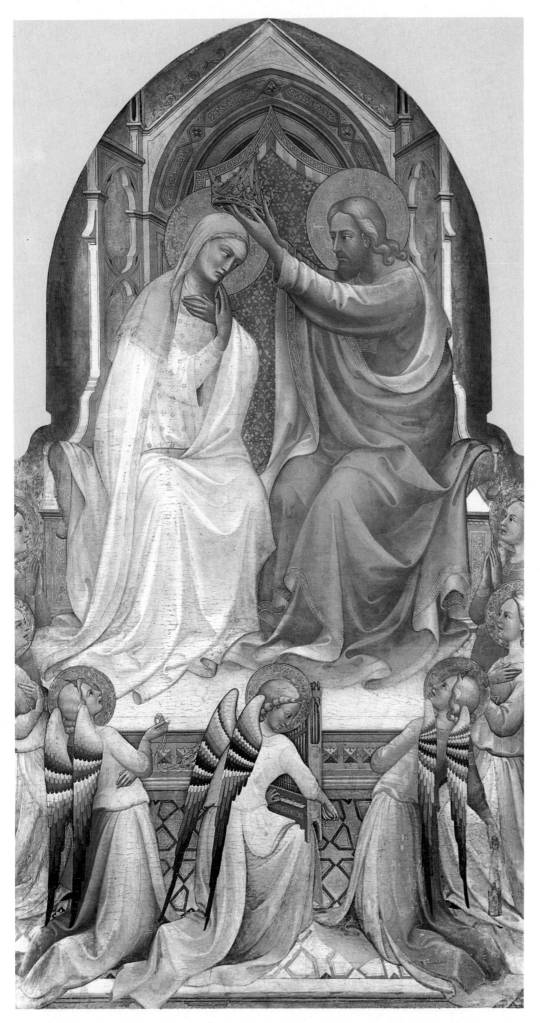

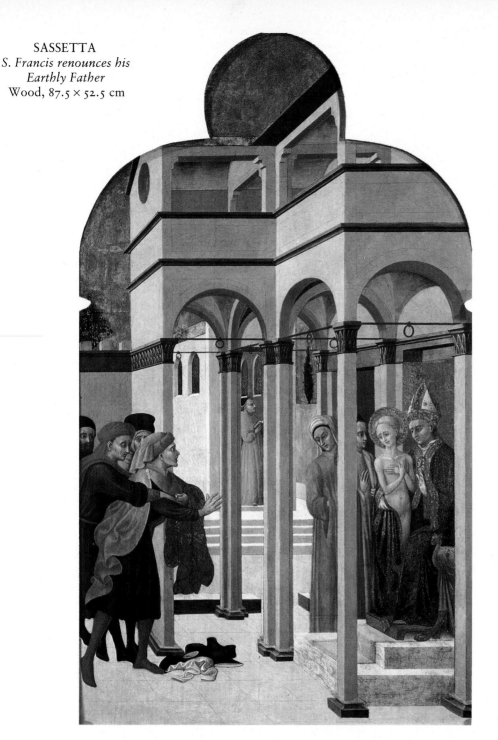

MASOLINO Florentine school, c. 1383–1432 *SS. John the Baptist and Jerome* and *A Pope and
S. Matthias* Page 23
These two panels once formed a double-sided wing of a triptych, the central part of which
showed *The Miracle of the Snow* and *The Assumption* (now in Naples), and the other wing
SS. John the Evangelist and Martin and *SS. Peter and Paul* (now in Philadelphia). Like the
National Gallery pictures these panels have been sawn apart to separate the two images, and in
them too a difference in treatment distinguishes the two sides. The front of the altarpiece, which
would have included *SS. John the Baptist and Jerome,* is painted in strong relief. The sharp
folds of the Baptist's robes, and the sculptural modelling of the features of the saints, with their
heavy-lidded eyes, contrast strikingly with the flatter and more softly modelled figures in the
panel formerly on the reverse. In his *Lives* of 1568, Vasari describes the triptych, then in S. Maria
Maggiore, Rome, and attributes it to Masolino. Most modern critics attribute it to Masolino
(an older artist temporarily influenced by Masaccio's monumental style) with the exception
of the *SS. John the Baptist and Jerome,* which, if by Masolino, has exceptional weight and
projection. Little is known of the circumstances of the altarpiece's origin, but it seems certain
that it was originally associated with the Roman family of the Colonna, for whose chapel in
S. Maria Maggiore it may have been commissioned. The body of S. Matthias is one of the
principal relics of S. Maria Maggiore, while the Pope has been identified as S. Liberius, the
founder of the church.

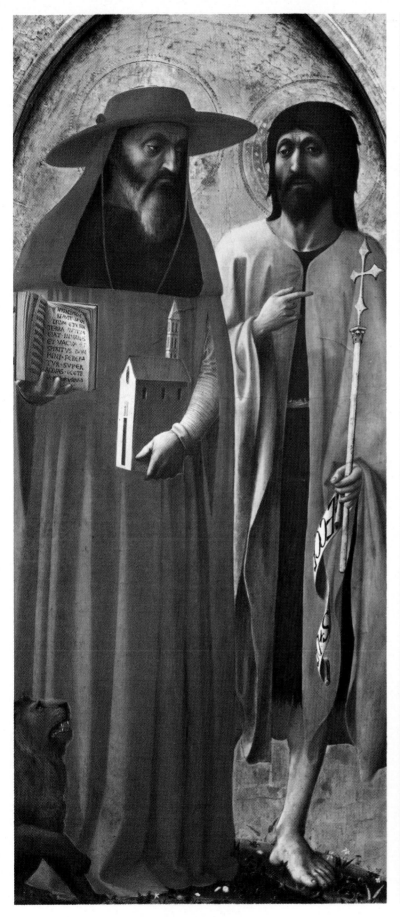

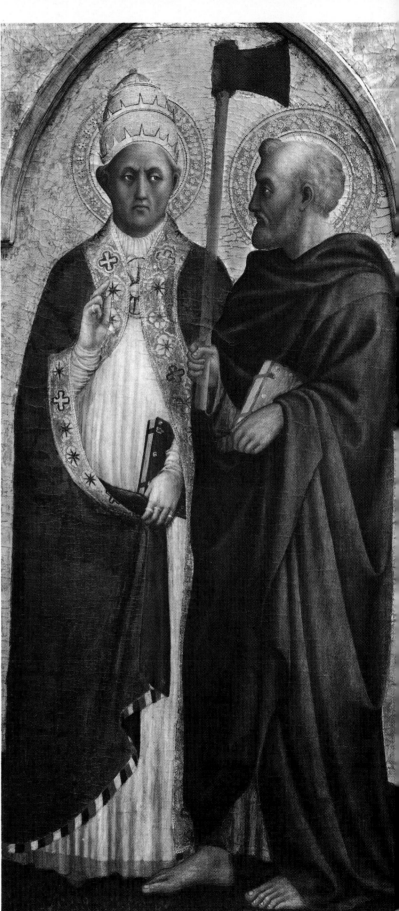

MASOLINO
SS. John the Baptist and Jero
Poplar, 114 × 54.5 cm

MASOLINO
A Pope and S. Matthias
Poplar, 114 × 54.5 cm

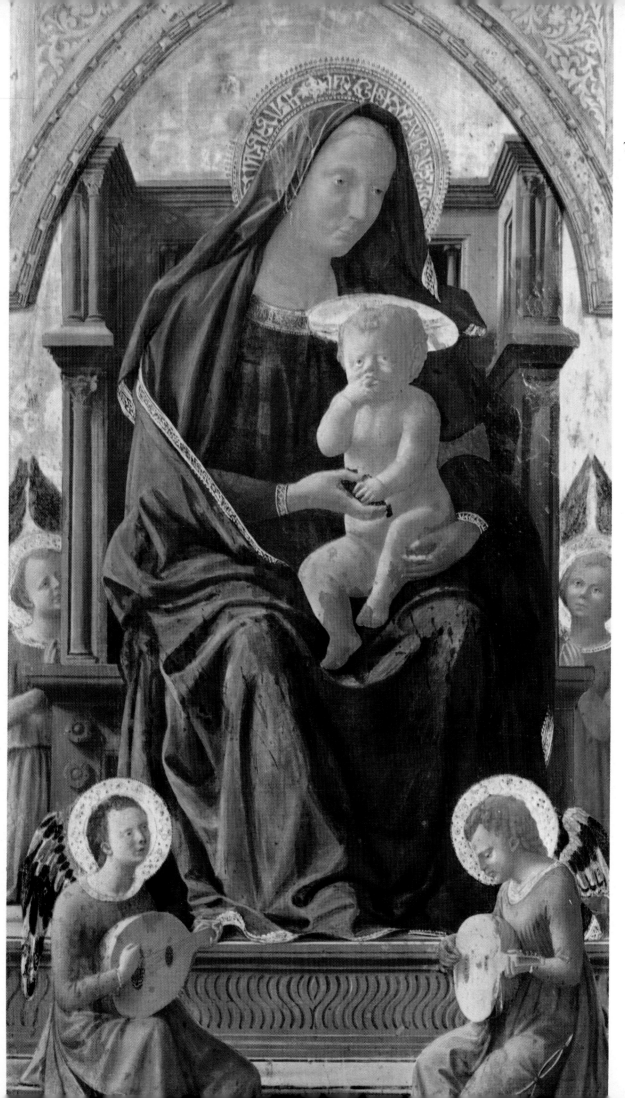

Left
MASACCIO
The Virgin and Child
Wood, 135 × 73 cm

Right
PISANELLO
The Vision of S. Eustace
Wood, 54.5 × 65 cm

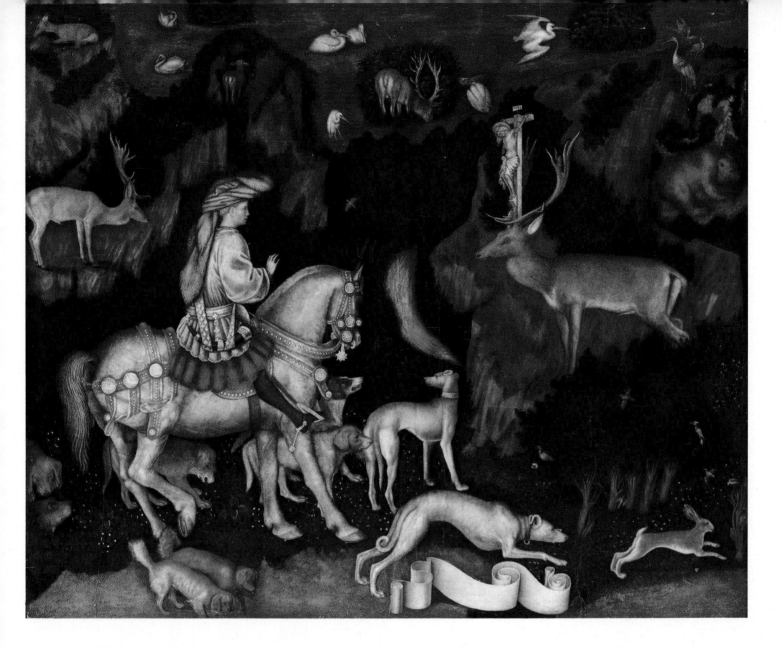

MASACCIO San Giovanni Valdarno 1401–Rome 1428 *The Virgin and Child* Page 24
Masaccio has always been regarded, with Giotto, as one of the founders of the Italian Renaissance. His frescoes in the Brancacci chapel, Florence, inspired many later artists working there, and yet he died young and few works by him are known. This Virgin and Child is almost certainly the central panel from a polyptych which he painted in 1426 for the church of the Carmine at Pisa, where it probably remained until the late 16th century when the church was reconstructed. In his account of the artist's life, Vasari describes the altarpiece in detail. Apparently it included to either side figures of SS. Peter, John the Baptist, Julian and Nicholas, and in the predella scenes from the lives of these saints and an Adoration of the Kings. Although it has not survived undamaged, this portion ably demonstrates the cool monumentality of Masaccio's figure style. The full folds of the draperies and the solid forms of the throne, which is conceived, if inaccurately, in classic terms, contribute to the austere grandeur of the central group.

PISANELLO Verona 1395–Naples(?) c.1455 *The Vision of S. Eustace*
Pisanello was active during the first half of the 15th century throughout Northern Italy and is also recorded at Rome and Naples. Many of his paintings have perished, but a number of frescoes, portrait medallions and drawings survive, and only recently scenes by him of horsemen and soldiers have been found decorating the walls of the Sala dei Principi in the Ducal Palace at Mantua. All bear witness to his masterly draughtsmanship and close observation of nature. In this painting, the woods, where S. Eustace encounters a vision of a stag with a crucifix between its antlers, abound with birds and beasts of all kinds, described in minutest detail. Yet they remain insubstantial, delicately incised against a background of rocks and foliage which conveys no impression of depth. Pisanello's world, like that of Gentile da Fabriano and other artists working in the International Gothic style, remains fanciful and unreal. Bright colours and finely detailed surfaces give this painting the appearance of a tapestry or an illuminated manuscript.

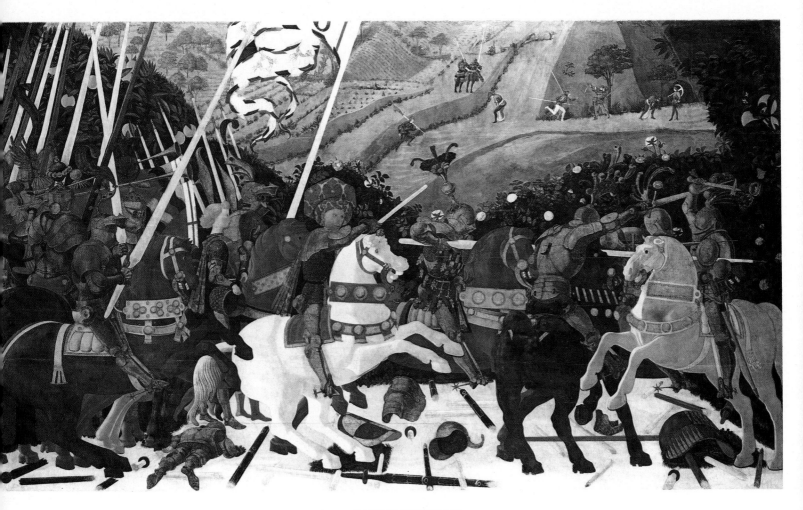

PAOLO UCCELLO
The Battle of San Romano
Wood, 181.5 × 32 cm

PAOLO UCCELLO Florentine school, c.1397–1475 *The Battle of San Romano*
The subject of this picture is a battle at which the Florentines, in 1432, won a rather dubious
victory over the Sienese. It is one of a series (the other two can be seen in the Louvre and the
Uffizi) executed in the 1450s for the Medici Palace in Florence, and shows Niccolò da Tolentino,
on a white horse, leading a magnificent array of horsemen against the meagre Sienese enemy.
More like a tournament than a battle, the action is concentrated on a narrow strip of land
between orange trees, bordered by a hedge of roses. But Uccello tries to give the illusion of depth
by employing the principles of perspective. On the ground a litter of broken lances and armour
and a sharply foreshortened soldier are laid out with geometric precision to point towards a
common vanishing point. Painted at a moment of artistic transition, Uccello's knights and
horses have bulk but appear stilted and wooden. It is as a colourful assemblage of shapes and
patterns, rather than a realistic account, that the picture is most memorable.

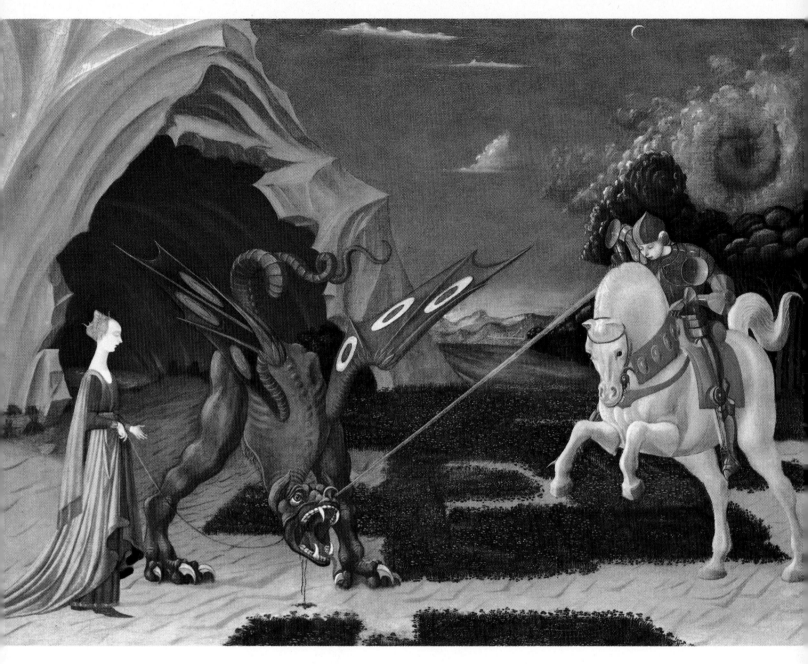

PAOLO UCCELLO
S. George and the Dragon
Canvas, 56 × 74 cm

PAOLO UCCELLO *S. George and the Dragon*
In *The Battle of San Romano* Uccello struggles towards the realistic depiction of historical events. In this painting the subject allows him to give free rein to his imagination, and the landscape and figures take on an archaic and fantastic character. On a terrain broken up into neat plots of grass, S. George, clad in armour as elaborate as some futurist machine, advances on a prancing, heraldic horse, and wounds the recoiling dragon. In anticipation of the next stage of the story the dragon is already shown girdled to the princess, who stands fantastically elongated with crowned head and tiny, pointed hands and feet, looking on impassively. The same angular invention persists in the scaly cavern of pink rock behind, while above S. George, clouds form into an ominous spiral, to indicate, perhaps, a celestial presence guiding events below.

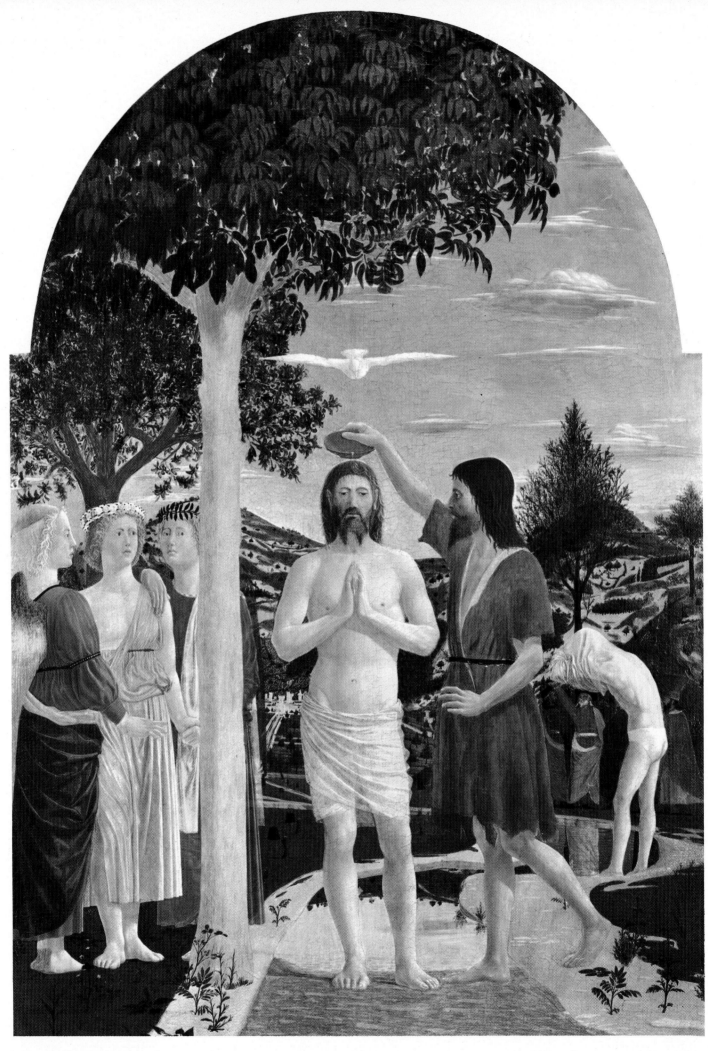

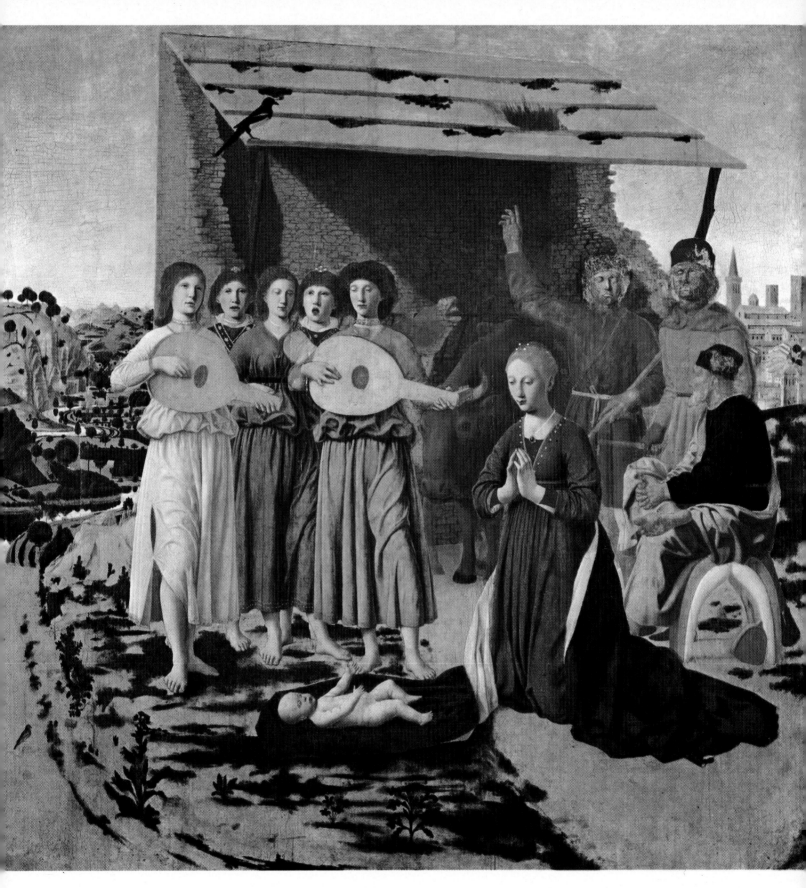

Above
PIERO DELLA FRANCESCA
The Nativity
Wood, 124 × 122 cm

Left
PIERO DELLA FRANCESCA
The Baptism of Christ
Wood, 167.5 × 116 cm

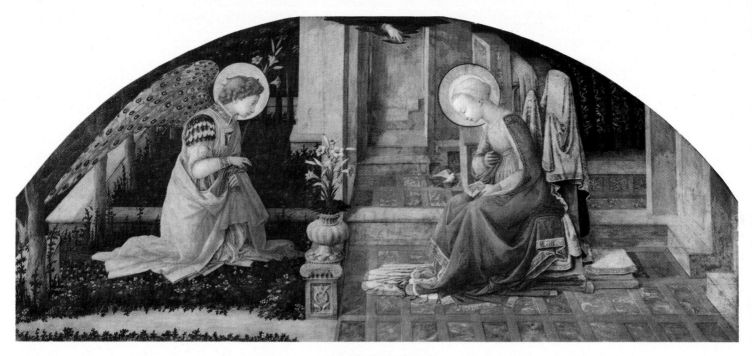

FRA FILIPPO LIPPI
The Annunciation
Wood, 68.5 × 152 cm

PIERO DELLA FRANCESCA *The Baptism of Christ* Page 28
In this painting the moment of Christ's baptism is caught and fixed in an austere image of complete stillness and harmony. It is an early work and was probably painted for the Priory of S. Giovanni Battista at Borgo San Sepolcro, Piero's native town. Piero has set the event in an Umbrian landscape which is rendered with great precision and includes a view of San Sepolcro itself. The figures are located within a rationally conceived space, and diminish in scale as they recede into the background. The soft light serves to define people and trees in a realistic manner, casting shadows and suggesting the volumes of the weighty figures, clad in garments which fold easily around them. But these seemingly natural elements are strictly organized. Their stability is stressed by a careful balance of vertical and horizontal lines. The angels and S. John turn in towards Christ, who stands rooted at the very centre of the composition, the cup and the dove poised immediately over him.

PIERO DELLA FRANCESCA Borgo San Sepolcro c.1415–1492 *The Nativity* Page 29
This is probably a late work; it was possibly never finished, and has suffered from over-cleaning —particularly in the figures of S. Joseph and the angels. But in this painting, Piero has limited himself to absolute essentials. The scene is set before a stable of spartan meagreness. The infant Jesus lies exposed on a corner of the Virgin's mantle—a motif Piero may have borrowed from the works of Netherlandish artists—while the Virgin contemplates her child from a distance with a gaze that combines reserve and reverence. Piero avoids all superfluous decoration, introducing no fantasies or supernatural effects; the angels celebrate the birth like a choir of simple musicians. The solemn and mysterious mood derives instead from the detached and self-absorbed character of the figures, who seem frozen into immobility by the momentous event.

FRA FILIPPO LIPPI Florentine school, c.1406–1469 *The Annunciation*
Filippo Lippi was placed as an orphan in the monastery of the Carmine in Florence, and the first major influence on his art was Masaccio, who painted frescoes there about 1427. But in this Annunciation, Masaccio's austere monumentality is softened by delicate colouring and a graceful lyricism which recalls instead the paintings of Fra Angelico. The bowed figures of Gabriel and the Virgin, the lawn patterned with tiny blooms, and the elaborate treatment of the costumes and the angel's wings seem even to return to the ornate effects of the International Gothic style. This painting and its pendant showing seven saints, also in the National Gallery, were sold in the 19th century from the Palazzo Riccardi (formerly the Palazzo Medici) in Florence, and were almost certainly commissioned by the Medici, for whom Lippi frequently worked. It has been suggested that they were in fact executed shortly before the birth of Lorenzo the Magnificent in 1449, to celebrate the expected arrival of an heir.

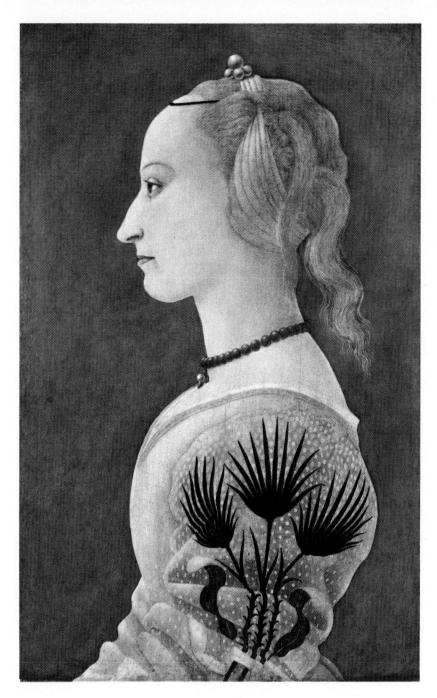

ALLESO BALDOVINETTI
Portrait of a Lady in Yellow
Wood, 63 × 40 cm

ALESSO BALDOVINETTI Florentine school, c.1426–1499 *Portrait of a Lady in Yellow*
One of many ways in which the 15th century returned to the example of antique art was in its portraits, which derive from the profile heads on Roman coins and reliefs. This profile portrait of a young lady, which is attributed to Alesso Baldovinetti (a Florentine artist influenced by Domenico Veneziano and Fra Angelico), is typical of many in its flattening of form and concentration on two-dimensional design. The blond tone of the girl's dress, hair and complexion is strikingly contrasted against a clear blue background, giving emphasis to the sinuous line which sharply defines the contours of her face and costume. Within the confines of this tense silhouette, the flower motif on the dress, the necklace and the headband elaborate on the design without disturbing the flatness of the image. Unmoved and aloof, the lady could be cut from stone. Her beauty is seen as something fixed and enduring.

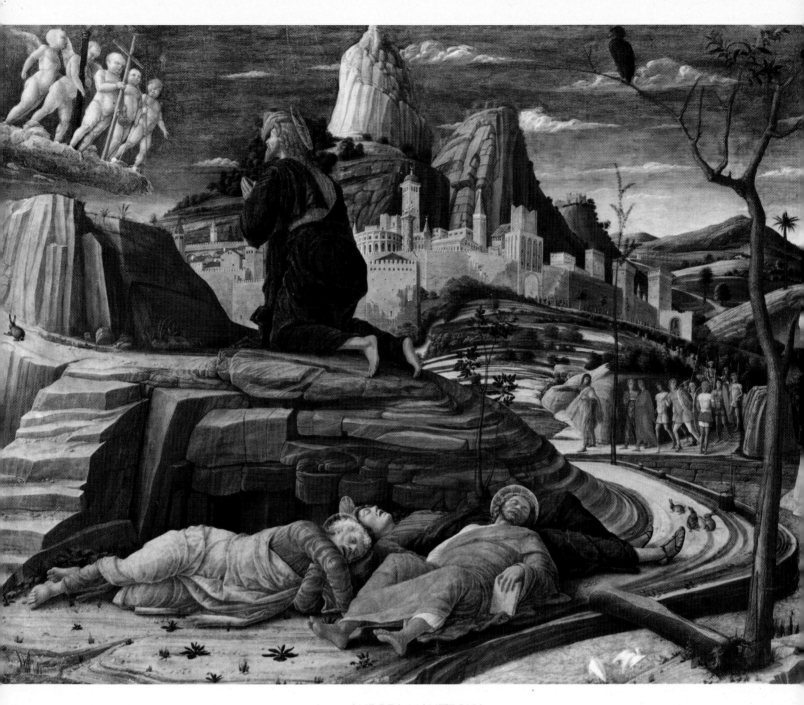

ANDREA MANTEGNA
The Agony in the Garden
Wood, 62.5 × 80 cm

ANDREA MANTEGNA Isola di Carturo 1431–Mantua 1506 *The Agony in the Garden*
It was in North Italy and not in Florence that the early discoveries of Masaccio and the sculptor
Donatello were most eagerly explored. In the middle of the 15th century, Andrea Mantegna,
working first in Padua, a famous university city, where the enthusiasm for antique art and
culture probably exceeded that of any other, and later in Mantua, brought to painting a de-
veloped sense of form and an extensive knowledge of Roman art and archeology. Both precoci-
ous and intellectual as an artist, he totally abandoned the decorative gothic style still prevalent,
in an attempt to define form in a realistic matter. As can be seen in this picture, the highly detailed
style that he developed endows people and landscape with a hard, crystalline solidity. The exact
plotting of the space and positioning of objects contribute to the impression that we are wit-
nessing an event—the moment before Christ's betrayal—as it actually happened.

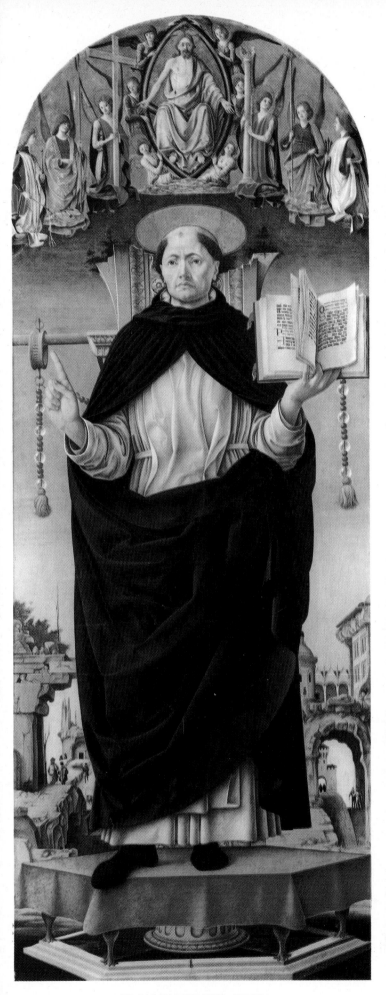

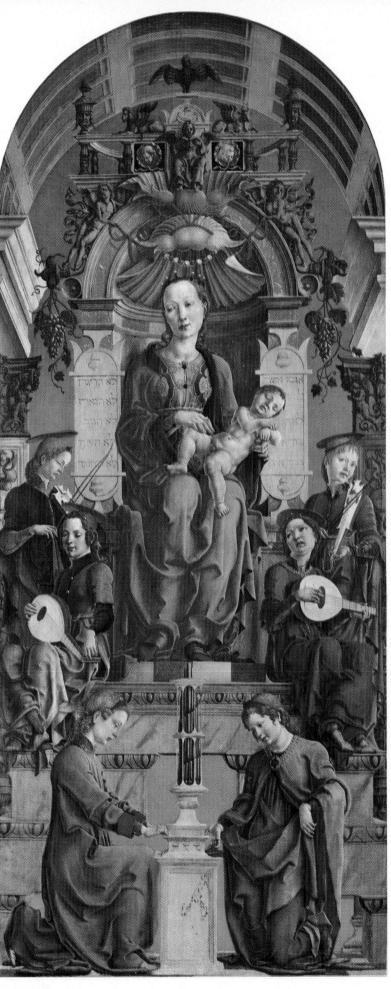

FRANCESCO DEL COSSA
S. Vincent Ferrer
Wood, 153 × 59 cm

COSIMO TURA
The Virgin and Child enthroned
Wood, 239 × 101 cm

FRANCESCO DEL COSSA Ferrara 1436–Bologna 1478 *S. Vincent Ferrer*　　　Page 33

Until his departure from Ferrara for Bologna, Francesco del Cossa was the rival of Cosimo Tura, who may also have been his teacher. The fantastic townscape, with its towers and tunnels of rock, in this picture of S. Vincent Ferrer, and the unnatural clarity of detail bear witness to the relation to Tura and to the influence of Mantegna. But the compact mass of the Saint's body recalls the work of another artist who worked at Ferrara, Piero della Francesca. At Ferrara, Cossa was involved with Tura in the decoration of the Este palaces, and in the Palazzo di Schifanoia produced a series of frescoes of the months that are comparable with Mantegna's frescoes in the Camera degli Sposi at Mantua. This panel is a late work and formed the central part of an altarpiece painted for the Griffoni chapel in the Church of S. Petronio at Bologna. Flanking figures of S. Peter and S. John the Baptist are in the Brera at Milan.

COSIMO TURA Ferrara c.1429–1495 *The Virgin and Child enthroned*　　　Page 33

The influence of Mantegna's novel, sculptural style of painting was felt throughout Northern Italy, and, in the duchy of the Este family at Ferrara, gave rise to the highly elaborate and esoteric art of Cosimo Tura. Linear inventions of ingenious complexity and a brittle cristalline style of modelling are here combined in the central panel of an altarpiece commissioned by the Roverella family for the church of S. Giorgio Fuori at Ferrara. The slit-eyed Virgin, clad in an intense blue robe that folds fantastically about her, is perched on a throne, set on a bizarre stepped arch. The throne itself is adorned with tablets inscribed with words of the Ten Commandments in Hebrew, and above, to symbolize the association of the Old and New Testaments, are the emblems of the four evangelists.

BRAMANTINO Milan(?) c.1480–1530 *The Adoration of the Kings*　　　Page 35

It is not known how close was the relationship between Bramante and Bramantino. But it is undoubtedly from the great architect that Bramantino inherited his concern for pictorial structure and his love for architectonic backgrounds. They were both active at the end of the 15th century in Milan, where in 1525 Bramantino was appointed painter and architect to Francesco Sforza II. This picture is an early work, and despite its undeniable power is strangely cold and academic. The figures are disposed symmetrically around the Virgin and Child in a formal tableau-like arrangement. As immobile and expressionless as stone, they are consciously heroic in type and statuesque in pose. This grandeur of form permeates the whole composition, most obviously in the austerely simple architecture. But it is no less evident in the towering cliffs behind and in the curious caskets, carefully laid out so as to lead towards the central vanishing point. It required the feeling of Leonardo to bring warmth to this stilted Milanese classicism.

CARLO CRIVELLI Venice, active 1457–Ascoli Piceno 1500(?) *The Annunciation with S. Emidius*　　　Page 36

This altarpiece was painted to commemorate the concession of certain rights of self-government by the Pope to the town of Ascoli. The news of this grant had reached the town on 25 March (the Feast of the Annunciation) 1482, and so in Crivelli's picture, painted for the church of the SS. Annunziata at Ascoli, the angel Gabriel is joined on his mission to the Virgin by Ascoli's patron saint, S. Emidius, bearing a model of the town. Crivelli spent most of his working life in the area of the Marches, west of Florence, and his work retains a certain provincial flavour. Although he here displays his knowledge of modern theories of perspective, other works, such as his 'Deimdoff' altarpiece (also in the Gallery) show the Virgin and saints in separate compartments as parts of an elaborate polyptych. Similarly, while he seems to owe his hard linear style to the influence of Mantegna—which was so significant for his generation—it is applied, in Gabriel's costume for example, to elaborate description and ornamentation which is still gothic in character.

ANTONELLO DA MESSINA Messina 1430–1479 *S. Jerome in his Study*　　　Page 37

The influence of Flemish painting on Antonello's art is clearly evident in this small and highly detailed picture. In the 19th century it was mistakenly attributed to Dürer and then to van Eyck. It is probably an early work and shows S. Jerome in a raised, open study which is set in a large vaulted gothic building. It accumulates detail and sets shapes and spaces one inside another, like a Chinese puzzle. But the profusion of objects and the description of surfaces is controlled by the logical system of perspective and the unifying light which illuminates S. Jerome and is reflected up into the roof. Despite the naturalism of the description, an other-worldly calm pervades the picture. The windows behind look out onto an idyllic country and a cloudless sky, while the saint sits deep in contemplation.

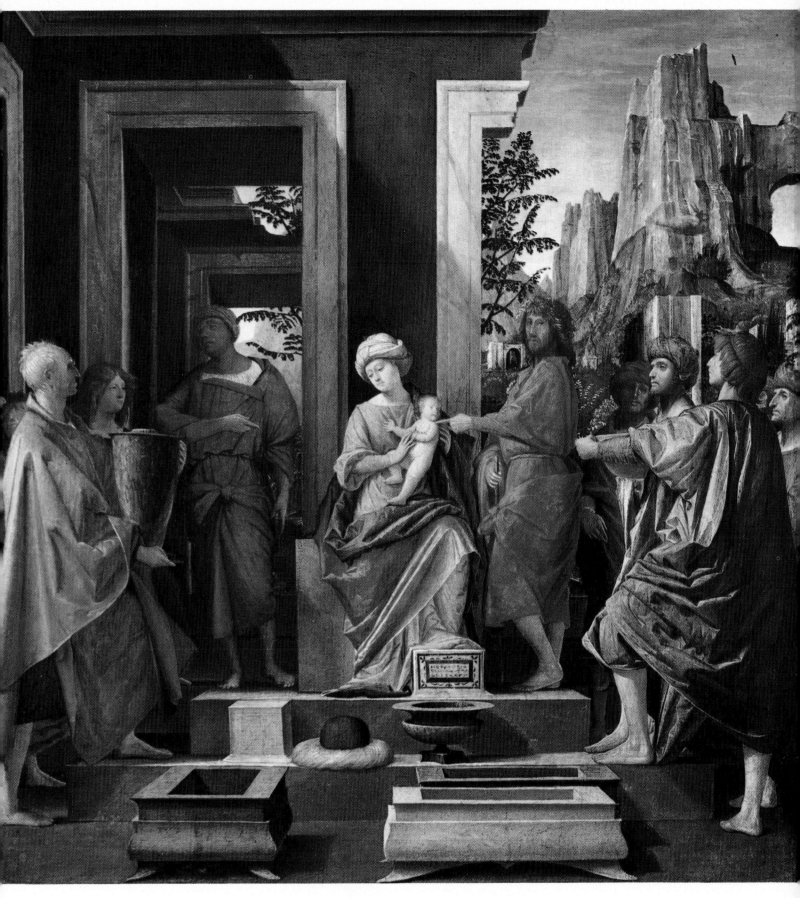

BRAMANTINO
The Adoration of the Kings
Poplar, 57 × 55 cm

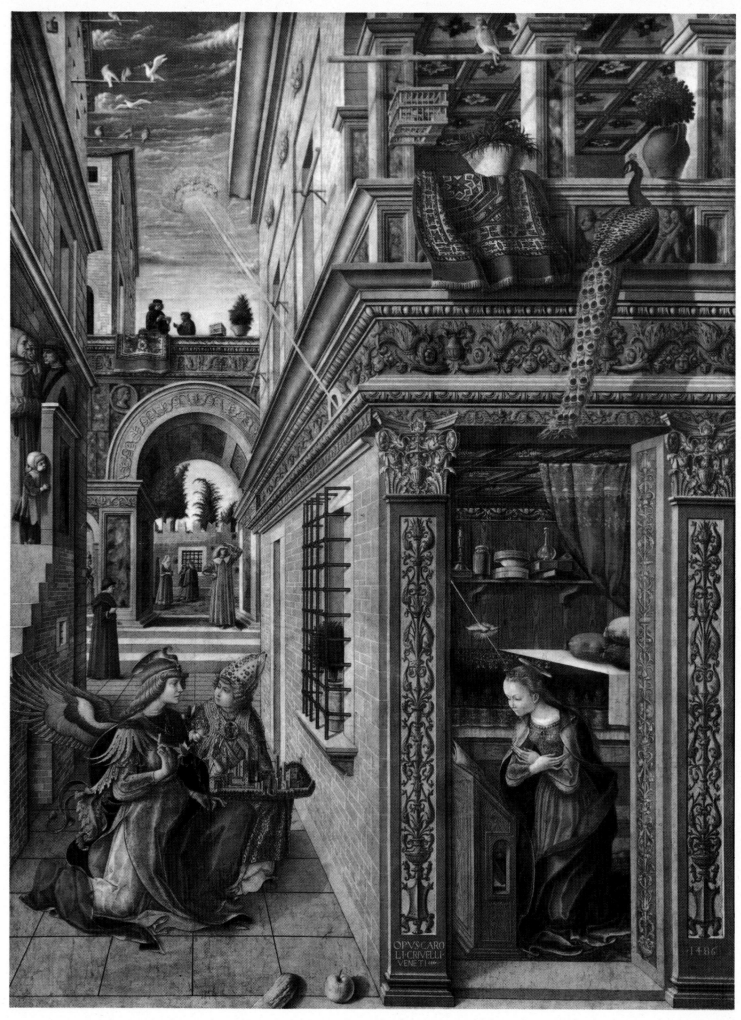

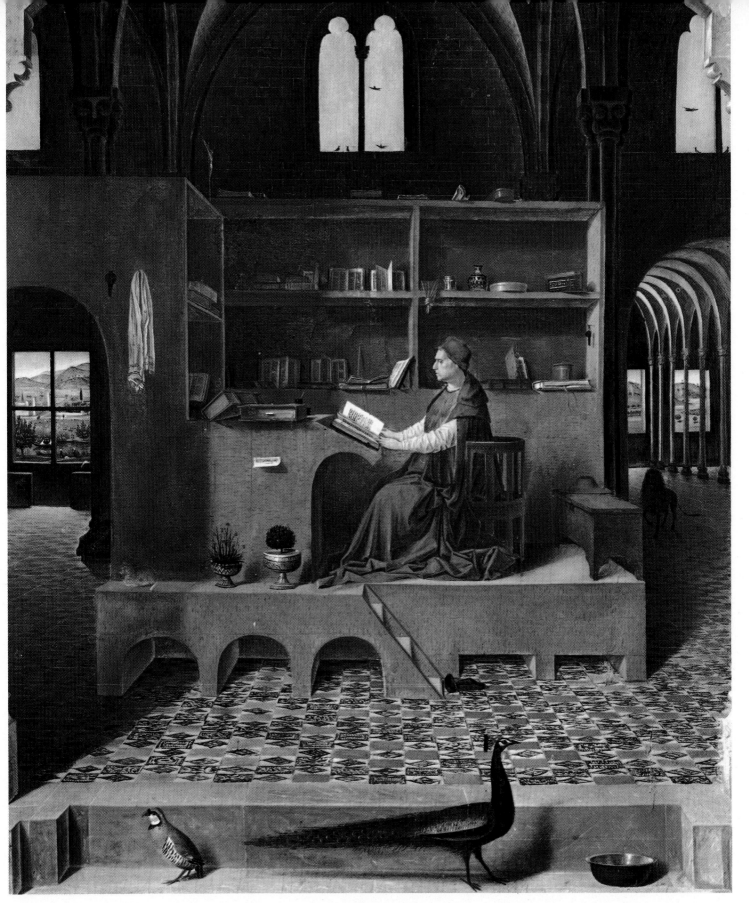

Above
ANTONELLO DA MESSINA
S. Jerome in his Study
(detail)
Limewood, 45.5 × 36 cm

Left
CARLO CRIVELLI
The Annunciation with S. Emidius
Canvas, 207 × 146.5 cm

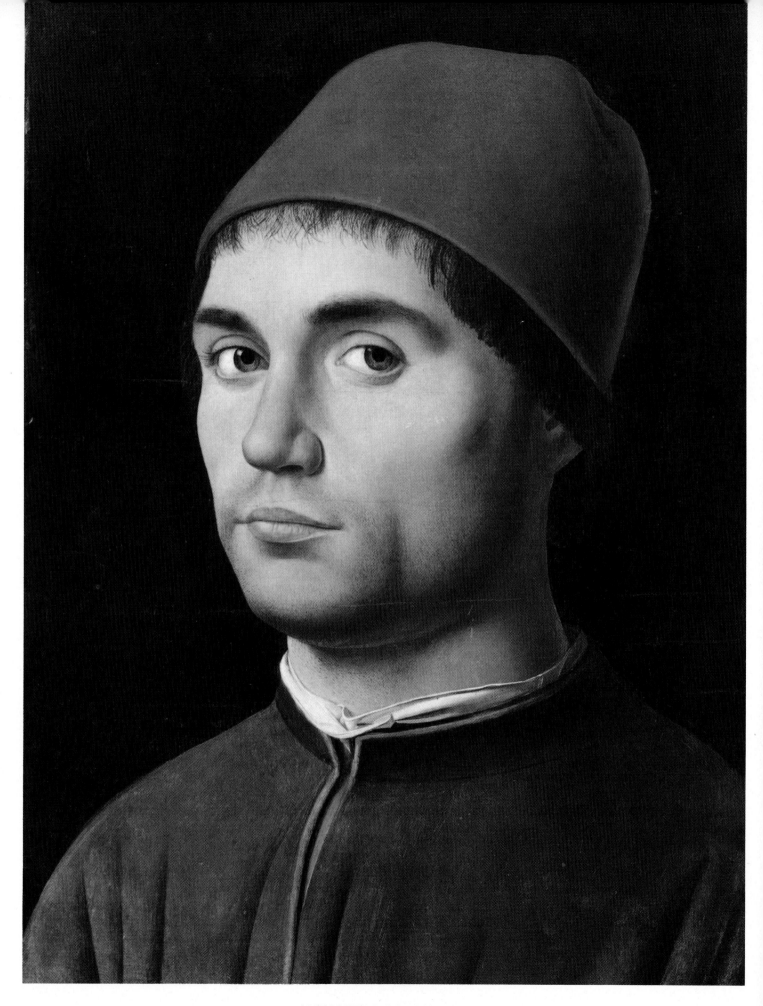

ANTONELLO DA MESSINA
Portrait of a Man
Poplar, 35.5 × 25 cm

ANTONELLO DA MESSINA *Portrait of a Man* Page 38

It was long thought that Antonello travelled to the Netherlands and acquired the technique of oil painting directly from Jan van Eyck, and that when he visited Venice around 1475 he introduced the technique there. It seems certain that portraits like this one influenced Giovanni Bellini, among others, but it is highly unlikely that Antonello visited Northern Europe. He probably came into contact with Flemish art in Naples, where there are known to have been works by Rogier van der Weyden and Jan van Eyck. Like van Eyck, he imitates the colour and texture of the man's sallow skin, the stubble on his chin, his clear lustrous eyes, his collar and his cap with the precision of the miniaturist. Yet the design remains bold and imposing. Silhouetted against a very dark, plain ground, the sharply-lit face of the sitter appears to project out of the frame.

GIOVANNI BELLINI Venice c.1430–1516 *The Agony in the Garden* Page 40

Bellini probably painted this version of the Agony in the Garden soon after Mantegna produced his—also in the National Gallery—with which it has so much in common. Bellini has imitated Mantegna's brittle rock-forms and sharp, detailed figure style. The pose of Christ, although reversed, is almost identical, and the sharply foreshortened figure of S. Peter seems consciously to exaggerate the similar effects of perspective in Mantegna's picture. But, significantly, Bellini's figures are smaller in scale. Judas and the soldiers are more remote. Almost engulfed in the landscape, they seem less threatening. For more important to Bellini than narrative clarity is the creation of an evocative atmosphere. It is the delicately coloured landscape, bathed in the first light of dawn, and the rosy cloud-flecked sky that dominate the picture, looking forward beyond the crucifixion to the hope born out of it.

GIOVANNI BELLINI *The Doge Leonardo Loredan* Page 40

Leonardo Loredan was Doge of Venice from 1501 to 1521, and Giovanni Bellini probably painted this portrait soon after his election. Like Baldovinetti's *Lady in Yellow*, the Doge is seen against a plain blue background. But following the example of Antonello, who spent some time in Venice in the 1470s, Bellini shuns the profile view to show the Doge full face, his head thrown into relief by the strong light that strikes it from the side. He fully exploits the oil technique in the meticulously painted cap and robe and the finely modelled face. But the bust has a solidity and nobility which belongs entirely to Italian art. Cut off by the stone parapet, it imitates in form the commemorative sculpted busts of the period, and reflects the preoccupation with sculpture of Mantegna, Bellini's brother-in-law.

GIOVANNI BELLINI *The Assassination of S. Peter Martyr* Page 41

As in *The Madonna of the Meadow*, a landscape in which ordinary people pursue their daily tasks here forms the background to a religious scene. S. Peter Martyr is stabbed and his companion attempts to evade a soldier's blade. Behind them, woodcutters caught in physical activity, superficially so like the soldiers', direct their energy to peaceful ends. The poignancy of the double murder is made keener by the pastoral setting, by the intrusion of such violence into a rural scene where sheep and cattle graze. Yet the foreground and background scenes are related in a still more significant way. It is only through S. Peter's passive acceptance of the roles of sufferer and victim that the tranquillity of the city and the countryside that extends behind his sinking figure is assured.

GIOVANNI BELLINI *The Madonna of the Meadow* Page 41

In this late treatment of the theme of the Madonna and Child, Bellini, perhaps in response to the effects of light and colour in the work of the young Giorgione, has placed the group against a serene landscape, which seems in some mysterious way to owe its tranquillity to their presence. A woman herds cattle, while a stork fights with a snake, prefiguring the battle against evil that the Christ-child will undertake. The Mother and Child dominate the composition not only by virtue of their central position, but also through the intense colouring of the Virgin's draperies. Her head is encircled by the intricate folds of a white cloth. At the centre of the picture a bright red draws our attention to the sleeping Christ, while the deep blue of the mantle throws him into dramatic relief. The Virgin's pensive face betrays intimations of her Son's fate, for cradled in her lap, eyes closed, he assumes the attitude he once again will take when dead.

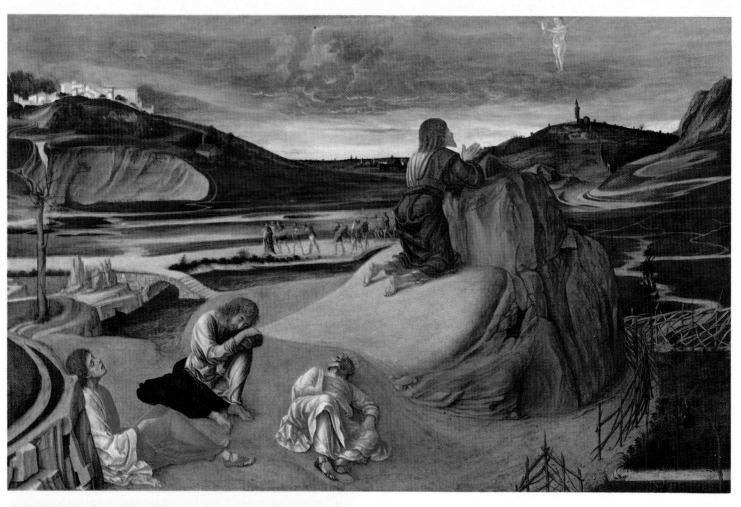

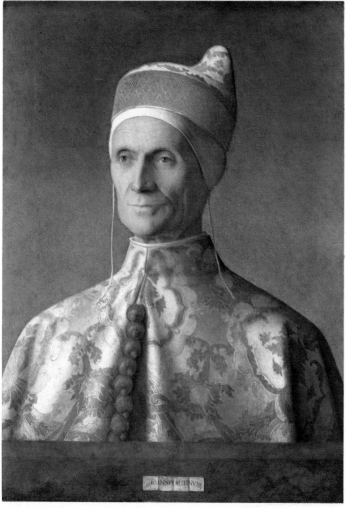

Above
GIOVANNI BELLINI
The Agony in the Garden
Wood, 81 × 127 cm

Left
GIOVANNI BELLINI
The Doge Leonardo Loredan
Wood, 62 × 45 cm

Above right
GIOVANNI BELLINI
The Assassination of S. Peter Martyr
Wood, 99.5 × 165 cm

Right
GIOVANNI BELLINI
The Madonna of the Meadow
Wood, 67 × 86 cm

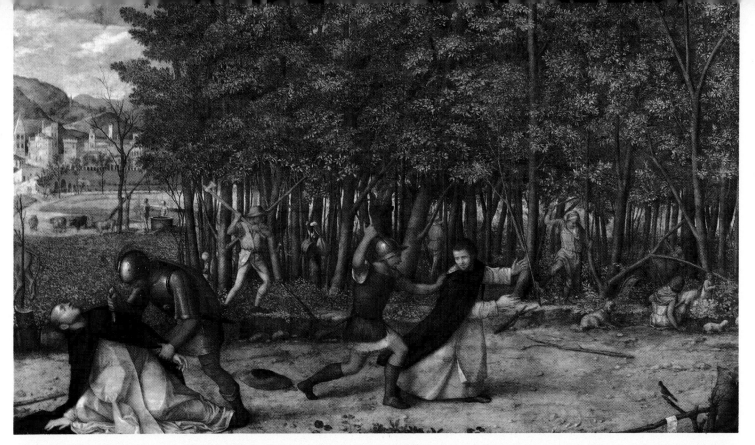

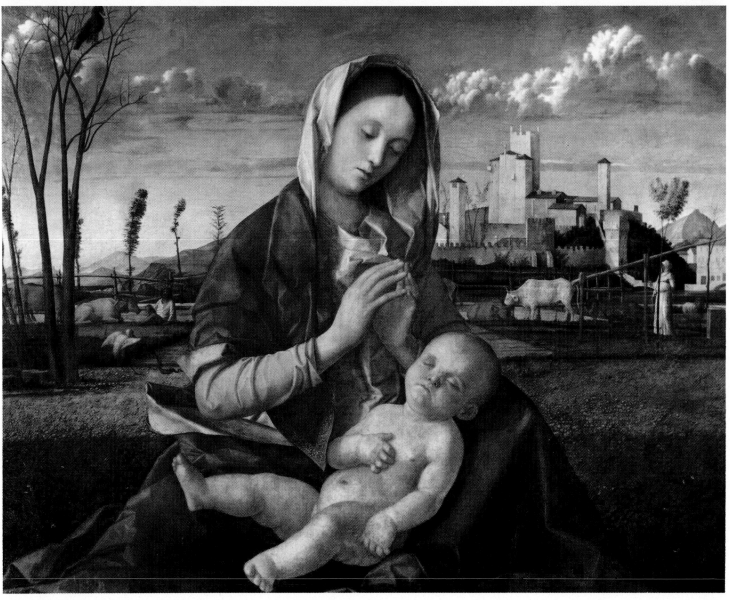

CIMA Conegliano c.1459–Venice 1518 *The Virgin and Child* Page 43

A native of Conegliano, Cima was working in Venice by 1492 and remained there until his death. This Madonna is a late work and shows how much his art is dominated by the example of Giovanni Bellini, who, almost thirty years his senior, may have been his master. After Bellini's tightly constructed and impeccably painted Madonnas, Cima's placid Virgin may seem bland and the soft modelling, blond tone, and harmonious colouring insipid, but the comparison is unjust. Undoubtedly the touching maternal sentiment and the landscape setting with its hill-top towns and glimpse of distant mountains are derived from similar works by the more famous artist, but this is not to deny Cima's mastery of the form. The tilt of the heads, which incline to meet each other, and the rhythmical movement of the hands cradling the child, contribute to a lyricism which, though quiet, is sincerely felt.

SANDRO BOTTICELLI Florence 1445–1510 *Venus and Mars* Page 43

Botticelli was one of the first artists of the Renaissance to treat pagan subjects with the seriousness and intensity previously reserved for religious paintings. No doubt this quite radical development was due in part to the influence of Botticelli's humanist friends. But it is Botticelli's lyrical style that instills his subjects with such potent beauty. Perhaps in response to a similar vein in the art of the man who probably taught him, Fra Filippo Lippi, Botticelli, in such paintings as this, contains forms within elegant rippling lines which suggest energy without weight or even depth. No surface naturalism detracts from the harmony of the composition, from the balance of the tones of smooth plain surfaces with fine linear patterns. The refined faultless bodies of Venus and Mars, the one alert and watchful, the other sleeping and languid, entwine in momentary accord before the imp-like satyrs arouse the god of War.

ANTONIO AND PIERO POLLAIUOLO Florence, 1429–1498 and c. 1441–1496 *The Martyrdom of S. Sebastian* Page 44

The subject of the martyrdom of S. Sebastian was especially popular in the 15th century because it allowed the artist to demonstrate, in the male nude, his knowledge of figure drawing and anatomy. In this altarpiece, commissioned by Antonio Pucci for the Oratory of S. Sebastiano in the church of the SS. Annunziata at Florence, the brothers Pollaiuolo, who were also sculptors and goldsmiths, have emphasized the plastic, sculptural quality of their male figures. In emulation of the three-dimensional quality of sculpture they have shown figures in similar poses from different angles. In the two standing archers and the two crouching ones in the foreground a single pose is observed from the front and the rear. Even the prancing horses in the distance mirror each other's movement. But eventually this realism is self-defeating. This formal system, not surprisingly, gives rise to a rather rigid symmetry which ill accords with the naturalistic observation of costume and landscape.

PIETRO PERUGINO Citta della Pieve c.1448–Fontignano 1523 *The Virgin and Child with SS. Raphael and Michael* Page 45

Perugino was trained, like Leonardo, in the studio of Verrocchio in Florence, but he later worked chiefly in or around Perugia, the Umbrian city from which he takes his name. These three panels formed part of an altarpiece in the Certosa near Pavia, and a fourth of *God the Father* can still be seen there. Perugino seems to have been slow in producing them. He may never have completed the altarpiece, and those pieces that survive probably date from early in the 16th century. It has even been suggested that the young Raphael, Perugino's pupil, may have had a hand in them. Nevertheless, their quiet lyricism is typical of Perugino's religious works. The elegant tapered figures pose dreamily in a still, hazy landscape. The diffused light softens the sinuous contours and gently blends the harmonious colours. It required the intellectual vigour of Raphael to bring to this innocent and placid interpretation of sacred subjects a greater substance and more dynamic energy.

FOLLOWER OF VERROCCHIO Florence 1435–Venice 1488 *Tobias and the Angel* Page 45

Although this picture must rank as one of the most polished and elegant of 15th century Florentine paintings, its authorship is unknown. It has been attributed to Verrochio, the master of Leonardo who was more notable as a sculptor; to Botticini; to Antonio del Pollaiuolo; and even to the young Perugino. It is certainly of a kind with the type of work produced by Verrocchio's studio: rhythmically buoyant—almost jaunty, in fact—elegant, sharply delineated and weightless. The story is from the apocryphal book of Tobit. Tobias sets out with the archangel Raphael to collect a loan due to his father, Tobit, and it is presumably a paper relating to this that Tobias carries, together with the fish that the angel instructed Tobias to take and put up safely.

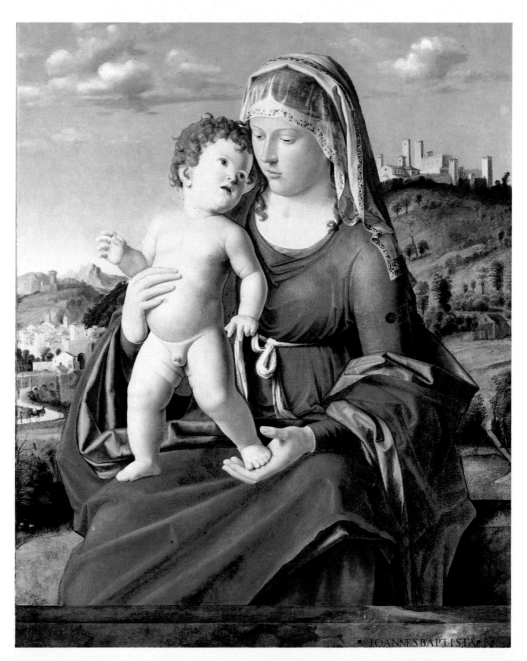

Right
CIMA
The Virgin and Child
Wood, 64.5 × 52 cm

Below
SANDRO BOTTICELLI
Venus and Mars
Wood, 69 × 173 cm

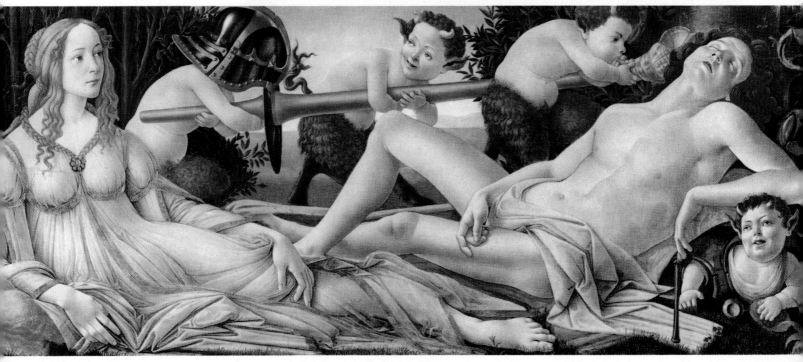

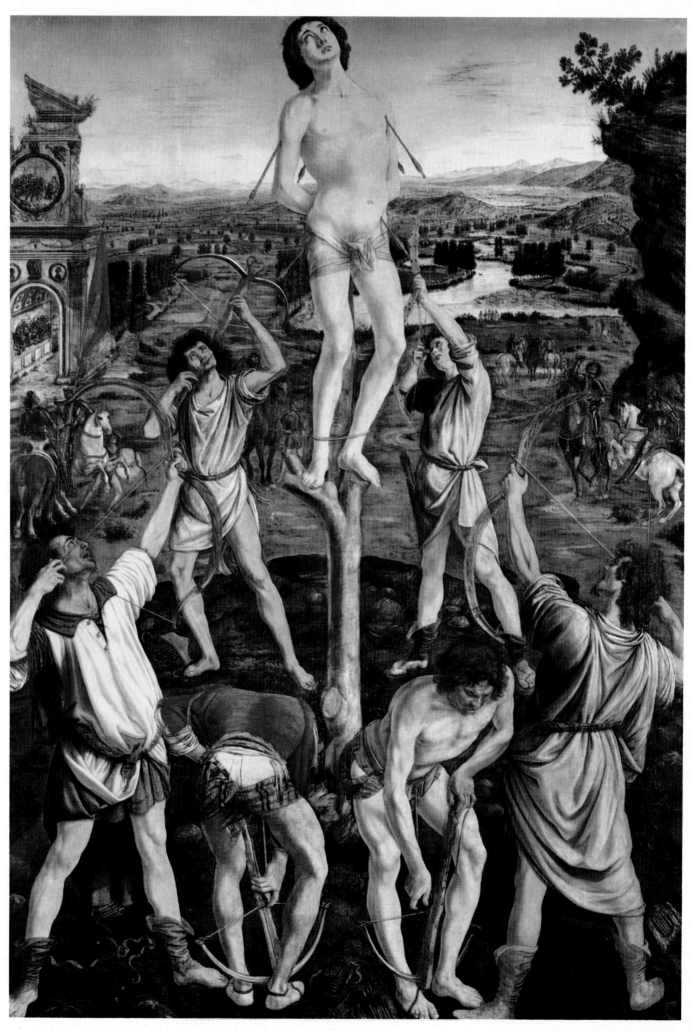

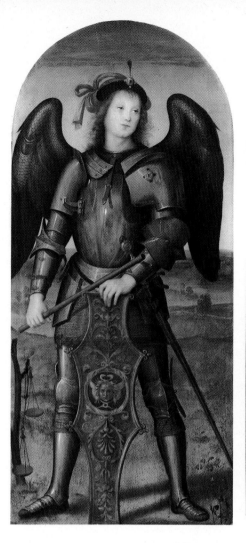
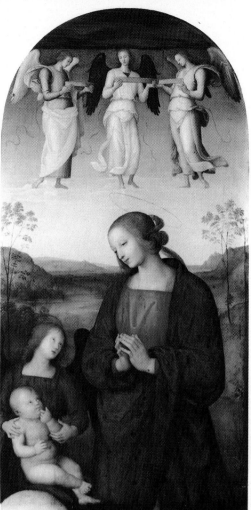
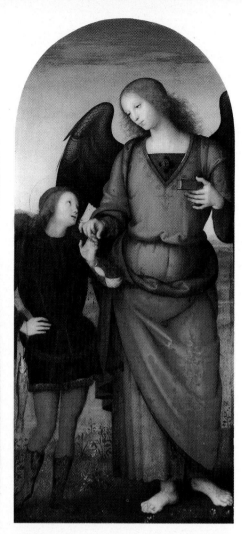

Above
PIETRO PERUGINO
The Virgin and Child with SS. Raphael and Michael
Wood, 126 × 57 cm; 127 × 64 cm; 127 × 57 cm

Left
ANTONIO AND PIERO POLLAIUOLO
The Martyrdom of S. Sebastian
Wood, 291 × 202 cm

Right
FOLLOWER OF VERROCCHIO
Tobias and the Angel
Wood, 83.5 × 66 cm

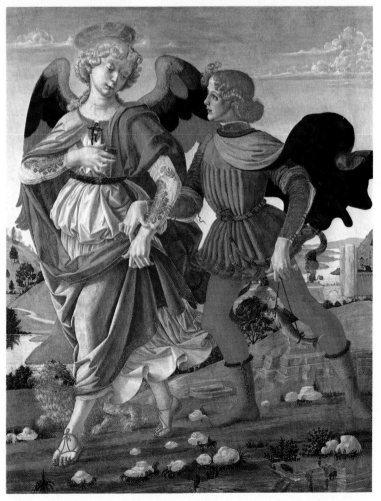

Early Netherlandish and German Painting

ROBERT CAMPIN Tournai 1378–1444 *The Virgin and Child before a Firescreen* Page 47
During the early 15th century, the International Gothic style gave way in the Netherlands to a new current of realism, which first finds coherent expression in the works associated with Robert Campin. Active at Tournai from 1406 and probably the master of Rogier van der Weyden, he has been identified with the Master of Merode and the Master of Flémalle, to whom a number of works are assigned. Common to all is a robust (if somewhat naive) naturalism. Here the Virgin is shown in a well-furnished 15th-century interior overlooking a town square with shops and men at work. Inside, everything is set in a clearly defined space, and even if the intricate folds of the Virgin's robe still recall the fanciful designs of gothic art, the sense of weight and volume is quite novel. So thorough-going is this realism that Campin substitutes for the customary gilded halo of the Virgin a wickerwork firescreen against which her head is silhouetted.

JAN VAN EYCK Maaseyck c.1390–Bruges 1441 *'The Arnolfini Marriage'* Page 48
The inscription above the mirror in this picture reads, translated, 'Jan van Eyck was here, 1434', and one of the figures reflected in the mirror is probably the artist himself, present as a witness to the marriage of Giovanni Arnolfini, an Italian then living in Bruges, to Giovanna Cenami. The carved figure of S. Margaret and the single lighted candle are symbols of the nuptial chamber and further religious references appear in the illustrations to the Passion surrounding the mirror and in the rosary hung on the wall. Yet while the picture is intended to bear more significance than an ordinary work of portraiture, van Eyck invests it with a realism that breaks with the elaborate conventions of northern gothic art. The couple is shown in a bedchamber which, like them, is described in minute detail; like van Eyck, the spectator seems to become a witness at the marriage ceremony.

JAN VAN EYCK *Portrait of a Man in a Turban* Page 49
For several centuries the technique of oil painting, which originated in the Netherlands, was believed to have been invented by Jan van Eyck. Certainly he was one of the first to realize its power to imitate textures and colours in a realistic manner. This small but arresting portrait, which may indeed be of the artist himself, does more than commemorate the virtue and nobility of the sitter, the major function of portraiture until this time. It presents the unidealized image of a particular personality. The eyes gaze directly out at the spectator, establishing a contact of completely novel intimacy, made more immediate by the vibrancy of the colour and the close description of the sitter's clothing and aging features. A complete personality is caught in an image which yet seems the record of a single instant. The picture's frame, which is original, bears a motto, the name of the artist, and the date 21 October 1433.

ROGIER VAN DER WEYDEN Tournai c.1399–Bruges 1464 *Portrait of a Woman* Page 49
Although this picture was possibly executed as one half of a diptych, it survives as a supreme example of Rogier van der Weyden's powers as a portraitist. He trained under Robert Campin and later became city painter of Brussels, whence his fame spread all over Europe. To Campin's keen observation he brings a greater refinement and a more sophisticated sense of design. Here the transparent fabric of the head-dress establishes the pyramidal basis of the composition and sets off the delicate complexion of the sitter. Fixed in still, grave contemplation, she is nevertheless vividly alive. The contours of her face are thrown into relief by the soft light, while every variation of tone, from the bleached white of the head-dress to the ivory of the chemise to the pale pink of the flesh which deepens in the lips, is meticulously recorded. In 1450 Rogier visited Italy, where this masterful use of oil paint left its mark on Antonello da Messina, and through him upon Giovanni Bellini.

ROGIER VAN DER WEYDEN *S. Ivo* Page 49
When this picture was purchased in 1971, it bore a false inscription at the top right identifying the subject as S. Ivo, a Breton saint who dedicated himself to the protection of poor persons. While the identification remains uncertain, the attitude of the man suggests that the picture was not simply intended as a portrait. Yet it would seem that Rogier has based the saint on a study from life. Every detail of his head, with a scar at the corner of the mouth and the faint bluish veins on the temple, is recorded impassionately but with great sensitivity. His features bespeak a quiet certainty of purpose which is reflected in the lucid, ordered design. As in Campin's *Madonna of the Firescreen* a window looks out on to a landscape, but one that, in this instance, is harmoniously organized, with a clear blue sky mirrored in sheets of still water.

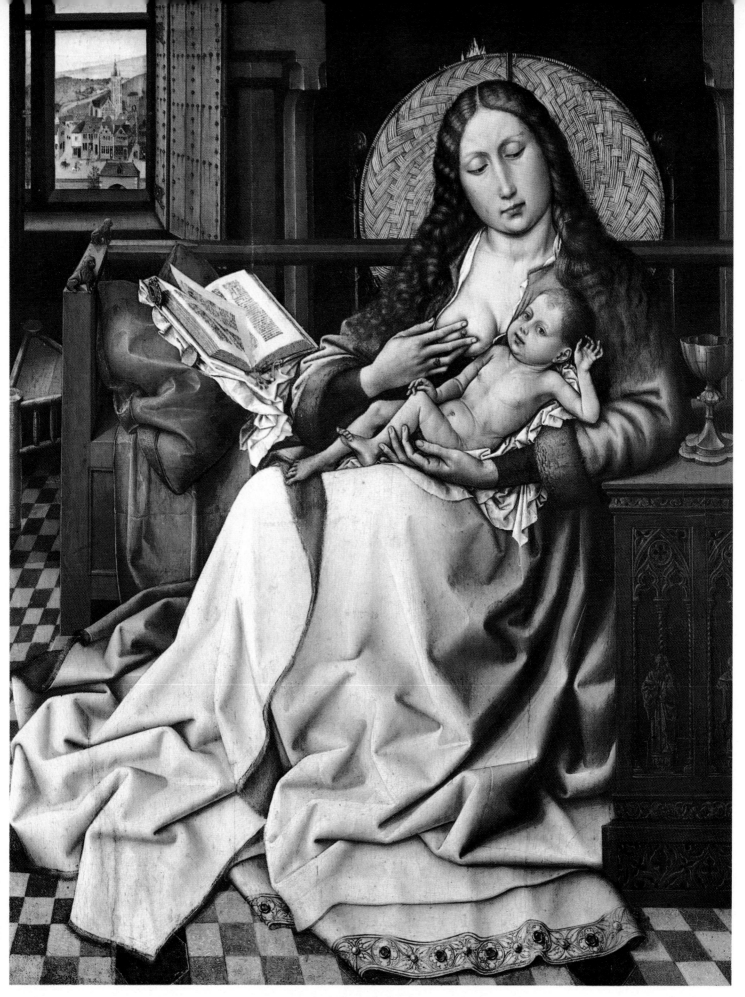

ROBERT CAMPIN
The Virgin and Child before a Firescreen
Oak, 63 × 49 cm

47

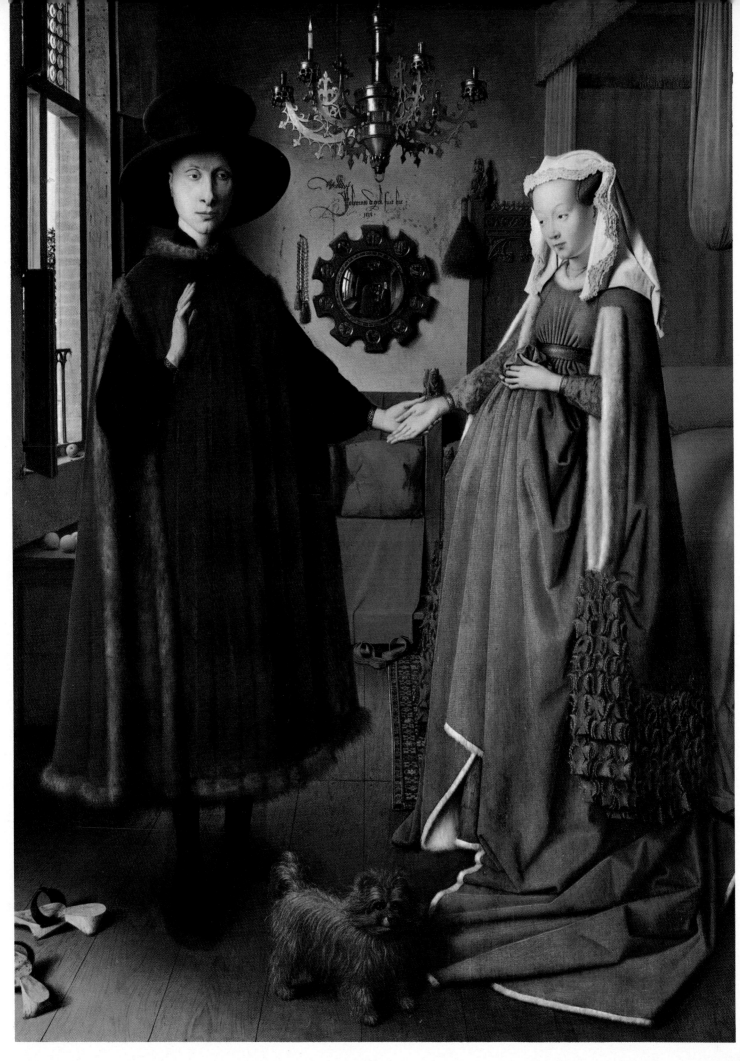

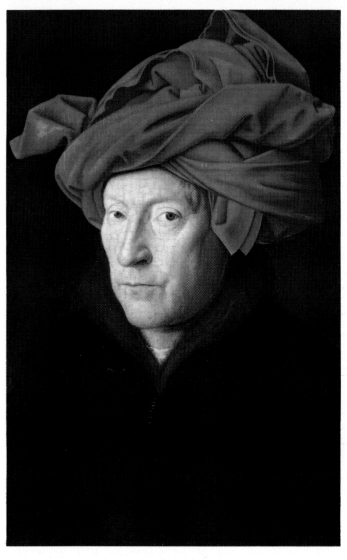

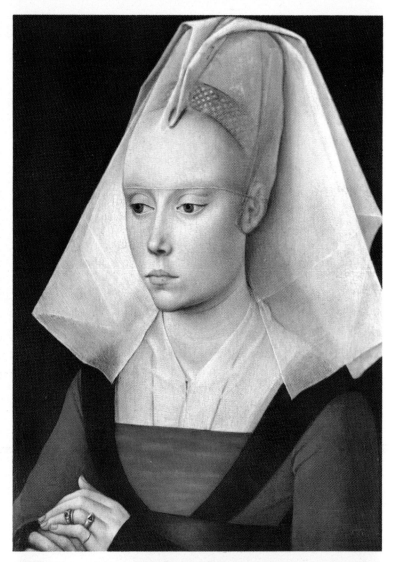

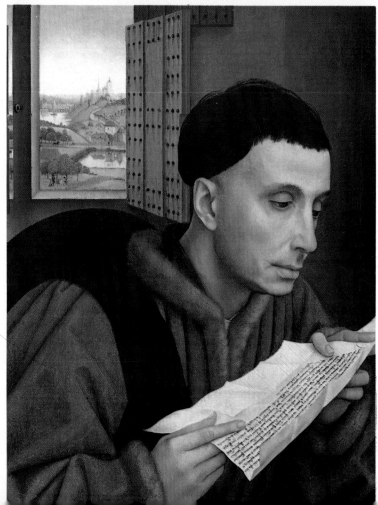

Above
JAN VAN EYCK
Portrait of a Man in a Turban
Oak, 25 × 19 cm

Left
JAN VAN EYCK
The Arnolfini Marriage
Oak, 81 × 59 cm

Above right
ROGIER VAN DER WEYDEN
Portrait of a Woman
Wood, 36 × 27 cm

Right
ROGIER VAN DER WEYDEN
S. Ivo
Wood, 45 × 38 cm

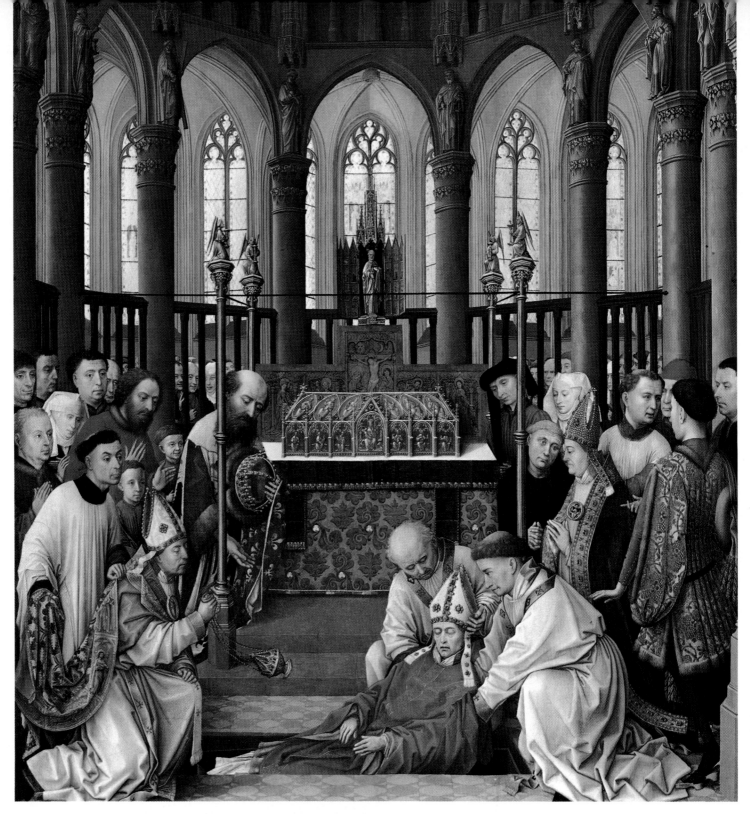

FOLLOWER OF ROGIER VAN DER WEYDEN
The Exhumation of S. Hubert
Wood, 87 × 80 cm

FOLLOWER OF ROGIER VAN DER WEYDEN *The Exhumation of S. Hubert*

Until the 17th century this crowded panel framed part of an altarpiece in a chapel dedicated to
S. Hubert in the church of S. Gudule, Brussels, for which it was probably commissioned soon
after the foundation of the chapel in 1437. In 825 the body of S. Hubert had been exhumed from
the church of S. Pierre, Liège, to be removed to the Abbey of Andagium, and it is this event that
the painting records. On the left are Walcandus, Bishop of Liège, and Louis le Débonnaire, King
of France, and on the right probably Adelbald, Archbishop of Cologne. They gather round the
high altar in the choir of a church which accords in style with Brabant architecture of the early
15th century. Although this picture is still sometimes attributed to Rogier van der Weyden him-
self, the constricted space and the formalized contours suggest the hand of a follower.

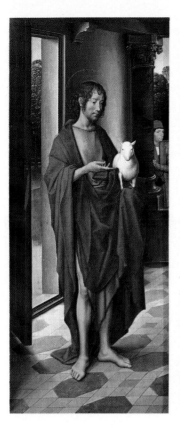
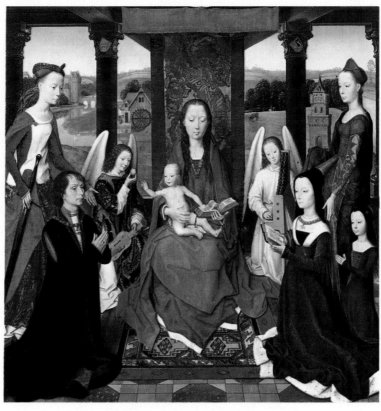
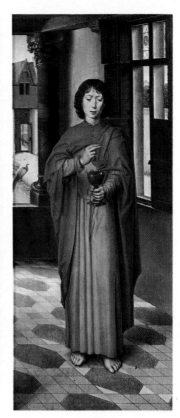

HANS MEMLINC
The Virgin and Child with Saints and Donors
Oak, 71 × 30 cm; 38 × 25 cm; 71 × 30 cm

HANS MEMLINC Mainz c.1430–Bruges 1495 *The Virgin and Child with Saints and Donors*
The donors in this triptych by Memlinc are Sir John Donne and his family, and the arms of
Donne and his wife appear on two of the capitals in the central panel. Donne seems to have been
resident at Calais for a considerable period and is known to have visited Bruges, where Memlinc
worked. The picture is exceptionally well preserved and demonstrates perfectly the ordered
clarity of his style. The architectural setting, an extensive tiled room that opens onto a broad
vista of cultivated rural scenery, is continued through the three panels so that all the figures,
including S. John the Baptist and S. John the Evangelist, move in the same pellucid atmosphere.
While the detailed description of textures and surfaces is part of Memlinc's northern inherit-
ance, the influence of Italy can be felt in the logical plotting of objects in space and in the slim,
idealized forms of the figures. And to this Memlinc adds, in the angel offering an apple to the
infant Christ, a note of touching humanity.

GERARD DAVID Oudewater c.1450–Bruges 1523 *The Adoration of the Kings* Page 52
Gerard David was active chiefly in Bruges, where van Eyck and Memlinc had worked, but also
seems to have been influenced by Quentin Massys at Antwerp. As with Memlinc, the realism of
his work is tempered by a refinement and a tendency to idealize his subjects. This panel and
The Deposition, also in the National Gallery, are almost identical in size and similar in style.
It seems likely that they formed part of the same altarpiece, perhaps of scenes of the life of Christ,
and date from about 1515. A quiet air of repose pervades them both. Here the kings approach the
Virgin and Child without pomp, with a benign, almost contemplative bearing. The cool daylight
softens the transitions of tone and subdues the colours. The costumes form a harmony of pinks
and blues against a setting of muted greys and calm classic order.

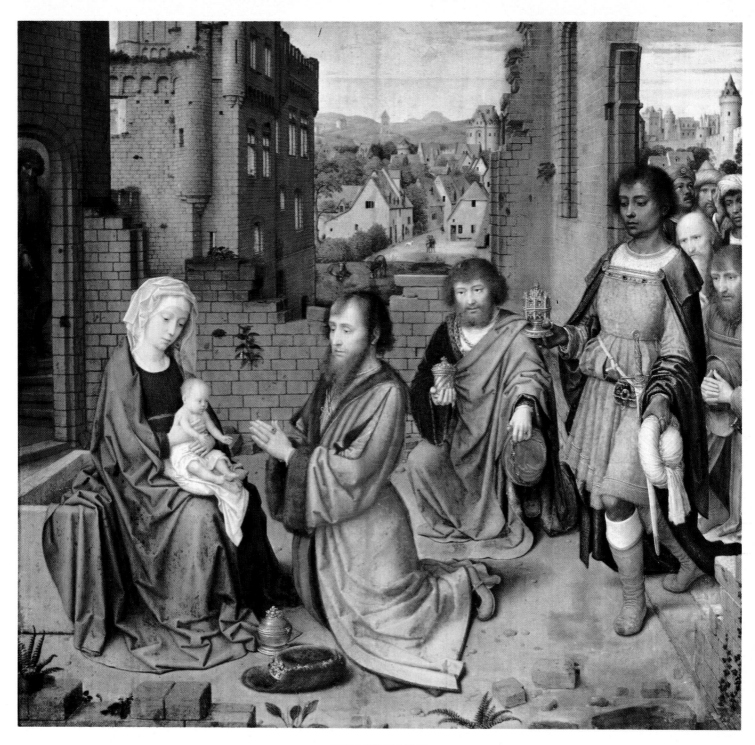

GERARD DAVID
The Adoration of the Kings
Oak, 59 × 58 cm

PIETER BRUEGEL THE ELDER Campin c.1525–Brussels 1569 *The Adoration of the Kings*

Page 53

Painted about fifty years later than David's version of the subject, Bruegel's treatment of the Adoration, signed and dated 1564, could not be more different. Working at Antwerp, Bruegel was greatly influenced by the work of Hieronymous Bosch, but less by his fantasy than by his satire. Here there is scarcely a figure that is not caricatured. A mob of soldiers and peasants press forward with stupid curiosity upon the holy family, outside a squalid stable. They are the same brutish types which Bosch shows in the *Christ Mocked*, also in the gallery. Untypical of Bruegel, but in the tradition of Netherlandish painting, is the scale of the figures, with a few large protagonists dominating the composition. Such a treatment offers the opportunity for vivid characterization, particularly in the wizened kings. Costume too plays a prominent role—hoods, fringes, and slashed sleeves contributing to the impression of a grotesque and motley throng.

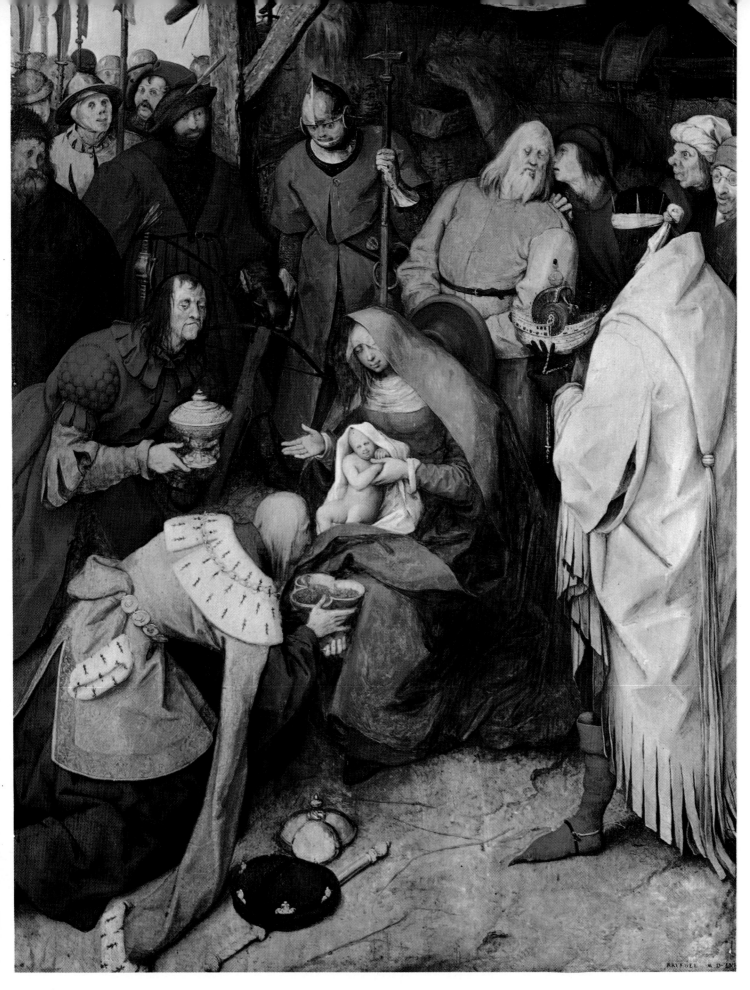

PIETER BRUEGEL THE ELDER
The Adoration of the Kings
Oak, 111 × 83 cm

53

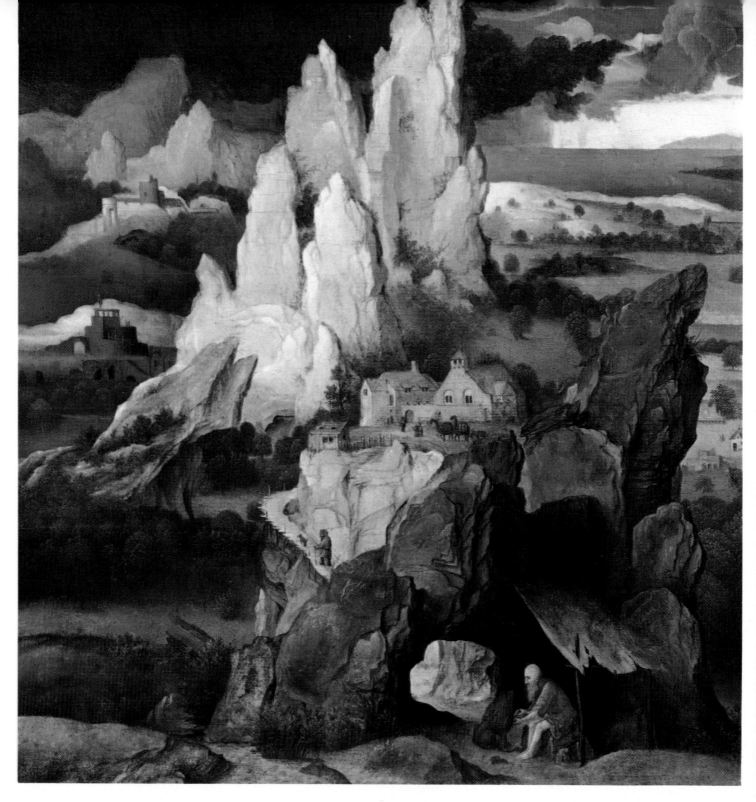

JOACHIM PATINIER
S. Jerome in a Landscape
Wood, 36 × 34 cm

JOACHIM PATINIER Bouvignes c.1475–Antwerp 1524 *S. Jerome in a Landscape*
Also active in Antwerp, Patinier is among the first artists to paint pictures in which landscape
predominates. He is mentioned by Dürer as a landscapist, and although his works generally
feature incidental figures, they are little more than pretexts for the creation of fantastic settings.
Here S. Jerome and the lion shelter beneath a rude construction at the very bottom of the picture.
Above rise several tiers of towering rock formations, sharply lit against inky blue storm-clouds.
A native of one of the flattest parts of Europe, Patinier has invented mountains of impossible
magnitude and ruggedness. Other versions, the finest of them in the Prado, repeat this composi-
tion in a more extended form, and since Patinier died young and famous it is possible that this
may be the work of an imitator, although signed works exist of lesser quality.

54

CIRCLE OF MICHAEL PACHER active 1465(?), died 1498 *The Virgin and Child enthroned with Angels and Saints* Page 56

Michael Pacher was a painter and sculptor working in the Tyrol in the last quarter of the 15th century, and this picture, while differing from his work in certain respects, reflects his influence. The figures, like Pacher's, are conceived in terms of painted sculpture and set beneath elaborate carved gothic canopies. The Virgin sits between S. Michael on the left, weighing a human soul, and a bishop-saint on the right. On the stone pillars to each side of her are the angel Gabriel and the Virgin annunciate, who, while forming part of the architectural setting, are no less alive than the principal figures. But the picture is smaller than those associated with Pacher, and the modelling of the figures more conventionally stylized.

MASTER OF THE LIFE OF THE VIRGIN active late 15th century *The Presentation in the Temple* Page 56

This 15th-century German artist is named after a series of eight panels that once formed a single altarpiece illustrating the life of the Virgin. Seven of them are in Munich, and the eighth is this picture. They were commissioned for the church of S. Ursula at Cologne by Dr. Johann von Schwartz-Hirtz, Counsellor at Cologne from 1439 to 1460, whose portrait appears in the scene of *The Visitation*. Only in the second half of the 15th century did the new developments in the Netherlands begin to affect German art. The influence of both Rogier van der Weyden and Dieric Bouts is evident here in the characterization of the figures and naturalistic description of the costumes. Yet the traditional gold ground is still retained. The incident portrayed is the presentation of the infant Christ, but it also signifies the purification of the Virgin. The doves held by the women on each side were required by the ritual purification prescribed by Mosaic law.

STUDIO OF THE MASTER OF THE LIFE OF THE VIRGIN *The Conversion of S. Hubert* Page 57

S. Hubert, who became first Bishop of Liège, kneels in adoration before a miraculous stag, bearing a crucifix between its antlers. It seems that this incident came to be introduced into the legend of S. Hubert through confusion with the story of S. Eustace—the subject of the picture by Pisanello. This picture formed one of the inside wings of an altarpiece from the Benedictine Abbey of Werden in Westphalia, now conserved in the National Gallery. The costume indicates a date late in the 1480s and it is possible that this wing, finer in quality than the outside wings, is a late work by the Master himself. It shows the emergence of German art from the International Gothic style. The background is still flat and decorative, and contains an animated hunt scene that might be found in a tapestry. But the men and animals in the foreground have volume and cast shadows. In the splendid figure of S. Hubert, with his sensitively modelled face, the whole legend takes on life.

ALBRECHT DÜRER Nuremberg 1471–1528 *The Painter's Father* Page 58

Dürer was so inspired by the Renaissance ideas that had penetrated into Germany that he refused to allow his origins in provincial Nuremberg to inhibit his development as an artist. Imbued, like Leonardo, with the conception of the artist as a kind of hero, he travelled to Italy and the Netherlands, and his work combines the classic design of Mantegna and Bellini with the psychological penetration of Rogier van der Weyden. This portrait of his father, inscribed with the date 1497, is probably the picture presented by the city of Nuremberg to Charles I, through the Earl of Arundel, in 1636. It is a scrupulous record of an individual personality, into which considerations of social status, style and beauty do not enter. The heavy coat is laid-in with broad brushstrokes, while the head is a consummate feat of character study and design. It is alive with rhythmical movement, in the strong contours, the folds of loose skin, and the fine wiry hair that springs about it, while the cap seems to become an extension of the face with its bold curves. And out of the middle, peering with concentrated inquiry, two fine grey eyes fix our regard.

LUCAS CRANACH THE ELDER Kronach 1472–Weimar 1553 *Charity* Page 59

From 1505 until his death in 1553, Lucas Cranach served as court painter to three successive electors of Saxony. His workshop produced numerous allegorical figures of this sort, although this picture is accepted as a late work by Cranach himself, and is unique among his versions of the subject in showing Charity standing rather than seated or lying down. The nude was still a novelty in northern art at this time, and was to be proscribed by the Protestant church. But here, in response to the Italian revival of Antique culture, Cranach creates a profane art which is totally northern in character. She is a German's idea of classical beauty. Sharply silhouetted against a flat background, these figures cut an intricate pattern of sinuous lines. The suggestion of sculptural form is contradicted by the overwhelming linear emphasis which, despite his deference to Renaissance art, betrays Cranach's gothic roots.

Left
CIRCLE OF MICHAEL PACHER
The Virgin and Child enthroned
with Angels and Saints
Silver fir, 40 × 39 cm

Below
MASTER OF THE LIFE OF THE VIRGIN
The Presentation in the Temple
Oak, 83 × 108 cm

Right
STUDIO OF THE MASTER OF THE LIFE
OF THE VIRGIN
The Conversion of S. Hubert
Oak, 123 × 83 cm

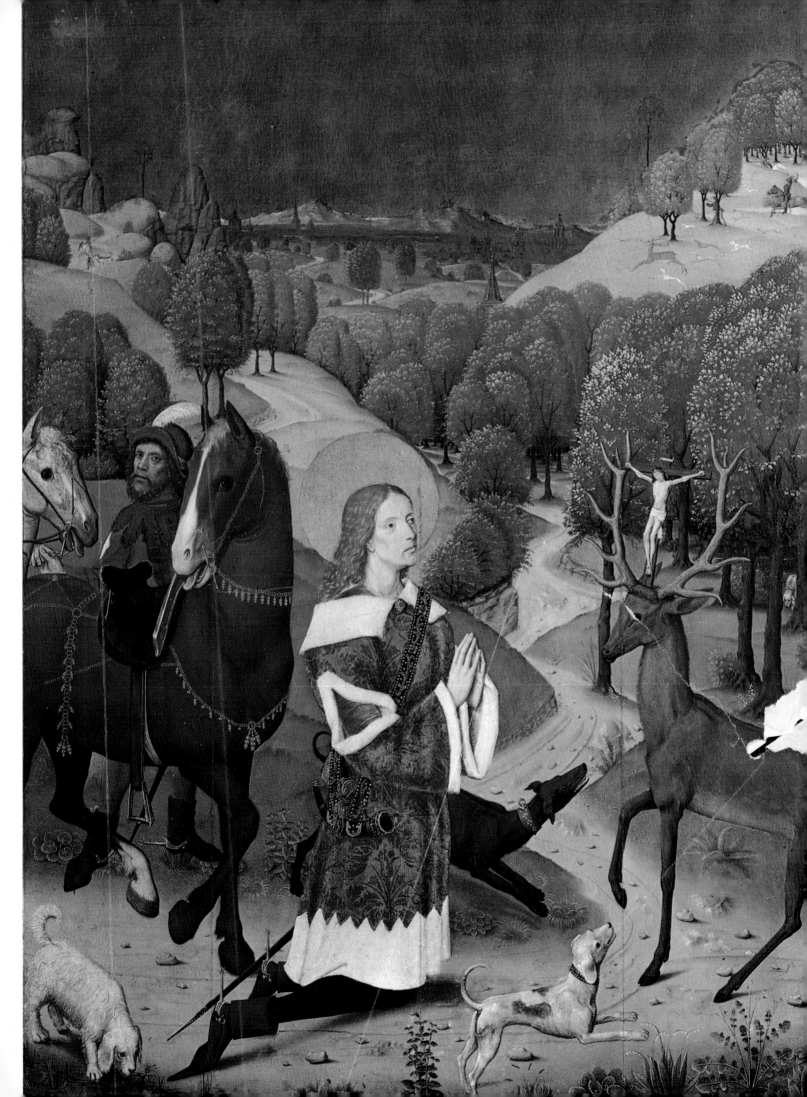

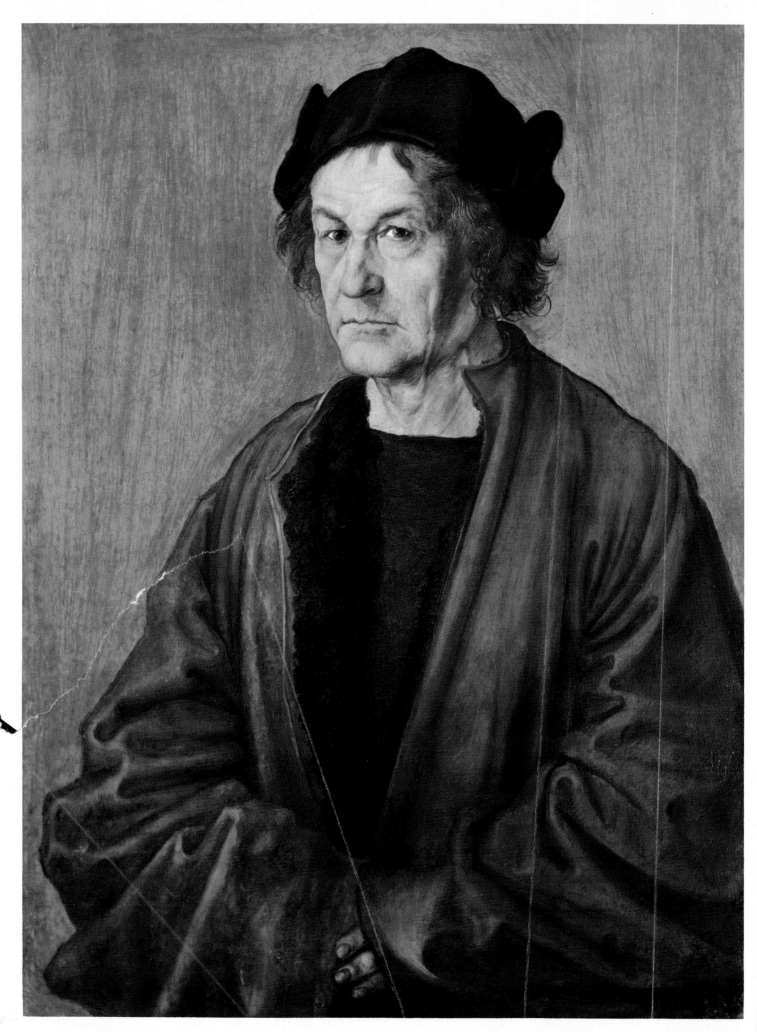

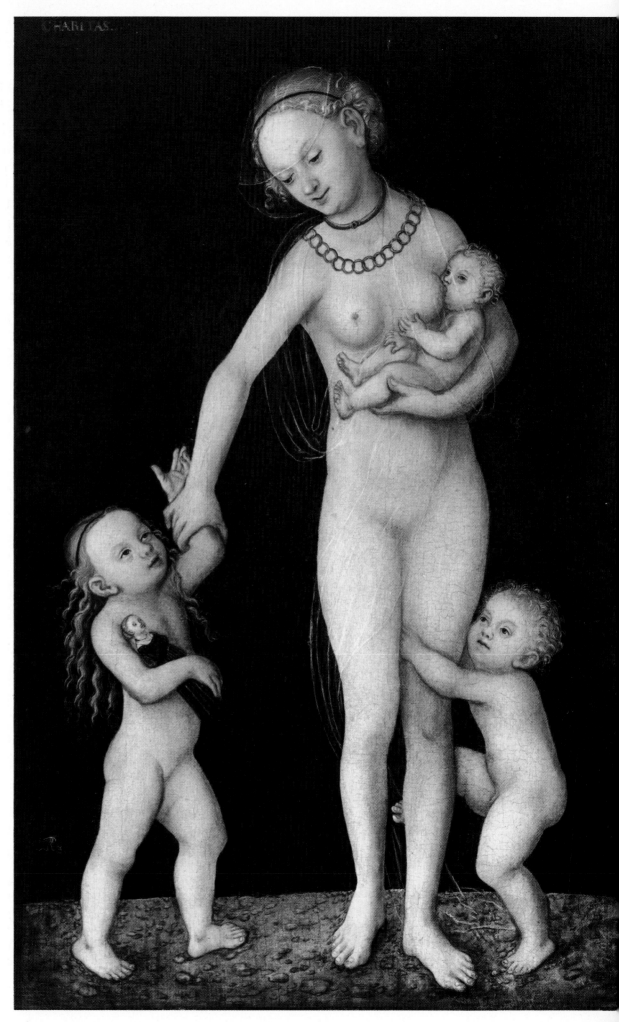

Left
ALBRECHT DÜRER
The Painter's Father
Lime, 51 × 40 cm

Right
LUCAS CRANACH
THE ELDER
Charity
Beech, 56 × 36 cm

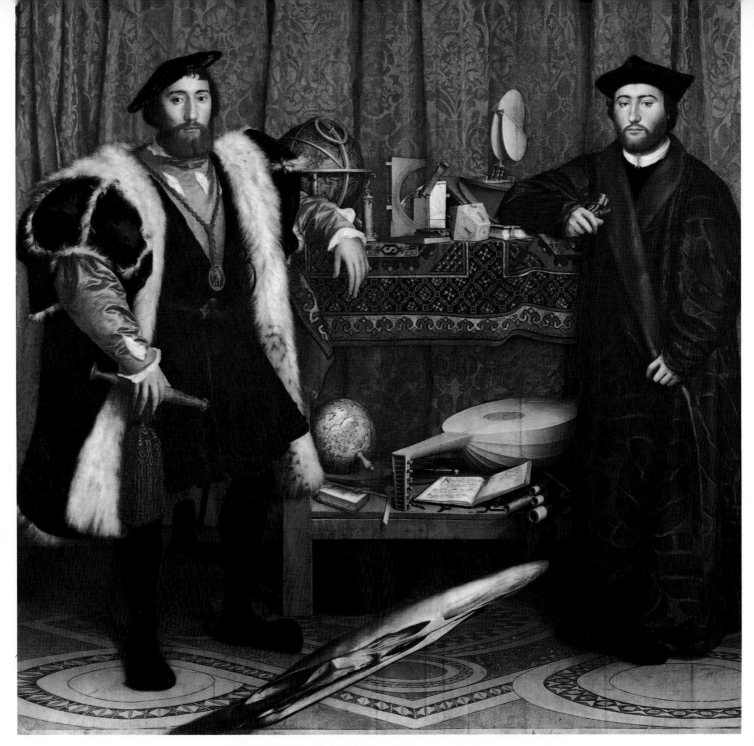

HANS HOLBEIN THE YOUNGER
Jean de Dinteville and Georges de Selve ('The Ambassadors')
Oak, 207 × 209 cm

HANS HOLBEIN THE YOUNGER Augsburg 1497–London 1543 *Jean de Dinteville and Georges de Selve ('The Ambassadors')*

In this double portrait, Holbein, through the accumulation of details of all kinds, not only indicates the character of his sitters but makes allusions of a wider significance. On the left he shows Jean de Dinteville, French ambassador to England, extravagantly dressed and self-assured, holding a dagger which bears his age, 29, on the sheath. The sober figure on the right is not an ambassador. He is Georges de Selve, Bishop of Lavaur, Dinteville's friend and junior by four years. The complicated dials on the rug between them record the exact moment, 10.30 a.m. on 11 April 1533, while the lute, the case of flutes, the globe and the astrological instruments bear witness to the breadth and modernity of their interests. Portrayed thus in the prime of life, surrounded by objects so accurately rendered, they seem to represent achievement in all spheres. Yet a chill note is struck by the broken lute string, by the Crucifix just visible in the top left corner, and by the attenuated shape in the lower portion of the canvas, which, when seen from the side, assumes the shape of a skull. All these serve as reminders of mortality, and point to the transcience of worldly possessions and pleasures.

60

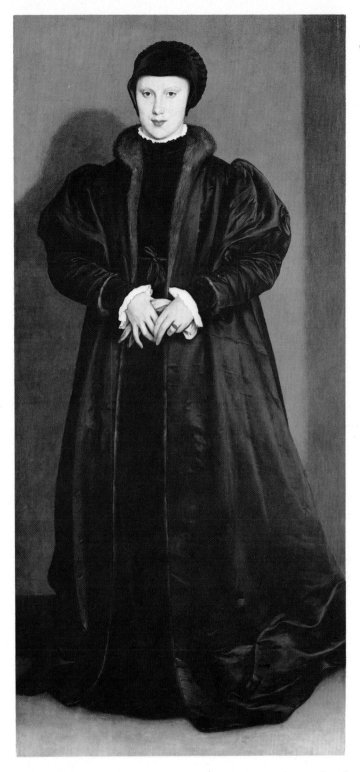

HANS HOLBEIN
THE YOUNGER
Christina of Denmark,
Duchess of Milan
Oak, 179 × 82 cm

HANS HOLBEIN THE YOUNGER *Christina of Denmark, Duchess of Milan*
In 1538, Henry VIII was seeking a fourth wife. Through marriage to Christina of Denmark,
he and his chief minister, Thomas Cromwell, hoped to win the goodwill of Charles V, her uncle,
the powerful Holy Roman Emperor. On the death of her husband, the Duke of Milan, in 1535,
Christina had retired to Brussels, and it was there that Henry VIII sent Holbein in 1538 to paint
her likeness. She sat for the artist for a period of three hours on 12 March, and from this study,
now lost, Holbein produced this painting on his return to England. At the time the full-length
portrait was still a relatively novel concept, and this is the only one of a woman by the artist.
This in itself seems to indicate the importance placed upon the proposed match. But the marriage
never occurred. In 1540 Henry married Anne of Cleves and Christina probably never saw
Holbein's picture of her. In its economy and absence of accessories it is typical of Holbein's
late portraits. The youthful Duchess wears mourning which contrasts simply with the bright
blue of the background and throws her face and hands into dramatic relief. While the image
remains formal, it avoids stiffness by virtue of the free rhythmic invention that animates the long
black gown.

Sixteenth-Century Italian Painting

LEONARDO DA VINCI Florence 1452–Amboise 1519 *Virgin and Child with SS. Anne and John the Baptist* Page 63
This drawing, which is probably a study for an earlier version of the painting in the Louvre of the same subject, has always been applauded as a great work of art, ever since it was executed (probably in Milan) at the beginning of the 16th century. Vasari records how it was put on display and attracted crowds of admirers. The enchanting beauty of the figures has assured its lasting popularity, but perhaps less obvious today is the significance of its role in the development of Renaissance art. Leonardo here inaugurates the heroic era of High Renaissance classicism in a composition of unprecedented sophistication. The figures are modelled virtually as one, grouped into a composite mass in which contours are blurred and the transition of planes softened by the *sfumato*, the misty blending of shadows and highlights. They move in space with natural grace and incomparable ease. The picture takes on a potency as all hardness is left behind.

LEONARDO DA VINCI *The Virgin of the Rocks* Page 64
Although it was probably not completed until 1508, this picture was commissioned from Leonardo for the Chapel of the Confraternity of the Immaculate Conception in S. Francesco Grande, Milan, in 1483. No other picture by the artist shows more clearly the peculiar cast of his imagination and the strain of melancholy that seems to pervade his work. The Virgin, the infant Christ, S. John and an angel are placed in the damp seclusion of an unpeopled rocky shore. A dim light filters through the towering pillars of rock and hanging vegetation to illumine these four figures, gathered in serious and mysterious union. The textures of skin, hair and satin are rendered with deceiving fidelity. But although they appear as human forms with mass and weight, their divinity casts a spell upon them and removes them light-years from us. With its strange rock formations and blue-green waters, the place they occupy does not seem to be of our world at all.

RAPHAEL Urbino 1483–Rome 1520 *Pope Julius II* Page 64
Until it was cleaned in 1970 this picture was thought to be only one of many early copies of Raphael's portrait of Pope Julius II. The removal of old varnish and dirt revealed the quality of the paintwork, and x-ray photographs and microscopical examination showing early changes to the background, provided proof that this was the original. Pope Julius II was the patron of both Raphael and Michelangelo, commissioning the decorations of the *Stanze* in the Vatican from the former, and those on the ceiling of the Sistine Chapel, as well as a colossal tomb (never completed) from the latter. This portrait must have been painted in 1511 or 1512, for only at that time did the Pope wear a beard. It immediately achieved great fame and set the pattern for innumerable portraits of popes and cardinals by later artists.

RAPHAEL *The Ansidei Madonna* Page 65
After a period of apprenticeship with Perugino, Raphael abandoned his master's highly lyrical but limited style for a more sculptural interpretation of form. This altarpiece, painted for the Ansidei family chapel in the church of S. Fiorenzo at Perugia, was completed in about 1505 and already contains the essentials of Raphael's classical style. The figures, which have far more substance than hitherto, are harmoniously arranged within a symmetrical framework, in a setting of almost stark simplicity and clarity. Beneath an unadorned Renaissance arch the Madonna is seated on a throne composed of solid geometrical forms. The contours of robes and limbs are defined with utter precision by the cool light which filters evenly over the surfaces, setting every object in its place for eternity. The protagonists are ideal types in a perfect world. Ignorance and ugliness are banished by the broad daylight of reason.

RAPHAEL *An Allegory ('Vision of a Knight')* Page 66
Both in style and scale this tiny panel is far from the monumentality of Raphael's Roman work. Delicately painted and perfectly composed, it has the beauty of a lyric. Little is known of its origin, but it probably dates from around 1504 when Raphael first came to Florence. The exact subject is also unclear. The knight may represent the young Roman hero, Scipio Africanus, and the female figures may be Minerva, the goddess of wisdom, and Venus, the goddess of love. However, the meaning of the little tableau is not obscure. The panel is divided in two by the tree, and the sleeping knight seems to be torn between the two alternatives symbolized by the women. On the left, plainly clad and bearing a sword and book, one woman represents a life of duty and study; on the right, the other figure, wearing loosely flowing garments, proffers the knight a flower and seems to call him to a life of pleasure.

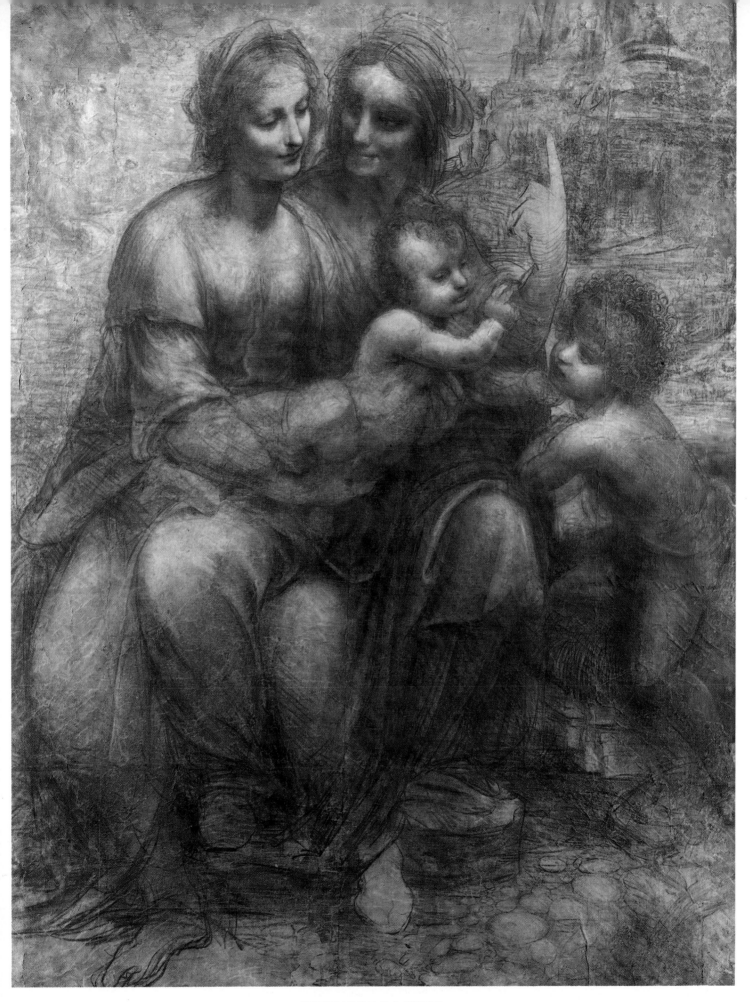

LEONARDO DA VINCI
Virgin and Child with SS. Anne and John the Baptist
Chalk on paper, 141 × 104 cm

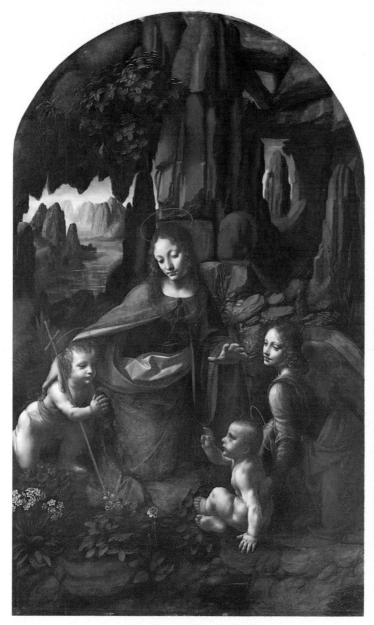

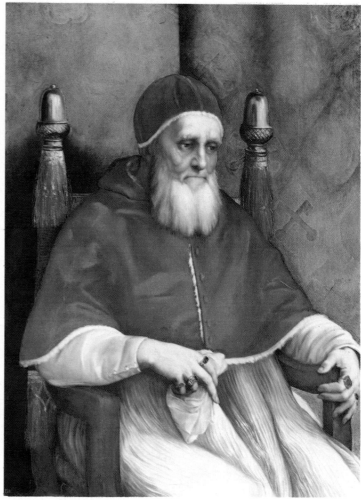

LEONARDO DA VINCI
The Virgin of the Rocks
Wood, 189 × 120 cm

RAPHAEL
Pope Julius II
Wood, 108 × 80 cm

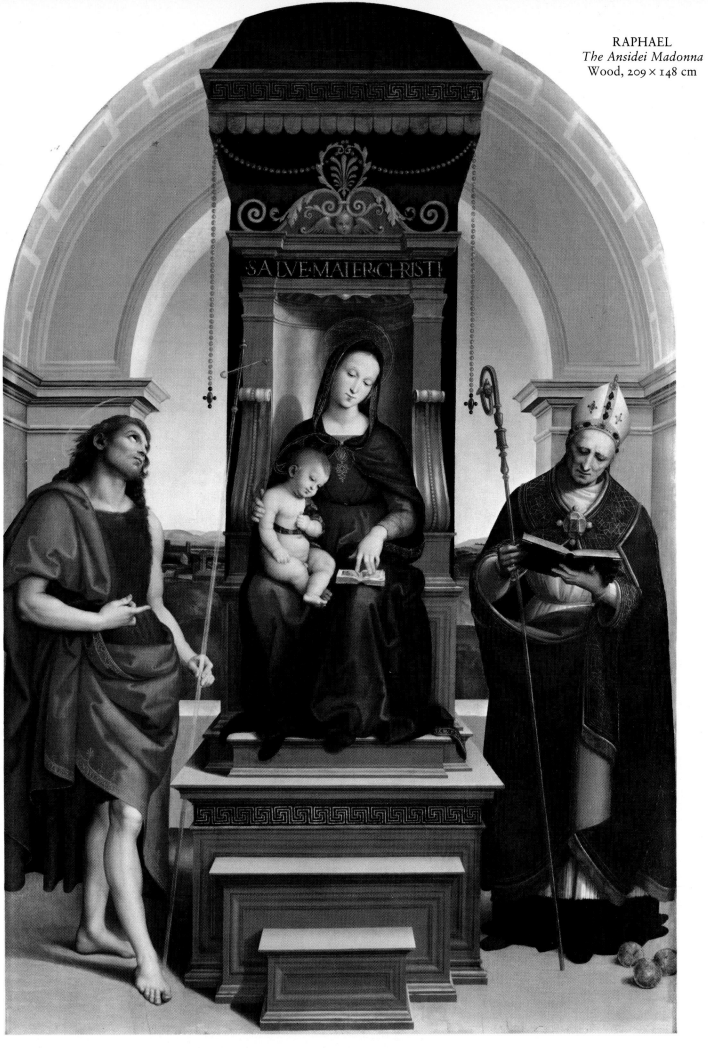

SALVE·MATER·CHRISTI

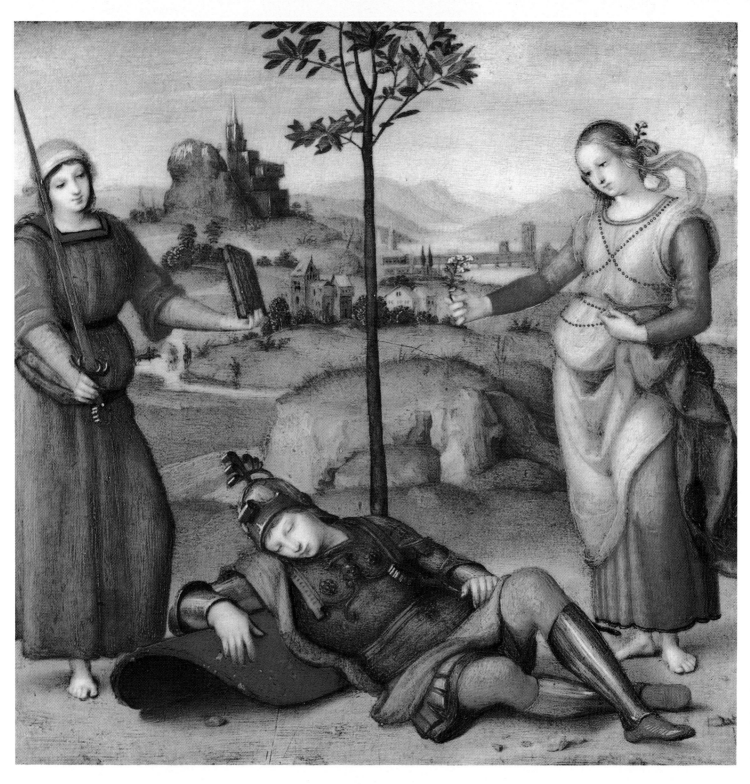

RAPHAEL
An Allegory ('Vision of a Knight')
Wood, 17 × 17 cm

ANTONIO ALLEGRI DA CORREGGIO Correggio 1489(?), died 1534 *Mercury instructing*
Cupid before Venus Page 67
In the 17th century both this picture and Correggio's *Antiope*, now in the Louvre, were in the
Gonzaga collection at Mantua, and despite slight discrepancies in size and style, it is possible
that they were painted as pendants representing contrasting types of love: divine love in this
picture, earthly love in its companion. Correggio never enjoyed such popularity as in the 18th
century, and it is in Boucher and Prud'hon that he found his true heirs. Like Leonardo he uses
soft light to describe forms emerging from obscure romantic settings. But while darkness in
Leonardo's work suggests melancholy and unhappy metaphysical probings, here it is sensual
intimacy. The soft transition of tones removes all hardness from the elaborate interlacing con-
tours, and the surrounding gloom lends a deeper radiance to the flesh of the divinities.

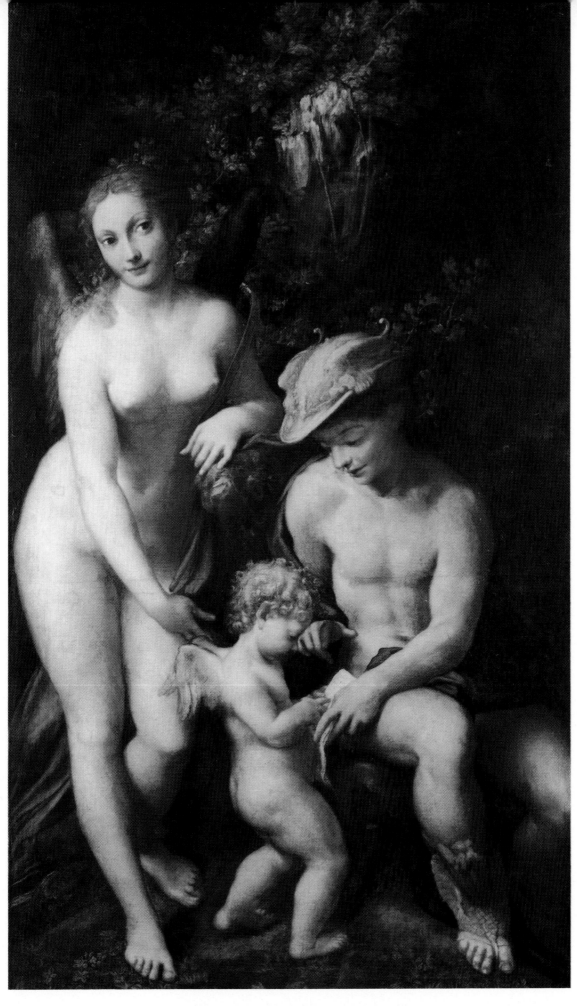

ANTONIO ALLEGRI DA CORREGGIO
Mercury instructing Cupid before Venus
Canvas, 155 × 91 cm

67

ANTONIO ALLEGRI DA CORREGGIO *The Madonna of the Basket* Page 69

Correggio anticipates by almost a century the rhythmical and sensuous art of the Baroque. At Parma he produced airy, light-filled decorations in which forms seem to dissolve in space. In this intimate treatment of the theme of Madonna and Child, the paint has the delicacy of pastel. Probably painted in the 1520s, it was engraved in 1577 and much copied. Although it is from Leonardo that Correggio inherited the soft-textured treatment of flesh and draperies, this painting is calmly oblivious of the intellectual preoccupations that obsessed his predecessor. But a serious vein runs through the picture, despite its domestic charm. The coat which the youthful Virgin gently pulls on the Infant foreshadows the seamless garment that Christ wore at his Passion, and for which the soldiers cast lots. This portent is reinforced by the detail of Joseph working in the background. The timber he saws conjures up the image of the cross upon which Christ died.

PARMIGIANINO Parma 1503–1540 *The Mystic Marriage of S. Catherine* Page 70

This intimate and elegant interpretation derives from a painting of the same subject by Correggio, who, like Parmigianino, worked chiefly in and around Parma. This picture, however, was probably painted during Parmigianino's stay at Bologna between 1527 and 1531. It is indebted also to the work of Raphael and Michelangelo, whose Libyan Sibyl on the Sistine ceiling is the prototype for the twisting pose of the Madonna. But from these borrowed elements Parmigianino has evolved a highly original form of Mannerism. He makes no concessions to naturalism, distorting forms and compressing space to create a tight, rhythmic design. A violently truncated head in the lower foreground balances the sweep of S. Catherine's wheel, which is echoed above by the fall of drapery and a semi-circular window. In the centre a doorway and tunnel-like vista draw attention to the ring, while around it, the three principal figures seem woven into a single web of elliptical movement.

ANDREA DEL SARTO Florence 1486–1531 *Portrait of a Young Man* Page 70

Andrea del Sarto was active at Florence and for a while in France under Francis I, and in his work are evident the muscular forms, the ample draperies, the assertive forms characteristic of High Renaissance painting. Yet undermining this confident expression of achievement is a note of doubt and melancholy. Here, the young man glances slowly over his shoulder with an expression mingling suspicion and bitterness. Sombrely clad, he appears the very type of the disenchanted scholar. The object he holds has been identified as a block of stone, and the picture has been catalogued as *Portrait of a Sculptor*. Alternatively it may be a book, and the man may be the artist himself. Certainly these features reappear in others of his paintings, in *The Madonna of the Harpies* in the Louvre, for example, but no doubt there is an element of idealization in this firmly modelled face with its refined bone structure and penetrating eyes.

BRONZINO Florence 1503–1572 *Venus, Cupid, Folly and Time* Page 70

While Michelangelo was at work in Rome and Titian in Venice, a new generation of artists working at the court of Cosimo I at Florence created a style in which classical equilibrium and harmony are lost in bizarre effects. It is Bronzino who, in mirroring the sophistication of the Florentine court, best represents this trend. An adolescent Cupid embraces Venus who, removing an arrow from his quiver, disarms him. Above, winged Time attempts to expose the hollow mask of Fraud, while (below) Jealousy tears her hair in distraction and childish Folly comes to shower the couple with roses. Behind him, Pleasure, offering a honeycomb with one hand, holds in the other her reptilian tail bearing a sting. While apparently demonstrating the snares of physical lust and vanity, the teasing symbolism of these figures and devices serves only as a foil to the erotic imagery. The sensuality of these bloodless, sinuous bodies grows more inveigling—and more obscene as the ritual surrounding it becomes more refined.

MICHELANGELO Caprese in Casentino 1475–Rome 1564 *The Entombment* Page 71

This picture was purchased by the Gallery in 1868 from the painter Robert Macpherson, who according to one account had discovered it in Rome being used as part of a street barrow. However, its present appearance is due to the fact that, like so much of Michelangelo's work, it is unfinished. Traditionally the composition is said to derive from Mantegna's engraving of the same subject. More recently, attention has been drawn to its debt to the *Laocöon*, a famous Antique marble group which was discovered in Rome in 1506, when Michelangelo is thought to have started work on this picture. The subject is certainly conceived in terms of a sculptural group, the three figures around Christ straining under the weight of his body. The picture also demonstrates Michelangelo's practice of applying colour in areas to a finished linear design. Thus the body of Joseph of Arimethea, behind Christ's head, and the arm of Mary Magdalen in the left foreground are untouched while the parts around them are highly finished.

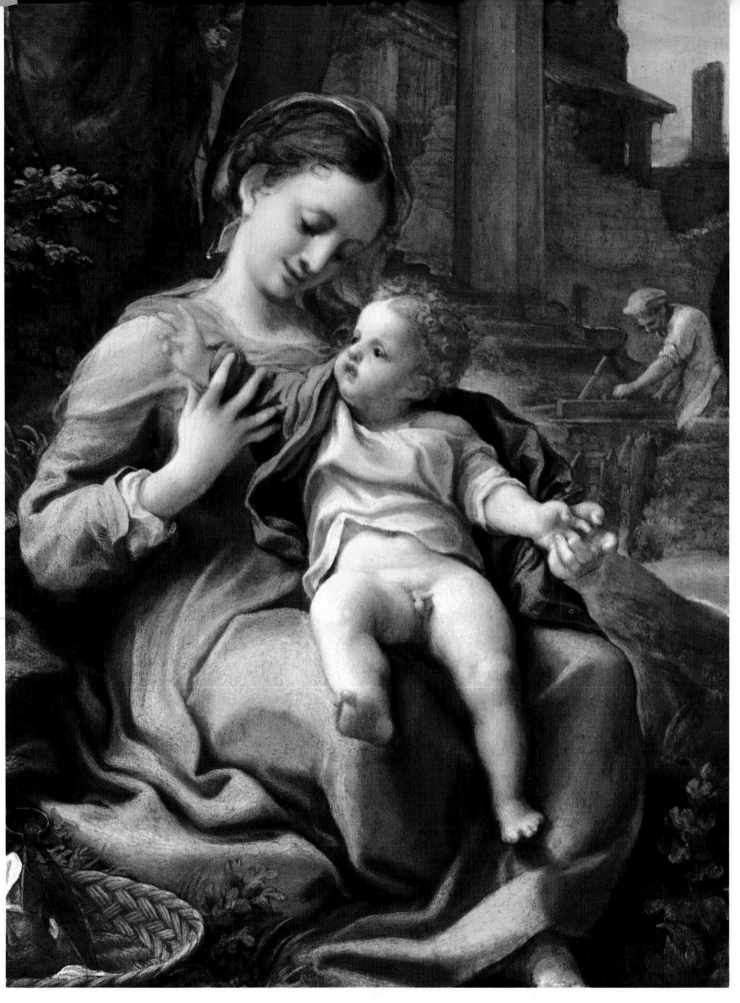

ANTONIO ALLEGRI DA CORREGGIO
'The Madonna of the Basket'
Wood, 33 × 25 cm

69

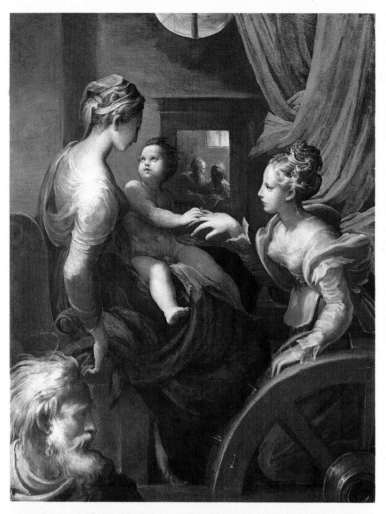

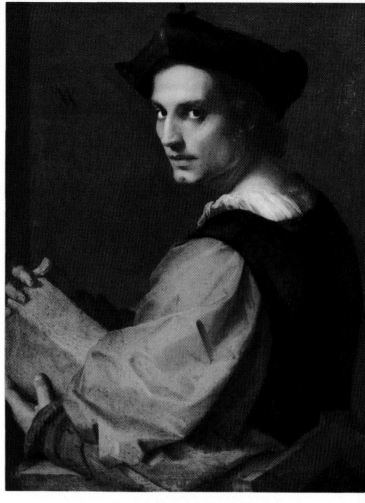

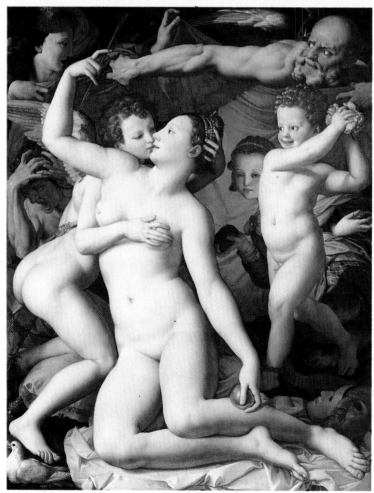

Above
ANDREA DEL SARTO
Portrait of a Young Man
Canvas, 72 × 57 cm

Above left
PARMIGIANINO
The Mystic Marriage of S. Catherine
Wood, 74 × 57 cm

Left
BRONZINO
Venus, Cupid, Folly and Time
Wood, 146 × 116 cm

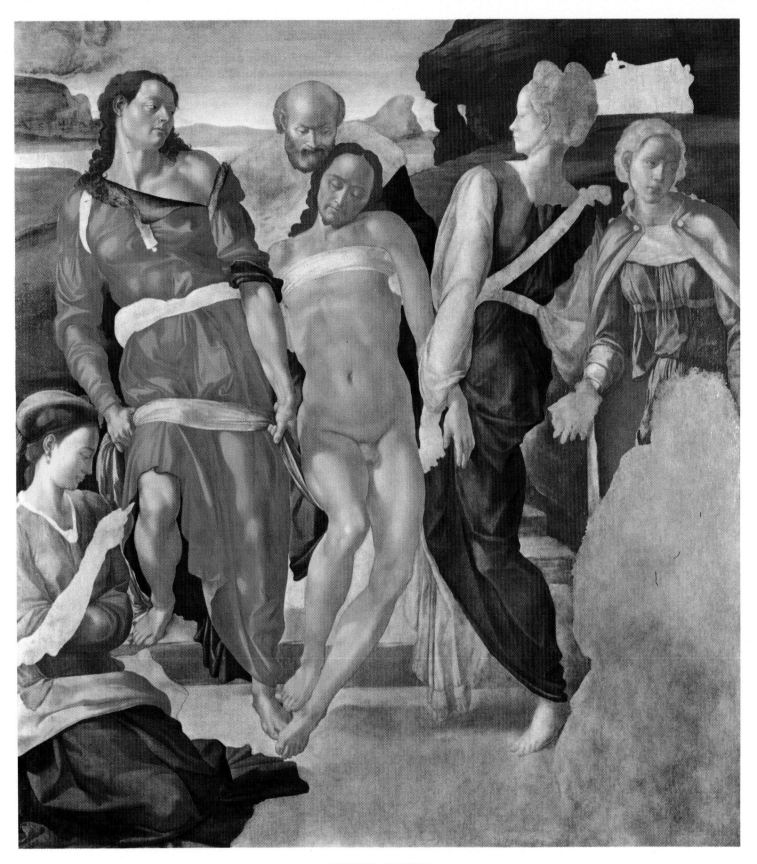

MICHELANGELO
The Entombment
Wood, 161 × 149 cm

SEBASTIANO DEL PIOMBO Venice 1485–Rome 1547 *The Raising of Lazarus* Page 73

In 1511 the young Sebastiano left Venice for Rome and stepped out of the orbit of Giovanni Bellini and Giorgione. There he encountered Michelangelo, who, it seems, took great pains to enlist Sebastiano's support against his arch-rival, Raphael. In 1516, Sebastiano and Raphael entered into direct competition when Cardinal Giulio de Medici, the future Pope Clement VII, commissioned from each of them an altarpiece for the cathedral of his bishopric at Narbonne. Raphael produced *The Transfiguration,* now in the Vatican, and in 1519 Sebastiano completed this enormous canvas which was shipped to France in 1520, shortly after Raphael's death. Several drawings by Michelangelo survive to confirm Vasari's statement that he provided Sebastiano with designs for parts of the composition. The figures here possess the massive sculptural quality of Michelangelo's work, and in Christ and Lazarus there is a reminiscence of the figures of God and Adam in the first four panels of the Sistine ceiling. Only the sombre landscape with its deep-hued sky bears witness to Sebastiano's Venetian origins.

GIORGIONE Castelfranco 1477–Venice 1510 *The Adoration of the Magi* Page 74

Although Giorgione had already acquired a considerable reputation during his lifetime, receiving commissions for the Doge's Palace at Venice and for paintings for the outside of the Fondaco dei Tedeschi, he died young and very little information survives concerning his life and work. He seems, however, to have had a decisive influence on Titian, Sebastiano, and the older Giovanni Bellini. Very few works can bē ascribed to him with complete certainty, but this panel of about 1507, which probably formed part of a predella of an altarpiece, accords closely with his style. Against a predominantly monochromatic background the actors stand in costumes of intense colour: blue, gold, green, crimson and scarlet. The forms are softly modelled, but highlights on bright objects provide sharp accents across the picture surface—on the kings' gifts, a helmet, bridles and the doublet and belt of the groom on the right. The orchestration of colour is matched by the grouping of the figures placed at measured intervals against the repeated verticals of the masonry, to form a total pictorial harmony.

LORENZO LOTTO Venice c.1480–Loreto 1566 *A Lady as Lucretia* Page 74

Glaring out at the spectator with a suspicious, almost accusing stare, the richly clad lady in Lotto's picture of about 1530 draws our attention to a drawing she holds in her left hand. It shows Lucretia, who, according to the Roman historian Livy (from whom the Latin inscription on the table is taken) was raped by Tarquin and took her own life rather than live dishonoured. Probably the name of the lady Lotto has here portrayed was also Lucretia, and the allusion to this incident from classical history serves as a sophisticated demonstration of her own virtue. Other examples of this type of allegorical portrait, in which the sitter assumes a *persona* from history or mythology, can be found, but Lotto uses it to dramatize his sitter's personality.

GIAN GIROLAMO SAVOLDO Brescia c.1480–Venice 1548(?) *S. Mary Magdalene approaching the Sepulchre* Page 75

Although he was apparently a native of Brescia, Savoldo spent most of his working life in Venice. The influence of Venetian painting can be clearly seen in his very evident preoccupation with the effects of light, a preoccupation that Caravaggio seems in part to have inherited from him. Here the biblical subject is little more than a pretext for the romantic portrayal of a woman in a twilit landscape. Behind are overgrown ruins and a distant view across water—perhaps of Venice. The dawn sky, which recalls Bellini's effects in *The Agony in the Garden,* is the record of precise observation—the more distant clouds already in full light, the nearer ones only flecked with pink. But it is the influence of Titian that is evident in the cloak which almost envelopes her body, and which the light catches in silvery highlights. Although he was not prolific, Savoldo seems to have been greatly attracted to this subject, and three variations of this composition are known.

MORETTO Brescia c.1498–1554 *Portrait of a Young Man* Page 75

Moretto's portrait of a young aristocrat is entirely characteristic of its period. Dating from around 1540, it probably depicts the Conte Sciarra Martinengo Cesaresco, splendidly attired and surrounded by the rich trappings of an educated noble. On the table are his gloves, coins, a seal, and an ink-well shaped like a foot in a Roman sandal. On his cap he wears a badge with a Greek inscription which has been related to the count's known desire to avenge the death of his father. With his head resting on his hand, he appears lost in thought—at once pensive and poetic, the very type of the Renaissance nobleman. Working at Brescia, Moretto was unable to escape totally the influence of Titian, but he succeeded in such works as this in establishing an independent style of portraiture. His works are more subdued in colour than Venetian painting and more concerned with the realistic portrayal of individuals surrounded by their possessions.

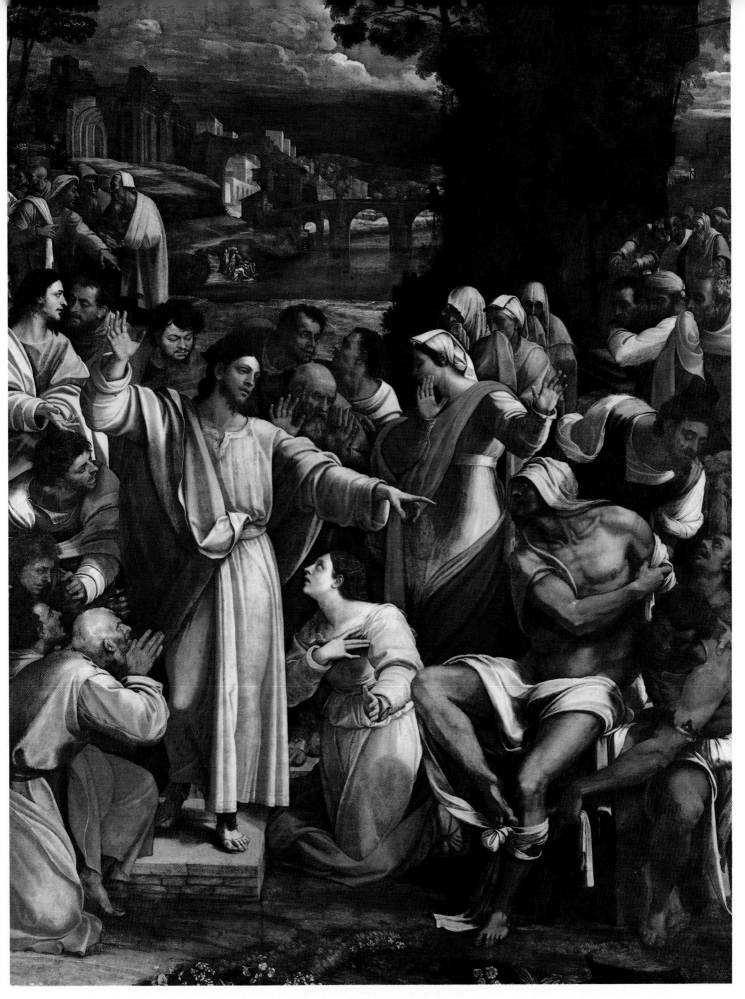

SEBASTIANO DEL PIOMBO
The Raising of Lazarus
Wood, 381 × 290 cm

73

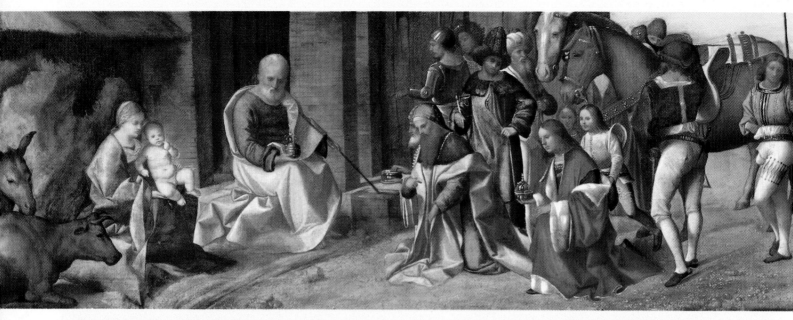

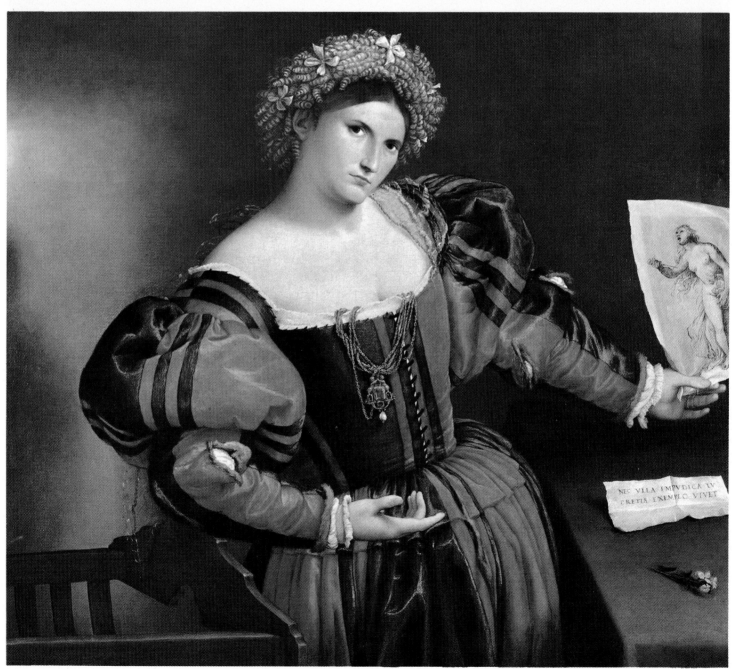

NEC VLLA IMPVDICA LV
CRETIA EXEMPLO VIVET

Left
GIORGIONE
The Adoration of the Magi
Wood, 29 × 81 cm

Below left
LORENZO LOTTO
A Lady as Lucretia
Canvas, 95 × 110 cm

Right
GIAN GIROLAMO SAVOLDO
S. Mary Magdalene approaching the Sepulchre
Canvas, 86 × 79 cm

Below
MORETTO
Portrait of a Young Man
Canvas, 113 × 94 cm

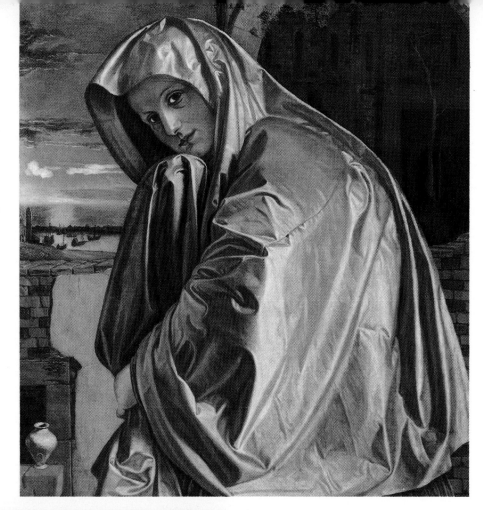

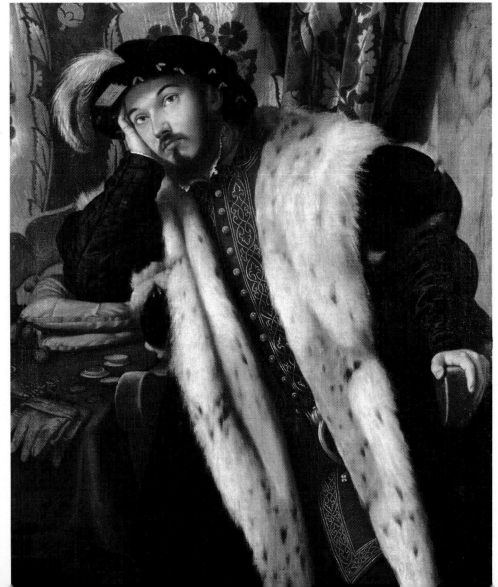

GIOVAN BATTISTA MORONI Albino c.1530–1578 *Portrait of a Gentleman* Page 77

Moroni, the pupil of Moretto, developed the vein of penetrating realism that characterizes the portraiture of his master, at first in Brescia where he was trained, and later in the area of Bergamo. Moretto was probably responsible for introducing the full-length portrait in Italy, but Moroni was instrumental in exploiting and popularizing the new format. In this portrait of a gentleman, the life-size format gives the subject added presence and credibility. His haughty and reserved character is conveyed without rhetorical devices by the air of restraint, the sideways glance, the tight, formal composition and, above all, by the faithful description of textures and details. The rather chilly setting, the sober-coloured clothing, and even the plumed helmet are treated without panache in a spirit of documentary realism, a realism that extends to the inclusion of the metal brace supporting a lame foot.

GIOVAN BATTISTA MORONI *'The Tailor'* Page 77

In this famous portrait, Moroni achieves an economy and clarity that make it his masterpiece. Without any air of contrivance, the tailor, a professional man of good social standing, himself richly dressed, pauses, momentarily interrupted in his work. His expression, both piercing and direct, seems to reflect the artist's own scrupulous and unflattering eye. In its naturalism, its psychological penetration and its avoidance of superfluous accessories and ornament, it anticipates Velázquez's portraits of the Spanish nobility a century later. The colouring, too, is discreet. Moroni creates a subtle harmony of muted tones, the white ruff and cuffs enlivening the restrained doublet, and the wooden bench and dull red breeches adding a note of warmth to a colour scheme dominated by cool grey tones.

TITIAN Pieve di Cadore c.1487–Venice 1576 *Portrait of a Man* Page 77

Sometimes attributed to Giorgione, this early portrait by Titian (the costume suggests a date around 1512) certainly depends upon his example for the pose and the soft blending of tones. But Titian's sitter has a corporeal presence absent from Giorgione's portraits. Even in comparison with Bellini's *Doge Leonardo Loredan*, there seems here to be a greater surge of life. Less sculptural, Titian's portrait carries the suggestion of spontaneous mental and physical energy. The arm projects at us across the parapet which bears Titian's initials, its impact strengthened by the opulence of the bulbous sleeve. With a keen feeling for textures, Titian lingers over the quilted silk, enhanced by a flash of white shirt and the gold chain across the neck. Long thought to represent the poet Ariosto, this picture may in fact be a self-portrait and was perhaps once in the collection of Van Dyck. It was known by Rembrandt, who recalled it when he executed his own self-portrait some hundred years later.

TITIAN *Bacchus and Ariadne* Page 78

Only in 1969, after it was cleaned, was the full brilliance of this masterpiece by Titian revealed. Emerging from the fringes of a wood, the god Bacchus encounters Ariadne on the seashore, deserted by Theseus. The satyrs and dancing Bacchantes, with drunken Silenus on his ass, are yet unaware of the presence of the startled Ariadne, to whom Bacchus will promise marriage and, as can already be seen between the clouds, a place in the stars as a constellation. The picture, which dates from 1522–3, was commissioned by Alfonso D'Este, Duke of Ferrara, as one of four pagan subjects to decorate the Alabaster Chamber in the Castello at Ferrara. The duke himself probably specified the subject, the exotic details of which are drawn from accounts by Catullus, Ovid and Philostratus. Another two of the series, which later found their way to Spain, were also executed by Titian, who altered the fourth, Giovanni Bellini's *Feast of the Gods*, to blend better with his own creations.

TITIAN *The Death of Actaeon* Page 78

Like the *Bacchus and Ariadne*, this picture represents a story from classical mythology. But an interval of forty years separates the two paintings, and the brilliant colour and crisp naturalistic rendering of the earlier work have been replaced by freely handled, sombre-toned paintwork. And this late manner, which evokes mood, summarizing forms rather than imitating them, could not be better suited to the mythic subject. While hunting, Actaeon stumbles by chance upon the goddess Diana and her nymphs bathing in the forest. He must suffer for his transgression, and here he is transformed into a stag and torn to pieces by his own hounds. The goddess, colossal and inhuman in her role as divine instrument of retribution, dominates the composition, while Actaeon, pitifully small and half-metamorphosed, is borne down by his hounds. The landscape, with its stormy light and writhing branches, amplifies the drama; it is animated by the same cruel spirit of indifference. Painted in the 1560s as one of a series intended for Philip II of Spain, the painting was purchased by the gallery in 1972 with the help of a special grant and public subscription.

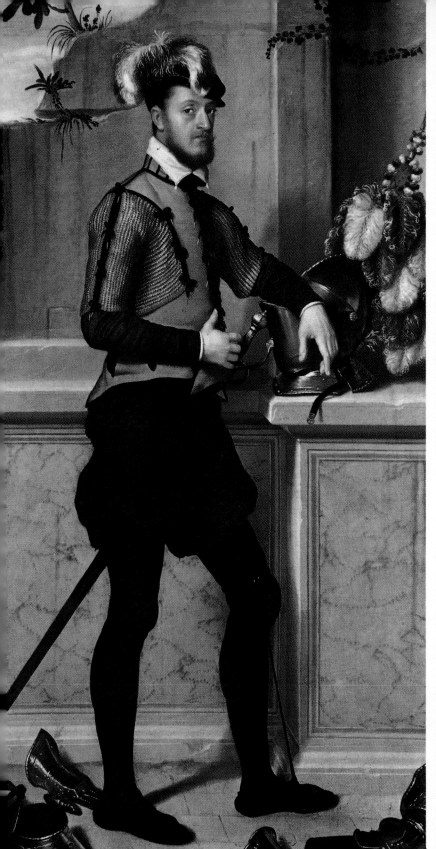

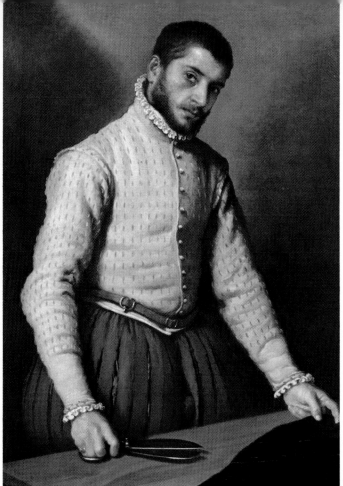

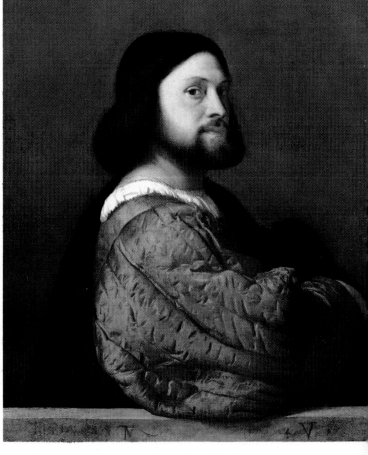

Above
GIOVAN BATTISTA MORONI
Portrait of a Gentleman
Canvas, 202 × 106 cm

Above right
GIOVAN BATTISTA MORONI
'The Tailor'
Canvas, 97 × 74 cm

Above
TITIAN
Portrait of a Man
Canvas, 81 × 66 cm

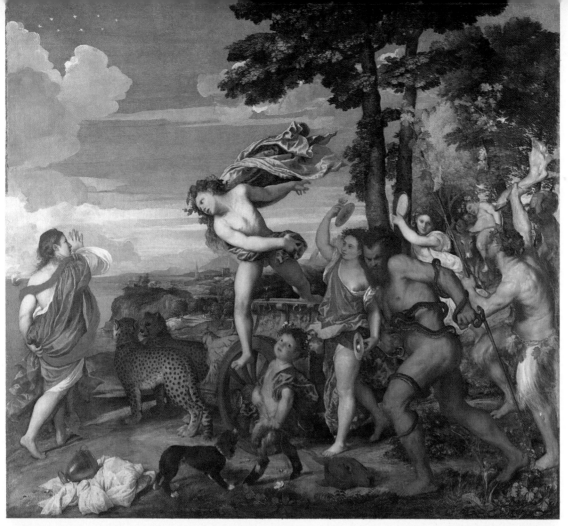

TITIAN
Bacchus and Ariadne
Canvas, 175 × 190 cm

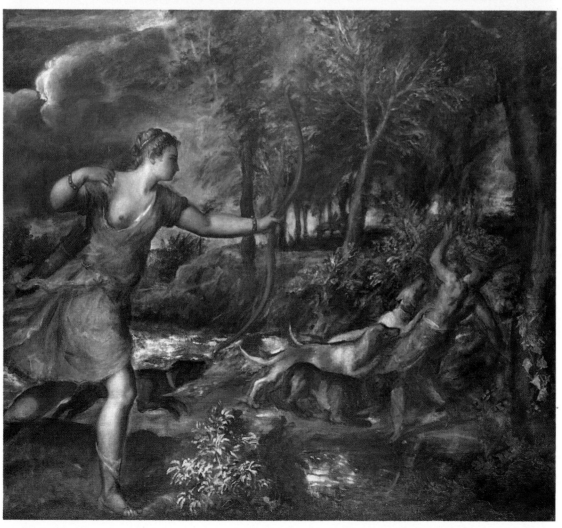

TITIAN
The Death of Actaeon
Canvas, 178 × 198 cm

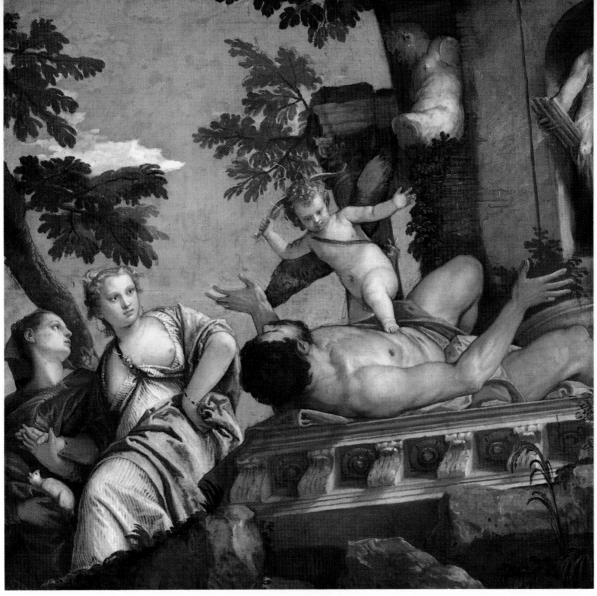

PAOLO VERONESE
Allegory of Love
Canvas, 186 × 188 cm

PAOLO VERONESE Verona 1528–Venice 1588 *Allegory of Love*
This is one of a set of four allegories that formed part of the collection of the Emperor Rudolph at Prague and may in fact have been commissioned by him. Their erotic flavour would no doubt have appealed to his taste. They seem to show types of virtue and unfaithfulness in love, and since the 18th century this one has been known as *Scorn*. Cupid, wielding his bow, admonishes the unfaithful man, while the figure of Chastity, bearing an ermine, comforts the betrayed lover. The idea of sexual abandon is amplified in the statues of Pan and a satyr, yet here, as in the other three canvases, the subject is little more than a pretext for superb decorative effects. Since the painting was probably intended for a ceiling or lofty wall, the figures are viewed from beneath, allowing Veronese to arrange them in unusual, almost balletic groups against backgrounds of luminous grey skies, fronds of foliage and fragments of architecture.

PAOLO VERONESE *The Family of Darius before Alexander* Page 80
In order to make his tableau more convincing and more lifelike, Veronese has translated an event which occurred in the 3rd century B.C. into contemporary terms. His actors wear 16th-century costumes and appear before a back-drop of Venetian High Renaissance architecture. But the scene is, in fact, Persia. The family of Darius, the defeated king, pay homage to his conqueror, but his mother mistakes Hephaestion, the friend of Alexander the Great (in gold), for Alexander himself (in red), who magnanimously excuses her error. Excited citizens and soldiers look on with curiosity, but Veronese succeeds in marshalling all this incidental detail into a unified and striking composition. To the dignity of the conception and the arrangement, the sumptuous colouring of the costumes adds a further opulence. The picture was painted for the Pisani family, probably sometime in the 1570s, and among these heroic personages may be included portraits of members of the family.

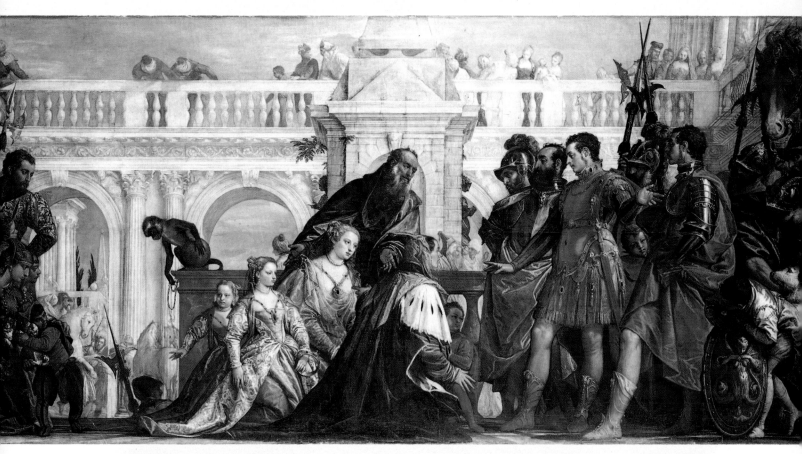

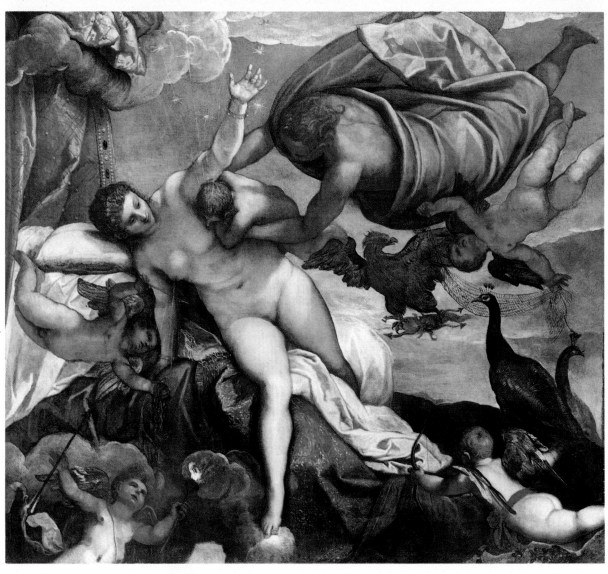

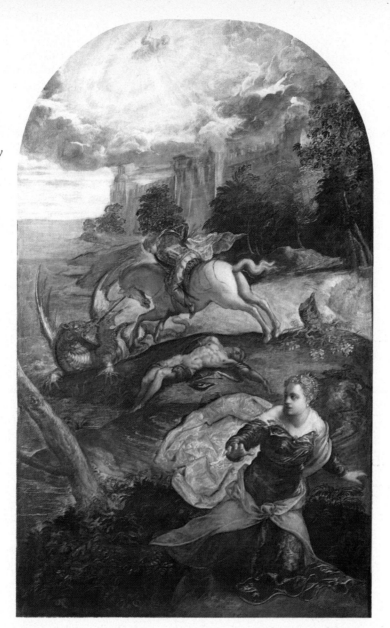

JACOPO TINTORETTO Venice 1518–1594 *The Origin of the Milky Way* Page 80
In such mythological compositions as this, Tintoretto adopts the luminous colouring of Titian in preference to the dramatic chiaroscuro of his more idiosyncratic religious pictures. Perhaps once part of the collection of the Emperor Rudolph II, this canvas was possibly designed for a ceiling. Jupiter, wishing to immortalize the infant Hercules, presses the child to Juno's breast. The goddess's milk, spilling from his lips, shoots upwards to form the Milky Way. According to legend, some fell also to earth to be transformed into lilies. A drawing in Venice shows this composition, with flowers sprouting beneath and a recumbent figure representing Earth, and it seems likely that at some stage a strip was removed from the canvas along the bottom. Even with the picture in its present form, Tintoretto's mastery of decorative effects is manifest. The ample figures, floating among draperies and *putti*, cut sweeping arcs against an intense blue sky in a slow-rhythmed majestical movement.

JACOPO TINTORETTO *S. George and the Dragon*
Pictures of this size are unusual among Tintoretto's works. Most of his paintings were commissioned by the various religious houses and churches of Venice, represent Biblical subjects, and are huge in scale. This picture was probably painted for a private patron, who may also have specified the unusual interpretation of the subject. A dead victim, strongly reminiscent of the crucified Christ, occupies a prominent position, while a radiant presence, perhaps God the Father, appears in the sky. Yet the treatment is in many respects characteristic of Tintoretto's highly personal style. The action takes place on a very deep stage; the frieze-like presentation of events typical of the early Renaissance is replaced by dramatic recession. In the foreground the princess flees towards us out of the picture, while the main event, S. George charging the dragon, is relegated to the background. But the unnatural light helps to focus upon the significant characters and throws them into relief against the sombre landscape.

The Seventeenth Century

MICHELANGELO MERISI DA CARAVAGGIO Caravaggio 1573–Porto Ercole 1610 *The Supper at Emmaus* Page 83

The astonishing naturalism of Caravaggio's painting assured both admiration and indignation in his own time in Rome (where the picture was painted) and since. In this interpretation of the supper at Emmaus he shuns idealization and depicts the event in contemporary terms. After the resurrection, Christ is met by two disciples who, without recognizing him, invite him to eat with them. Only when he breaks the bread and blesses it, as at the Last Supper, do they discover his true identity. It is this dramatic moment of recognition which is the subject of Caravaggio's painting, and it is made striking and immediate by the precise description of details— the blighted apples, the worn clothes and coarse features of the disciples and innkeeper and their violent gestures. Outstretched arms and virtuoso effects of foreshortening draw the spectator into the picture and force him to react with the disciples.

DOMENICHINO Bologna 1581–Naples 1641 *Landscape with Tobias laying hold of the Fish* Page 84

Originally a pupil of Ludovico Carracci in Bologna, Domenichino came under the influence of Ludovico's brother, Annibale, the greatest of the Bolognese family of artists, when he moved to Rome around 1602. Yet while the elegance and poise of his figures in this picture demonstrate the influence of the idealizing classicism of the Carracci brothers, the landscape looks back to the example of Titian and the Venetian school. The brilliant, diminutive figures of Tobias and the angel are placed in the very foreground, while behind them, between the flanking masses of the trees, the landscape extends to the distant blue of the mountains, setting the dream-like tone of the picture. Over a century later it was landscapes such as this, with their wild profusion of trees, their distant vistas, and craggy hills topped with ancient masonry, which inspired the yet more luminous landscapes of Claude and Poussin.

ANNIBALE CARRACCI Bologna 1560–Rome 1609 *The Dead Christ mourned* Page 85

Annibale Carracci, the greatest of a family of artists from Bologna, established a form of Classicism which was to dominate painting in Rome for over half a century. His style is diametrically opposed to the brutal realism of Caravaggio, who abandoned the formalized language of High Renaissance painting to show ordinary people in contemporary dress strongly modelled by dramatic lighting. Annibale Carracci, far from rejecting the example of the 16th century, synthesizes the styles of Raphael, of Correggio and of Tintoretto. Caravaggio's work is a declaration of individuality and independence; Annibale seems to prefer anonymity and conceals his personality behind idealized forms and refined emotions. In this picture, painted in Rome about 1604, no incidental detail, no ugliness, is allowed to detract from the lyrical grouping of the figures. The Maries gather round the dead Christ, whose perfect body is unmarked by his suffering, with hands raised in ritualized expressions of grief. The Virgin's head is thrown back to echo the pose of her dead son.

BERNARDO CAVALLINO Naples 1616–1656 *Christ driving the Traders from the Temple* Page 86

Bernardo Cavallino was born in Naples six years after the death of Caravaggio, but the influence of his great predecessor is paramount in his work. Caravaggio was working in Naples in 1607 and returned there again in 1609 shortly before his death, and it was here, rather than at Rome, that his work met with the most enthusiastic response—from, among others, the Spaniard Ribera. But Cavallino, by the time he painted this picture (probably around 1645), seems also to have encountered the work of Rubens and Van Dyck. It is from Caraveggio that he has adopted the raking light which throws the actors into dramatic relief against the cavernous shadows of the background. But the play of light is heightened by a storm of Baroque movement emanating from the figure of Christ. Poised with arm raised, like the avenging Christ in Michelangelo's *Last Judgement,* he occupies the centre of a system of diagonals that converge at his feet.

EL GRECO Candia 1541–Toledo 1614 *Christ driving the Traders from the Temple* Page 87

A kind of spiritual energy sweeps through the paintings of El Greco, tapering the figures, billowing the draperies and illuminating all things with a metallic incandescence. The motifs of High Renaissance painting are wrenched into a personal idiom. The lifelike imitation of textures and of forms in space is totally forgotten in his hallucinatory vision of sacred events. A Cretan by birth, El Greco studied under Titian in Venice, and there came under the influence of Tintoretto.

In Rome he encountered the work of Michelangelo, and by 1577 he had settled in Toledo where he formed the style by which he is known. It did not find favour with the Spanish Court. Philip II of Spain, the patron of Titian, could not accept such imaginative eccentricity, but El Greco received plentiful commissions from the Church. This picture, which dates from about 1600, is one of several surviving versions of the subject, and it is likely that in Christ's cleansing of the Temple, El Greco and his patrons saw a parallel to the Counter-Reformation movement to purge the Church of heresy.

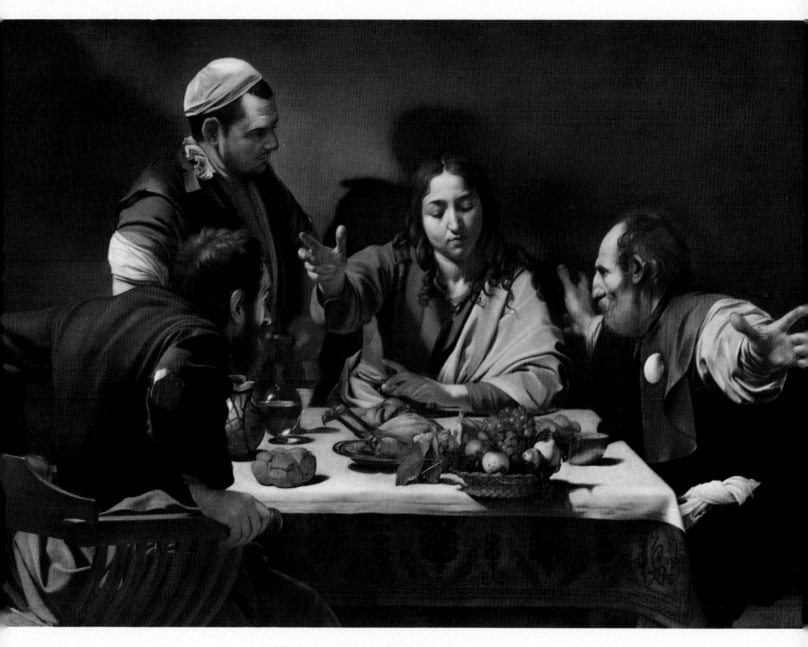

MICHELANGELO MERISI DA CARAVAGGIO
The Supper at Emmaus
Canvas, 141 × 196 cm

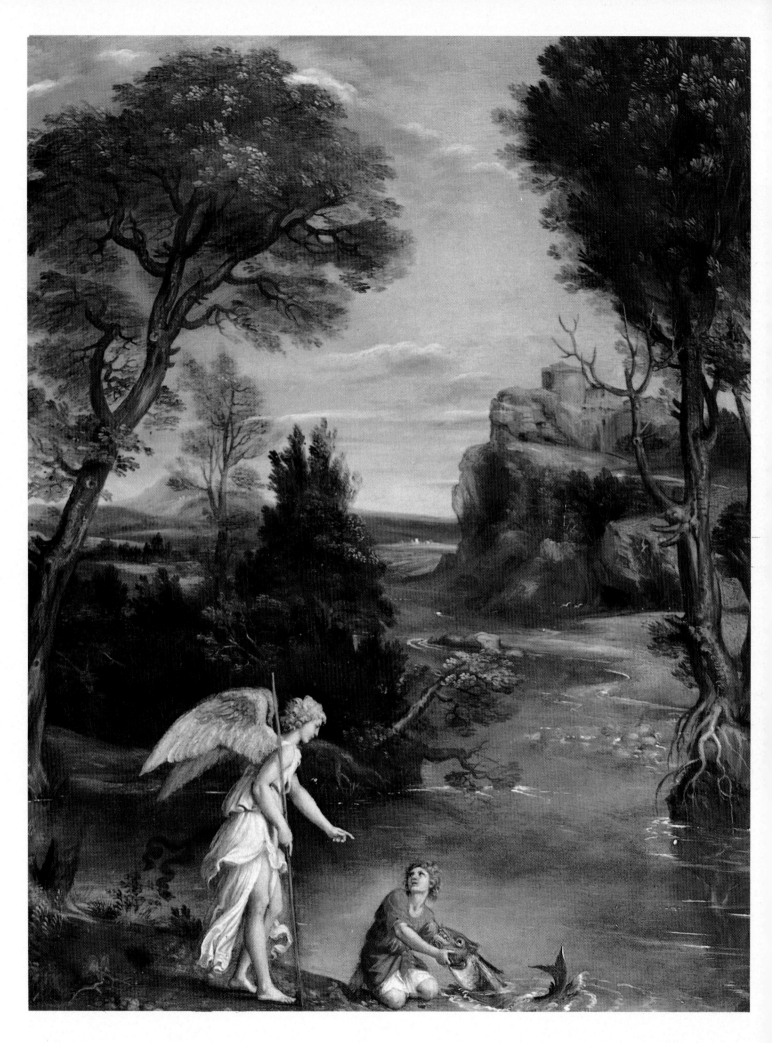

84

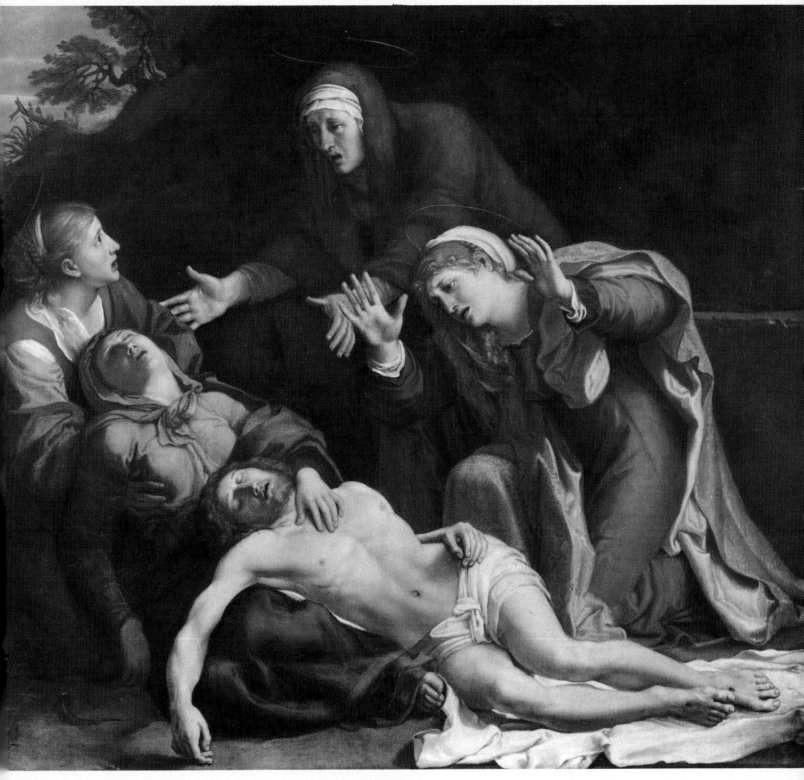

Above
ANNIBALE CARRACCI
The Dead Christ mourned
Canvas, 92 × 103 cm

Left
DOMENICHINO
Landscape with Tobias laying hold of the Fish
Copper, 45 × 34 cm

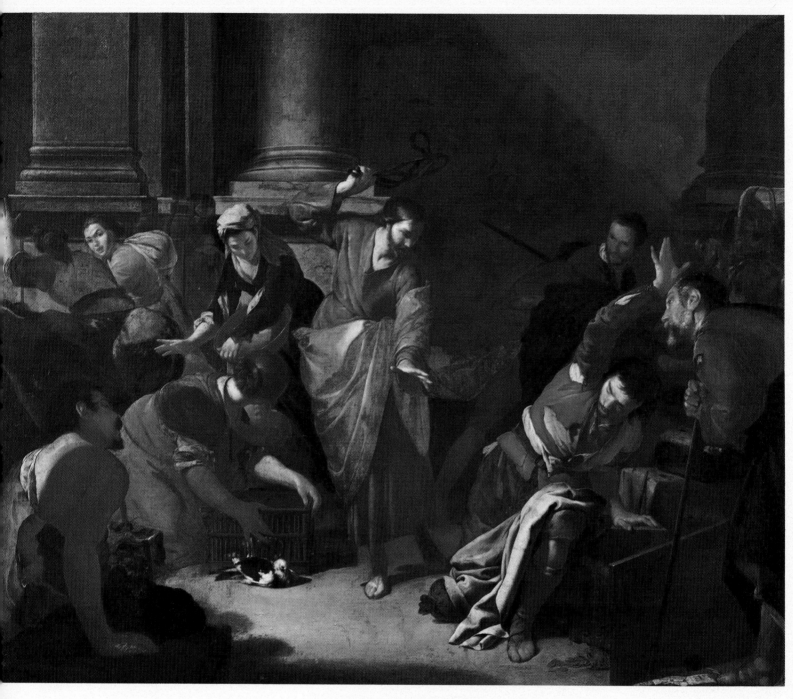

BERNARDO CAVALLINO
Christ driving the Traders from the Temple
Canvas, 101 × 127 cm

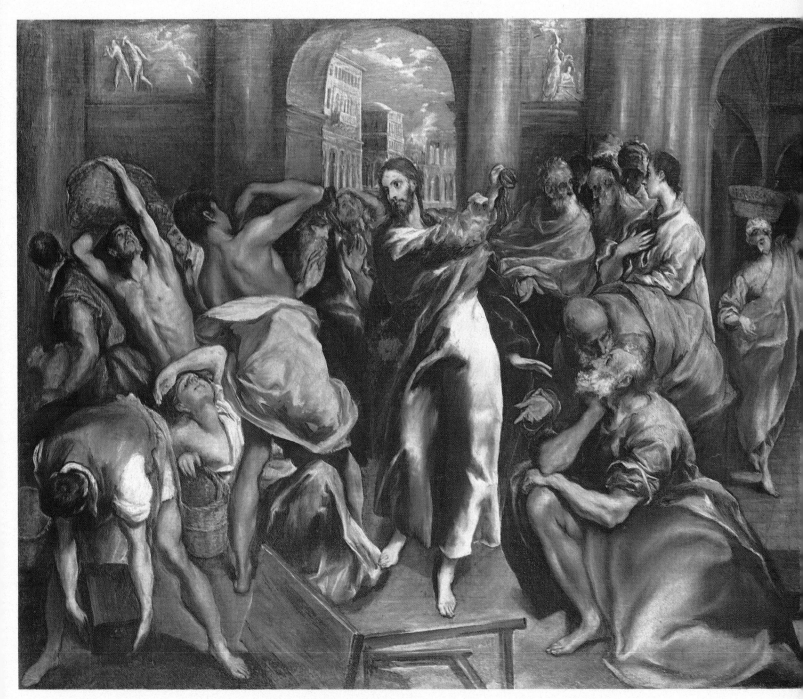

EL GRECO
Christ driving the Traders from the Temple
Canvas, 106 × 129 cm

DIEGO VELÁZQUEZ Seville 1599–Madrid 1660 *Christ after the Flagellation contemplated by the Christian Soul* Page 88

As a visionary subject this picture is unusual among Velázquez's works. A child, who represents the Christian soul and humanity, kneels awestruck before the terrible sight of Christ's suffering. The picture was probably painted at the time of Velázquez's first visit to Italy in 1629–31 and the paint still has the thick grainy quality of *Christ in the House of Martha and Mary* of 1618, also in the National Gallery. The restrained naturalism with which he treats the figures, particularly the child and angel with their heavy homespun clothes, is a measure of his debt to Caravaggio. So too is the simplicity of the composition. The three figures are isolated on a shallow darkened stage. Christ has fallen to the ground, still tethered like an animal, the instruments of his torture scattered around him. Nothing interrupts the dramatic moment as the angel directs the child's gaze to his bleeding back, to show that no human being can be free from blame for the suffering that Christ bore for man's sake.

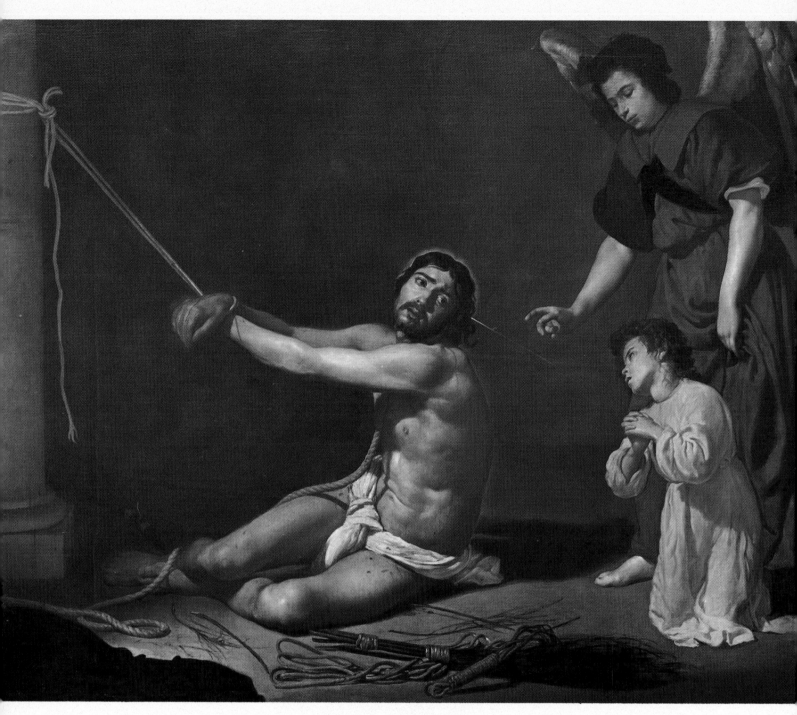

DIEGO VELÁZQUEZ
Christ after the Flagellation contemplated by the Christian Soul
Canvas, 165 × 206 cm

DIEGO VELÁZQUEZ *The Tiolet of Venus ('The Rokeby Venus')* Page 89
Both the subject of this picture (the only surviving female nude by Velázquez) and the handling
are strongly influenced by Venetian painting, and it is possible that Velázquez painted it during
his second visit to Italy in 1649–51. Titian had popularized the themes of the reclining Venus
and the Venus at her mirror attended by Cupid, although Velázquez possibly borrowed the
pose of his Venus from an antique sculpture of a sleeping hermaphrodite. But these influences
have been completely assimilated. Even while he was painting, Velázquez seems to have modified
his ideas. The head of Venus has changed its position, and Cupid and the mirror are a later addi-
tion—the canvas has been enlarged along the top to make room for them. The result is quite
original. The face in the mirror, optically impossible, becomes the pivotal point of the com-
position and perhaps introduces an element of portraiture. Yet Venus, her head turned away,
remains anonymous and unapproachable. The textures of flesh and silk are deftly suggested by
the loose, fluent brushwork, but the image remains silent and impenetrable. Visually so eloquent,
it defies explanation.

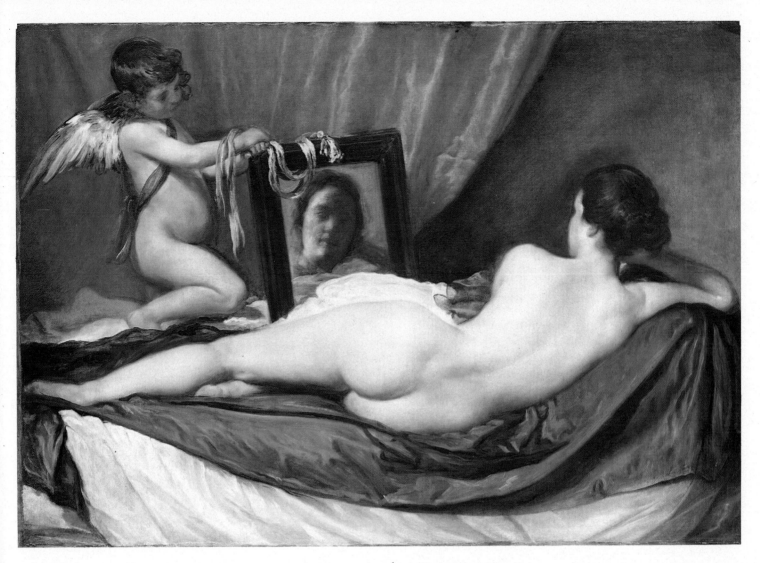

DIEGO VELÁZQUEZ
The Toilet of Venus ('The Rokeby Venus')
Canvas, 122 × 177 cm

DIEGO VELÁZQUEZ *Philip IV of Spain in Brown and Silver* Page 90

In 1623 Velázquez was summoned from his native Seville to Madrid, where he worked as court painter until his death in 1660. Much of his time therefore was taken up in painting portraits of the Spanish royal family, and particularly of Philip IV, the Hapsburg king who succeeded to the throne in 1621. This painting, which is more than usually splendid, was probably painted in the early 1630s, after Velázquez's first visit to Italy. The pose owes something to Rubens, who painted the king during or just after his visit to Madrid in 1628–9, but the free handling and rich colouring result from the study of Venetian painting. Resident at the royal court and increasingly burdened with court duties, Velázquez was well trained in the art of discretion. Nevertheless, the regal costume and the dignified formality of the pose seem almost to eclipse the shadowy presence of the palid, weakly king.

BARTHOLOMÉ ESTEBAN MURILLO Seville 1617–1682 *A Peasant Boy leaning on a Sill*
Page 90

Although he worked all his life at Seville, Murillo was strongly affected by the Baroque idiom that reached Spain through the works of Rubens and Van Dyck. His most characteristic paintings, usually religious in subject, are softly painted with sweet merging colours. Form and outline are tempered by flowing draperies and vaporous clouds. Even in such genre scenes as this, hard facts are softened by the fluid brushwork. Childhood and poverty become the subjects of pleasing decorative improvisations which easily degenerate into sentimentality. Here the simplicity of the composition and the firmness of the characterization preserve a sense of immediacy and vitality. Such pictures, appealing to romantic sensibility, found great favour in the 18th and 19th centuries, and inspired in part the 'fancy pictures' of Gainsborough and Greuze.

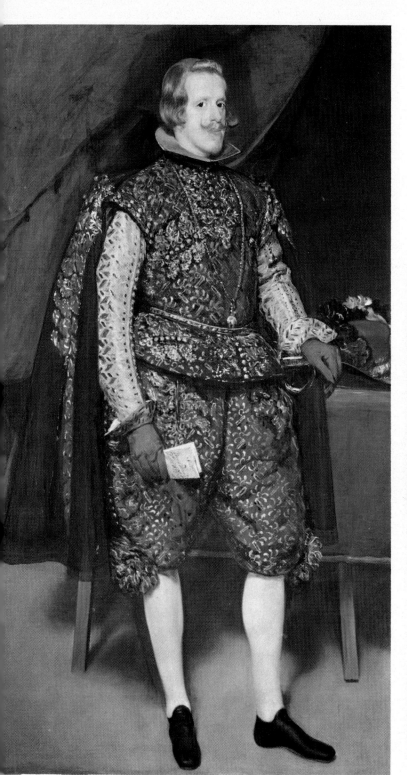

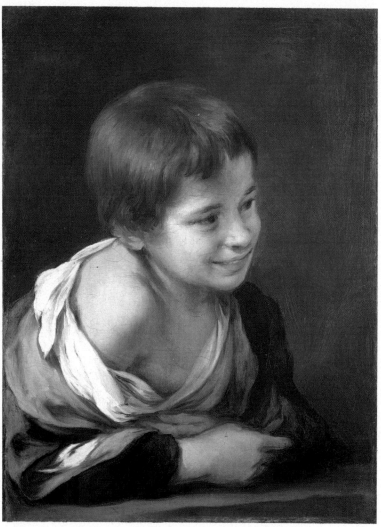

FRANCISCO DE ZURBARAN Fuente de Cantos 1598–Madrid 1664 *S. Francis in Meditation*

Page 91

Zurbaran, like Murillo, was active chiefly in Seville, but in preference to the flamboyant Baroque fantasies of his junior he shows tangible forms defined by clear sharp light, in a style more akin to Velázquez's early work. Most of his subjects are religious, and the Caravaggesque realism with which he treats them invests them with a mysterious intensity perfectly suited to their devotional character. The worn habit of S. Francis curves flame-like against the silent void. His uplifted head and clasped hands barely emerge out of the darkness. Contemplation of Death was encouraged by the Jesuits, and in 17th century Spanish and Italian painting, saints are frequently shown meditating on a skull. Several variants of this subject exist by Zurbaran, including another in the National Gallery.

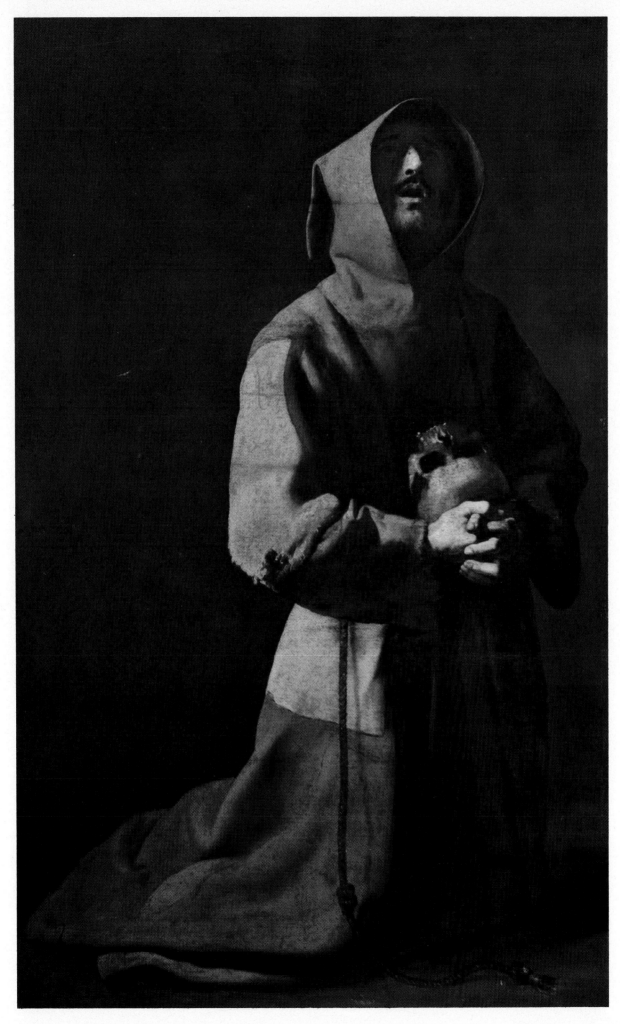

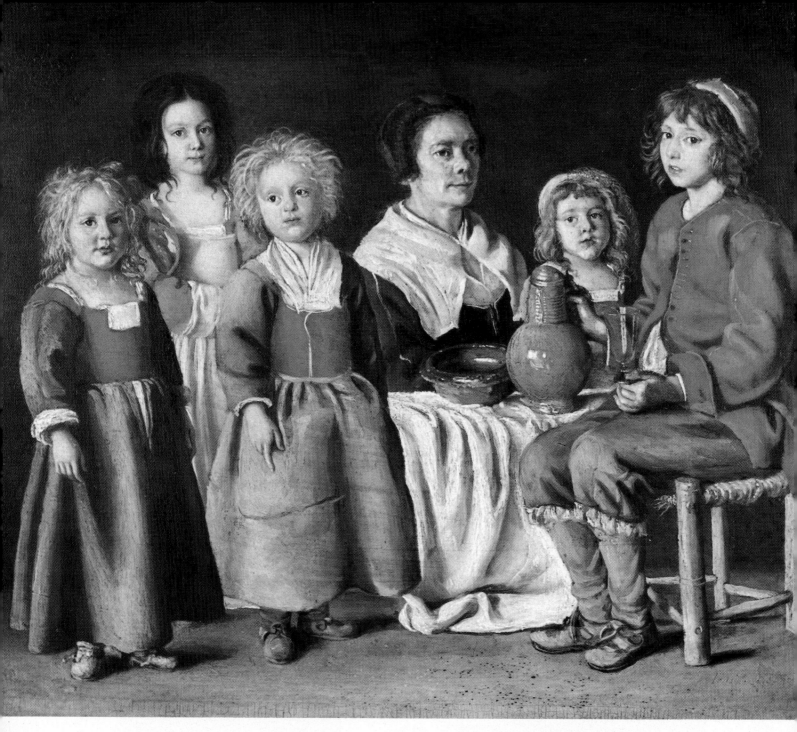

Above
ANTOINE LENAIN
A Woman and Five Children
Copper, 21 × 29 cm

Above right
NICOLAS POUSSIN
Bacchanalian Revel before a Term of Pan
Canvas, 99 × 142 cm

Right
NICOLAS POUSSIN
Landscape with a Snake
Canvas, 119 × 198 cm

ANTOINE LENAIN Laon c.1588–Paris 1648 *A Woman and Five Children*
Caravaggio's influence is discernible in this picture, not only in the modelling of form in light
and shade, but also in the realistic description of the facts of poverty. The brothers Lenain—
Antoine, Louis and Mathieu—are known to have worked together in Paris and collaborated on
pictures. But small works on copper, like this painting dated 1642, are generally attributed to
the eldest of the brothers, Antoine. Despite the size, the figures have an almost monumental
presence. They possess a natural dignity. The artist seems consciously to avoid 'art' in his faith-
ful, almost matter-of-fact recording of the details, and in the unsophisticated arrangement of the
figures, aligned in a row. In the pursuit of truth he reserves comment and rigorously avoids
rhetoric and sentimentality.

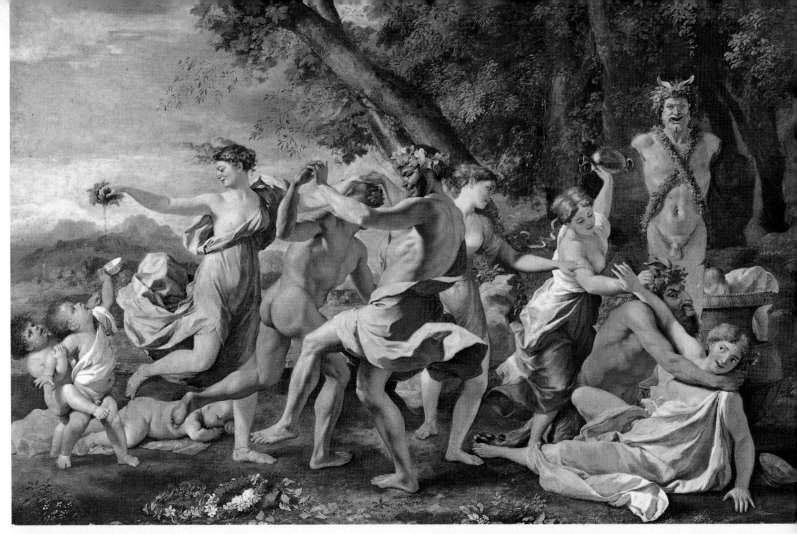

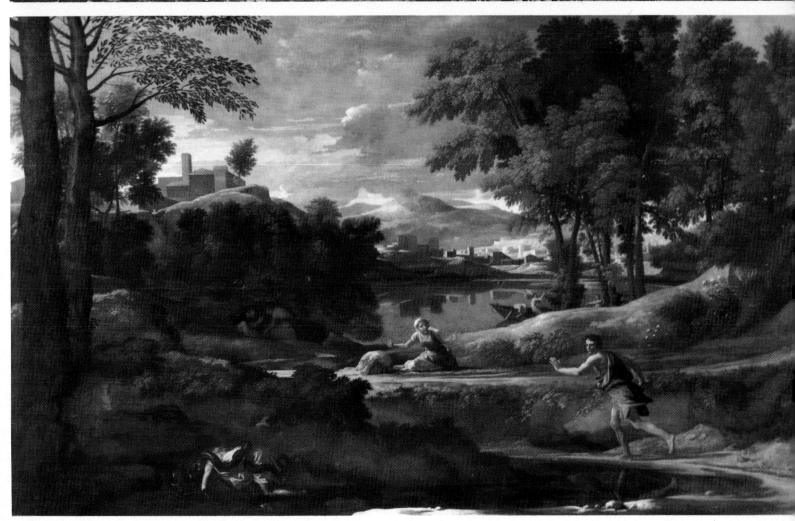

CLAUDE
*Landscape:
The Marriage of
Isaac and Rebekah*
Canvas, 149 × 196 cm

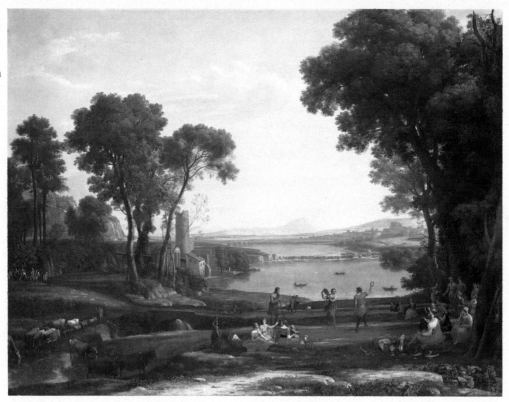

NICOLAS POUSSIN Les Andelys 1594–Rome 1665 *Bacchanalian Revel before a Term of Pan*
Page 93
To his re-creation of the stories of classical history and mythology Poussin brought an unprecedented seriousness and authenticity. He arrived in Rome in 1624 at the age of thirty and, with the exception of a brief period in Paris in 1641–2, never returned to France. He was not inclined towards the grand decorative style then evolving in Rome, and turned instead to Raphael, Titian and above all the art of classical antiquity for inspiration. Even in this bacchanalian scene painted in the late 1630s, seemingly so lighthearted and spontaneous in conception, he strives in the chain of dancing figures to recapture the formal order of an antique freize. But there is nothing cold or stone-like about these dancers. Poussin's admiration for Venetian painting is apparent in the rich colouring and in the romantic wooded landscape.

NICOLAS POUSSIN *Landscape with a Snake* Page 93
The mood of this picture, painted about 1648, is far removed from that of the *Bacchanalian Revel*. Within a space of about ten years Poussin has chastened his style. The soft Venetian landscape has been replaced by. a grave natural order, the hazy mountains and broken foliage by clearly defined land and tree masses. Nature is reconstructed according to strict intellectual principles, forms are simplified and so ordered as to present an austere harmony of shapes and tones. But within this supremely rational framework Poussin introduces an element of horror, which, in contrast to such order, is all the more dramatic. In the foreground lies the dead body of a man killed by a snake. Turning, the man in blue conveys his alarm to the woman beyond who catches the attention of the fisherman on the lake. The note of tragedy and of panic cuts into the calm landscape like the echo of a shriek of terror.

CLAUDE Chamagne 1600–Rome 1682 *Landscape: The Marriage of Isaac and Rebekah*
Like Poussin, six years his senior, Claude, a Frenchman by birth, made his abode at Rome. Specializing exclusively in landscapes—landscapes peopled with characters from the Bible and classical mythology—he found his inspiration in the country around Rome, rich in historic associations. Claude did not attempt to recreate the classical world, but only to evoke its mood; consequently, effects of light and distant vistas are more valuable to him than the events acted out on the stage-like foreground. This picture with its pendant, the *Embarkation of the Queen of Sheba* which is also in the gallery, was painted in 1648, and the subject, the marriage of Isaac and Rebekah, is inscribed on the tree-stump in the centre. But like the huntsmen and the herdsman with his cattle, the wedding guests are merely incidental to the idyllic pastoral scene. Between arching trees extends a splendid panorama suffused in the hazy evening light, a poignant evocation of a lost golden age.

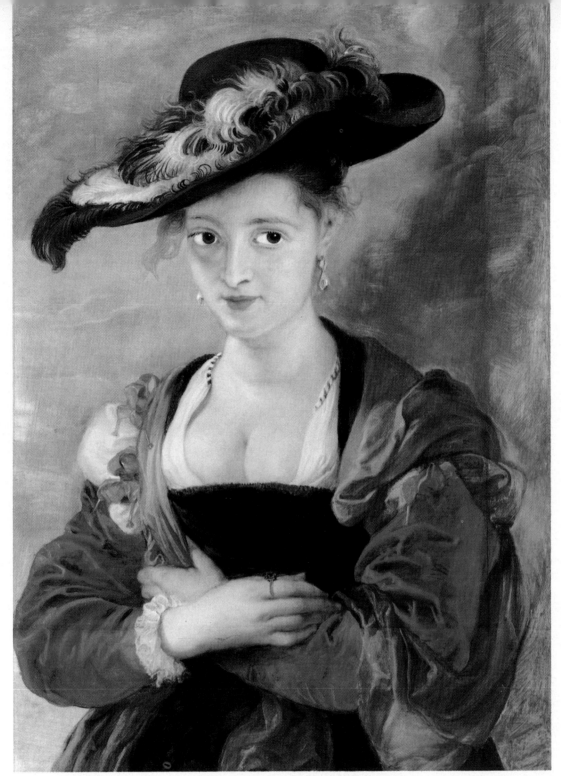

PEETER PAUWEL RUBENS
Susanna Lunden ('Le Chapeau de Paille')
Wood, 79 × 54 cm

PEETER PAUWEL RUBENS Siegen 1577–Brussels 1640 *Susanna Lunden ('Le Chapeau de Paille')*

This famous picture has long been familiarly known as *Le Chapeau de Paille*, although the sitter in fact wears a hat of felt and not of straw (*paille*). Most probably the sitter is Susanna Fourment, the elder sister of Rubens's second wife, Helena. In 1622 she married Arnold Lunden, and this picture, which dates from about that time, may be a marriage portrait. It overflows with youthful vitality and freshness. The hastily laid-in dress and mantle seem caught up in motion. The feathers on her hat seem to writhe with a life of their own, and strands of hair stray loose in the breeze. Rubens accentuates her soft-skinned beauty by subtle distortions: he elongates her neck and exaggerates the curves of her face and the fullness of her eyes. But his characterization is not unpenetrating. These large animal eyes betray a shyness, a natural modesty that temporarily checks her restless energy. The freshness and informality of this affectionate study are matched by the setting, where clouds part to reveal an expanse of clear blue sky.

95

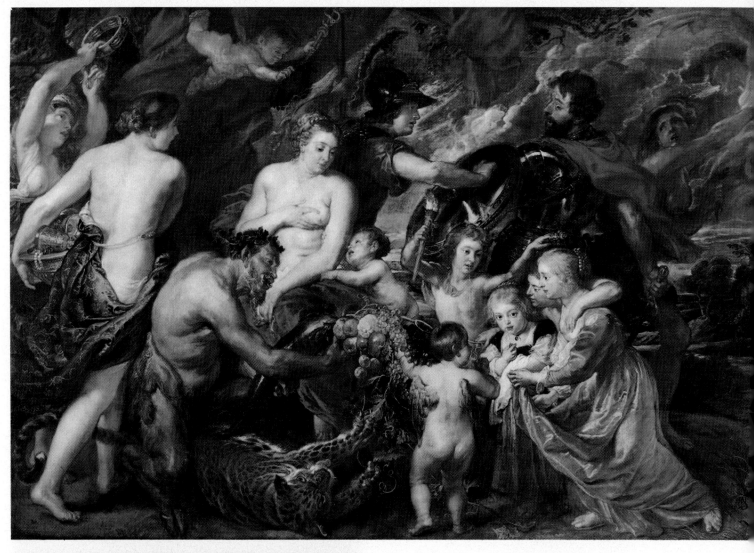

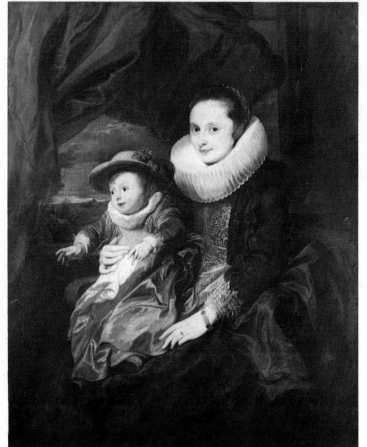

Above
PEETER PAUWEL RUBENS
Minerva protects Pax from Mars ('Peace and War')
Canvas, 203 × 298 cm

Left
ANTHONY VAN DYCK
A Woman and Child
Canvas, 131 × 106 cm

Above right
FRANS HALS
A Family Group in a Landscape
Canvas, 149 × 251 cm

Right
FRANS HALS
Portrait of a Man in his Thirties
Canvas, 64 × 50 cm

Far right
REMBRANDT
Self-Portrait aged 34
Canvas, 102 × 80 cm

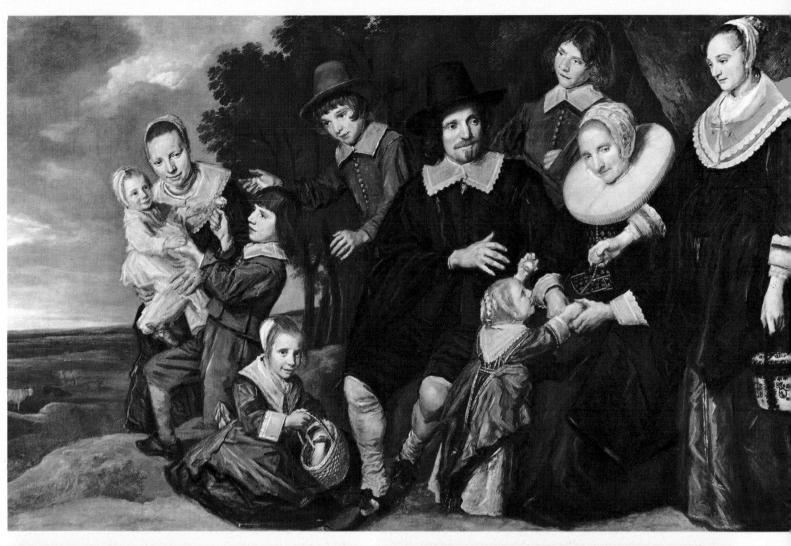

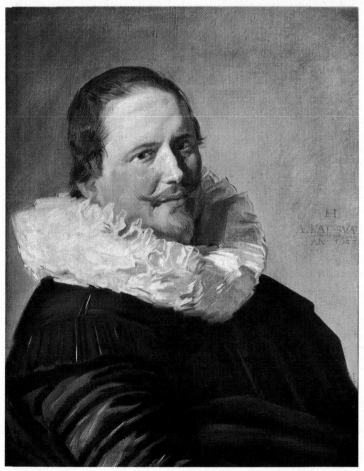

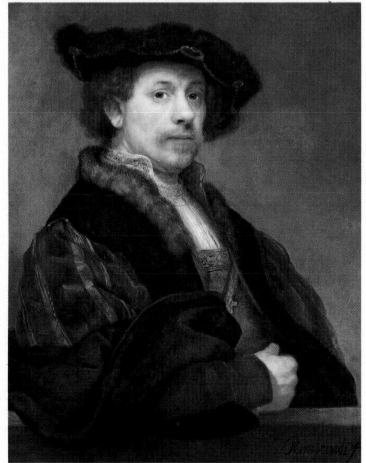

97

PEETER PAUWEL RUBENS *Minerva protects Pax from Mars ('Peace and War')* Page 96

For a period of nine months in 1629 and 1630 Rubens was in England, negotiating a peace on behalf of the Spanish Crown. His mission was successful. He was knighted by Charles I and painted this picture as a present for the English king. Although it is inspired by a picture by Tintoretto, the allegory relates specifically to Rubens's political aims in England. Helmeted Minerva, goddess of Wisdom, protects Pax—who feeds the infant Plutus, god of Wealth—from Mars and the Fury behind him, the emissaries of war. A satyr offers a cornucopia overflowing with the fruits of peace to two young girls, one of whom is crowned by Hymen, while a woman with a tambourine and another bearing riches represent the further benefits of peace. Such symbolic imagery is the natural means of expression for Rubens, but in his hands allegory is in no way a cold and stilted form. Far from being mere ciphers, the figures possess a full-blooded vitality; the dynamic movement creates a sense of dramatic urgency. Alone among these mythological persons, the two girls, who may be portraits of the daughters of Rubens's friend and host in England, Balthazar Gerbier, are in contemporary dress. It is at this point that Rubens departs from allegory to show that it is real lives that war threatens.

ANTHONY VAN DYCK Antwerp 1599–London 1641 *A Woman and Child* Page 96

Van Dyck is probably best known for his impressively grandiloquent portraits of Charles I, for whom he worked as principal painter from 1632. But even before his departure from Antwerp to Italy in 1621, he had produced works of outstanding accomplishment. Although he worked as an assistant to Rubens, he already, at seventeen, had a studio and pupils of his own. This portrait was probably painted on the eve of his stay in Italy, and shows his keen response to character, his ability to catch a sitter's particular vitality in fluent paintwork. It is a secular variation on the theme of Madonna and Child. The mother glances out at us with a warm and sensitive smile, her demure charm enhanced by the broad sweep of the ruff. The child, poised on her knee, reaches out as if towards its father, who may have been portrayed in a companion portrait. A glimpse of landscape shows the last glow of sunset. The dim light flares up in points of brilliance on the rich costumes, and the colour forms a deeply resonant harmony of blacks, golds, and muted purple.

FRANS HALS Antwerp 1580(?)–Haarlem 1666 *A Family Group in a Landscape* Page 97

Frans Hals painted a great number of group portraits of this sort, not only of families, but of companies of militia, of musketeers and of members of the regent class of Haarlem. After about 1650 the demand for his work dropped and he ended his life destitute, supported by a meagre allowance from the municipal almshouse. One of the latest—and finest—of these group portraits shows, in fact, the governesses of the almshouse. But this picture probably dates from the 1640s, and while the figures are Hals's own, the landscape setting is by another hand. The rich dress shows the family to be prosperous, but their features are common enough and unidealized. They strike no poses and are busily preoccupied with one another. This unpretentious and intimate tone is reinforced by the broad brushwork and the dull, earthy colouring, enlivened only by the crisp white of their collars and cuffs.

FRANS HALS *A Portrait of a Man in his Thirties* Page 97

Rembrandt's portraits always seem fixed and still, the result of long intense observation, despite the rough broken texture of the paint. Hals, Rembrandt's senior by over twenty years, seems here to have registered the impression of an instant. His sitter turns and glances out at the spectator as though momentarily interrupted in his activities. The loose, liquid paintwork appears to have been hurriedly laid-in without an afterthought, with total spontaneity. After Italian portraiture, his approach seems remarkably informal and modern; Manet, two hundred years later, was struck by the freedom of his technique. But although this freshness is part of Hals's great achievement, it is perhaps deceptive. Such apparent spontaneity is the result of consummate skill.

REMBRANDT Leyden 1606–Amsterdam 1669 *Self-Portrait aged 34* Page 97

Although Rembrandt never cared to write down his observations and thoughts as Leonardo had done, and no-one else cared to record them for him as Vasari had for Michelangelo, he left a far more eloquent and intimate record in a series of self-portraits dating from every period of his life. This picture was painted at the height of his prosperity, when his services as a portraitist were still much sought after. Dressed in a rich fur-trimmed jacket and cap, he appears confident and well-to-do, unmarked by the misfortune apparent in the care-worn features, nearly 30 years later, of the *Self-Portrait aged 63*, also in the gallery. The assertive aristocratic air of his present picture is not just fortuitous. In painting it, Rembrandt recalled the examples of the most illustrious Renaissance masters, including Titian (page 77).

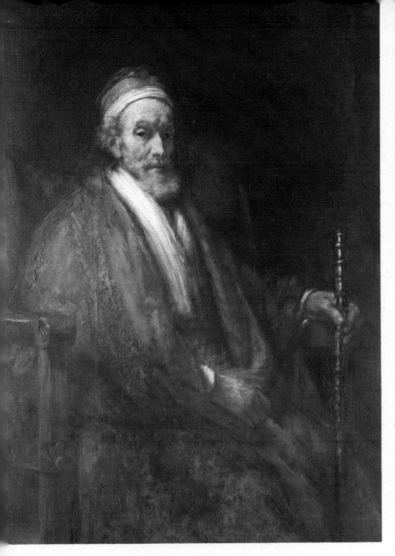

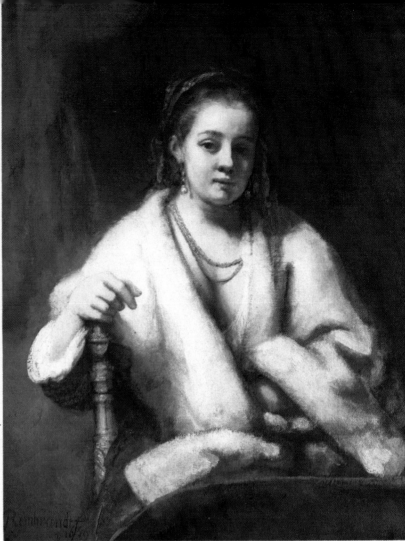

REMBRANDT
Portrait of Jacob Trip
Canvas, 130 × 97 cm

REMBRANDT
Portrait of Hendrickje Stoffels
Canvas, 101 × 83 cm

REMBRANDT *Portrait of Jacob Trip*
Jacob Trip was a wealthy merchant from Dordrecht and husband of Margaretha de Geer, who appears in two other portraits by Rembrandt in the National Gallery. Many pictures of the couple survive by other eminent artists of the period, including Aelbert Cuyp and Nicolaes Maes. The handling of this portrait, and the age of the sitter, who was born in 1575, indicate a late date, possibly 1661, the year of Trip's death. Only the head, illuminated by a soft, warm light, is at all highly finished. The dress, the bony hands, and the chair are summarily indicated by the rough-textured paintwork, thin and scrubbed in parts, elsewhere heavily impastoed, which conveys a feeling of volume and texture without minute description. The shattered surface, which breaks out of the confines of contours, seems to imitate the living presence of the old man on the verge of dissolution.

REMBRANDT *Portrait of Hendrickje Stoffels*
In 1649, seven years after the death of Rembrandt's wife Saskia, Geertje Dircz, the woman he had employed to look after his son Titus, brought a breach-of-promise suit against him. Hendrickje Stoffels gave evidence on Rembrandt's behalf and afterwards entered his house as Titus's nurse and the artist's mistress. In 1654, when she became pregnant, she was punished and admonished to repentence by the Dutch Church Council for the sin of fornication, and later that year she bore Rembrandt a daughter. Although she remained with him until her death in 1663, he never married her because this would have deprived him of the much-needed income from his wife's will. Such were his financial difficulties that in 1658 Hendrickje and Titus formed a business partnership as art-dealers, making Rembrandt their employee, in order to protect him from his creditors. When this recently acquired portrait was cleaned, its date was discovered to be 1659, and the subtle contrast of the flesh tones with the cooler white of the jacket, which had long been disguised by a heavy layer of discoloured varnish, was once again revealed. Hendrickje appears in a number of Rembrandt's works of this period, including the *Woman Bathing in a Stream*, also in the gallery.

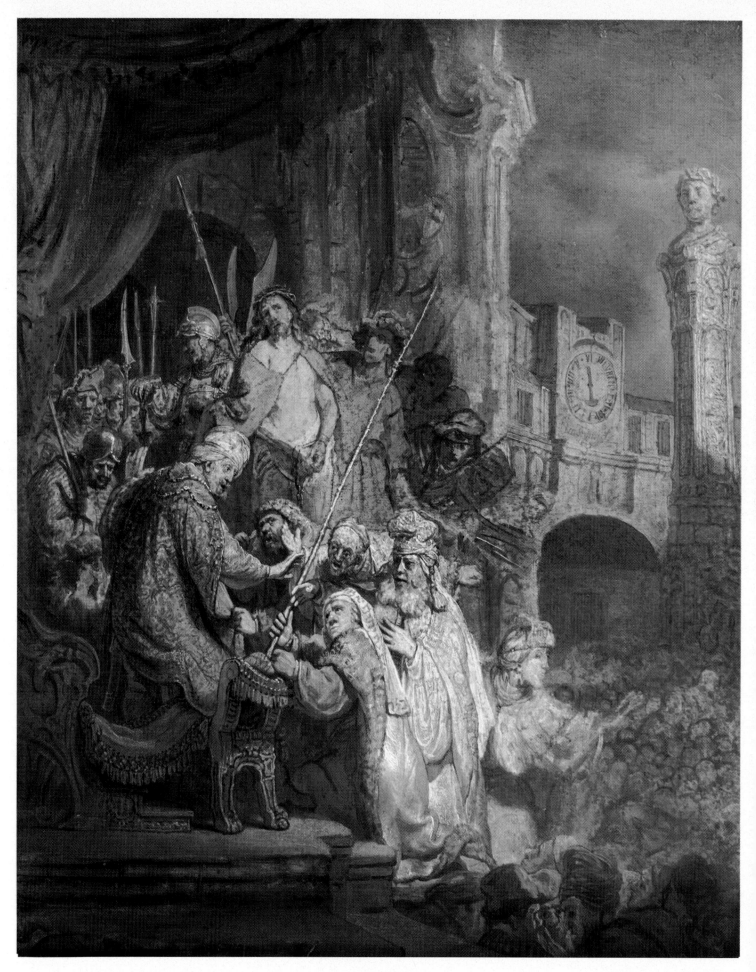

REMBRANDT
Christ presented to the People
Canvas, 54 × 44 cm

100

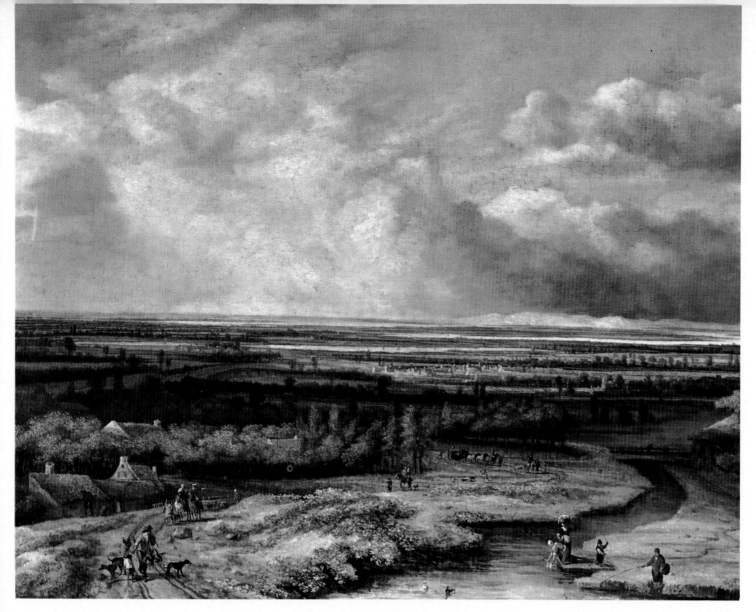

PHILIPS KONINCK
An Extensive Landscape with a Hawking Party
Canvas, 132 × 160 cm

REMBRANDT *Christ presented to the People* Page 100
This oil sketch is a preparatory study for an etching, one of the most popular and often-copied
of Rembrandt's prints. It is dated 1634, the year of his marriage to Saskia van Ulenborch, and
two years after he left Leyden for Amsterdam. In many respects it is typical of Rembrandt's
highly personal interpretation of Biblical events: in the towering composition crowded with
figures, for example, and in the use of light to focus on the principal actors. Although small and
executed in monochrome, the picture conveys an impression of vast numbers and of great
richness. Like many of Rembrandt's Old Testament characters, Pilate and the Jews wear turbans
and are draped in sumptuous oriental-type costumes. The setting too is blatantly anachronistic,
mingling baroque and medieval buildings and a most improbable Imperial bust. But unlike his
contemporaries in Rome, Rembrandt never intended to recreate the appearance of the ancient
world in his paintings. Instead he re-interprets his subjects in imaginative terms, invoking mood
through free inventions.

PHILIPS KONINCK Amsterdam 1619–1688 *An Extensive Landscape with a Hawking Party*
Like his predecessor Hercules Seghers, and his junior by ten years, Jacob van Ruisdael, Koninck
fully exploited the flatness of the Dutch countryside in his panoramic views. In this picture the
foreground is animated by incidental detail: washerwomen, huntsmen, dogs and horses, which
are probably the work of Johannes Lingelbach, who frequently painted such figures in others'
landscapes. From here the eye is led into a vast tract of country, threaded with silver stretches of
water, to the distant horizon. And above opens up a dramatic sweep of sky, with looming clouds
and glimpses of blue beyond. It was from Rembrandt, who was possibly his master, that Koninck
learned to articulate the prosaic landscape of Holland in terms of light and shade.

PIETER SAENREDAM Assendelft 1597–Haarlem 1665 *The Interior of the Grote Kerk at Haarlem* Page 103

Views of the interiors of churches, like still-life and genre painting, flourished in Holland during the 17th century. However, after the interiors of such predecessors as Pieter Neefs and Dirck van Delen, always filled to bursting with incident, this view of the Grote Kerk at Haarlem, dated 1637, exudes a feeling of calm and repose which is as unexpected as the composition is striking. Saenredam does not attempt to analyze the structure of the building as a whole but offers instead a glimpse of part of the interior. The spectator is made to feel the power of the building, with its massive blocks of masonry, as would an actual visitor. The sense of place and scale impinges violently through the sharp recession, and through the contrast between the colossal pillars which tower above the spectator and their distant counterparts across the nave.

JAN STEEN Leyden 1626–1679 *Skittle Players outside an Inn* Page 103

Jan Steen seems to resolve the contradictory biases of his two masters: that of Adriaen van Ostade for peasant scenes, and that of Jan van Goyen for landscape. Here he combines a light-filled outdoor view with a scene of peasants drinking and playing skittles. But fidelity to nature predominates over the distortion and caricature which is most commonly found in such peasant scenes. Here there is no drunkenness or brawling. The few figures are portrayed with a scrupulous naturalism. Jan Steen was familiar with Italian painting, and the three characters on the left seem to re-enact a Giorgionesque *fête champêtre*. But in the costumes and the setting, the artist does not diverge from contemporary fact. He records, apparently without comment, and with only a simple pleasure in his perceptions.

PIETER DE HOOGH Rotterdam 1629–Amsterdam 1684(?) *A Woman and her Maid in a Courtyard* Page 104

De Hoogh's courtyard scene has the informal and candid air of a photograph. Yet natural though it seems, the picture is brilliantly contrived. It is a studied arrangement of carefully observed parts, orchestrated like objects in a still life. The pump and the summer house against the wall in the background can in fact be found in others of his paintings, also executed in Delft. A variety of shapes are fitted together in an intricate and harmonious pattern. A gateway, partially obscured by the mistress in her black coat, frames the figure of a man. Behind him rise steps through another gate, which leads onto what has been identified as the old town wall of Delft. Dated 1660 or soon after, this was probably one of the last pictures de Hoogh was to paint before moving to Amsterdam. Like the work of Carel Fabritius and Vermeer, it shows a feeling for design and for textures described by light that was the hallmark of painting in Delft.

MEYNDERT HOBBEMA Amsterdam 1638–1709 *The Avenue at Middelharnis* Page 105

This justly famous work combines the finest qualities of Dutch painting: a fidelity to nature, a feeling for the play of light—a sense of naturalness, in fact, that recalls Ruisdael, Hobbema's teacher—and an ability to arrange the parts in a harmonious composition. It demonstrates the order of Vermeer applied to landscape. Signed and dated 1689, it shows the environs of Middelharnis—its 15th-century church can be seen on the horizon—on the island of Overflakee in South Holland. Without sacrificing naturalism, Hobbema marshalled the forms of the Dutch landscape into a composition of monumental design. At the centre of the picture, dominating the scene with its typically low, flat horizon and vast sky, is the avenue. Yet the symmetry is tempered by subtle variations in the shapes of the clouds and in the forms of the trees and the intervals between them, and by the irregular, seemingly fortuitous placing of buildings and figures.

JOHANNES VERMEER Delft 1632–1675 *A Young Woman standing at a Virginal* Page 105

In Vermeer's work, neglected until the 19th century, modest subjects—a girl sewing, reading a letter, or, here, playing a virginal—assume a mysterious potency. One of his late works, this picture dates from after 1670. A cool light pervades the room. A moment of time, the moment when the woman alone at the virginal turns, alerted perhaps by an awaited visitor, is crystallized in an image of permanence and finality. The scene is registered in a total harmony of shape, of tone, of colour. The focus is so sharpened that incidental details—a gilt frame, a silk dress, a tiled floor, brass studs on a chair—take on a reality that exceeds the everyday. But the parts cohere in a way that is not only visually meaningful. For the very special lucidity of the picture seems to centre upon the lady and reflect her state of mind. In the picture on the wall a cupid holds a card, an emblem of fidelity in love. And the face of the lady, radiant yet composed, turned in greeting, betrays a secret passion. Here, Vermeer hints, is the creative force which infuses and transforms her surroundings.

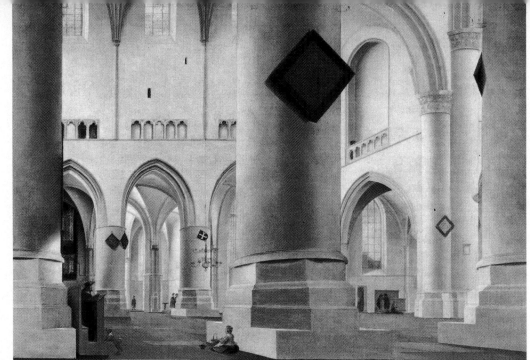

PIETER SAENREDAM
*The Interior of the Grote Kerk
at Haarlem*
Wood, 59 × 81 cm

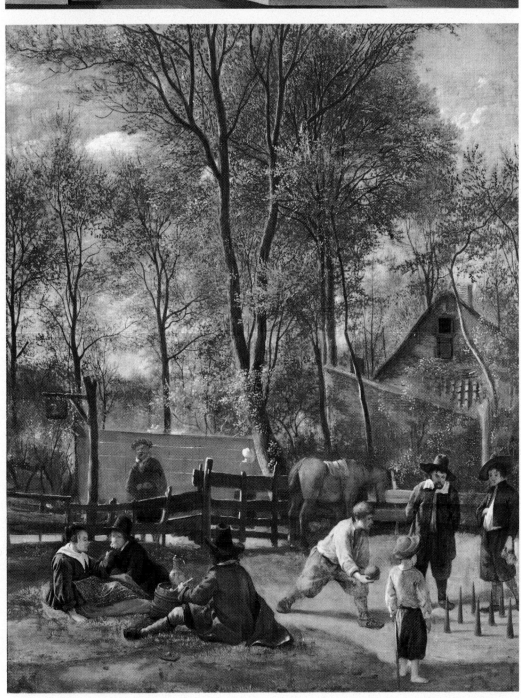

JAN STEEN
Skittle Players outside an Inn
Wood, 33 × 27 cm

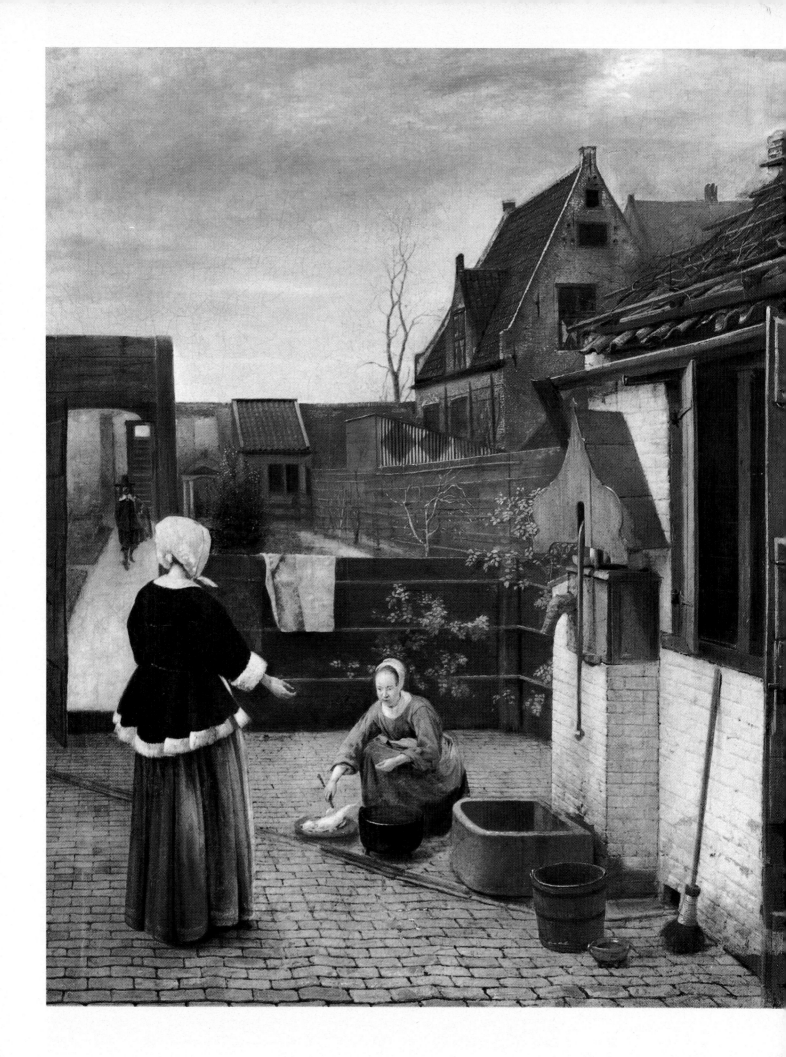

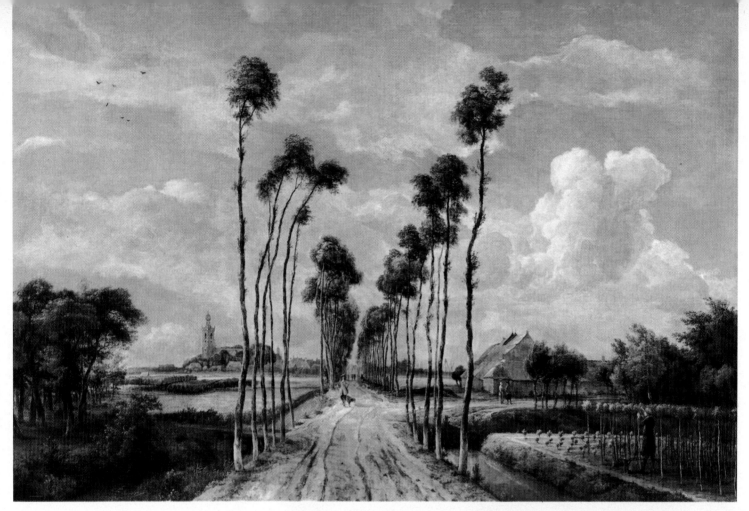

Above
MYNDERT HOBBEMA
The Avenue at Middelharnis
Canvas, 103 × 141 cm

Left
PIETER DE HOOGH
A Woman and her Maid in a Courtyard
Canvas, 74 × 62 cm

Right
JOHANNES VERMEER
A Young Woman standing at a Virginal
Canvas, 51 × 45 cm

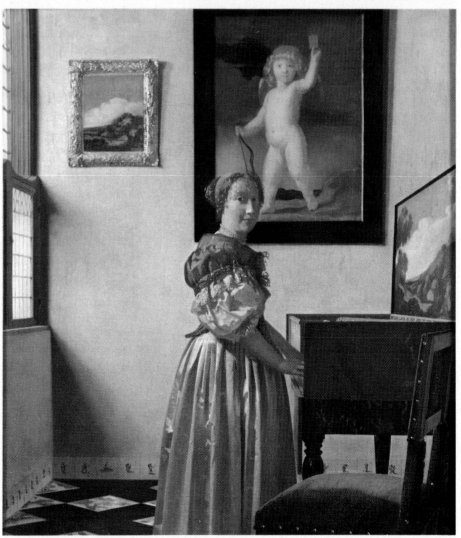

The Eighteenth Century

GIOVANNI BATTISTA TIEPOLO Venice 1696–Madrid 1770 *An Allegory with Venus and Time* Page 107

This ceiling painting, which was found in 1969 in a London house, is a masterpiece of decorative design. The composition ascends in a zig-zag movement from the *putto* bearing a quiver, along the line of the scythe, to the winged figure of Time, and then diagonally back to Venus, splendidly shown off by draperies of gold and pink at the centre. It rises once more to the group of flower-tossing graces and thence to the doves, white and grey against an expanse of clear blue sky. As they tower air-borne above us, the groups recede into space, while the full brilliance of the light falls upon the radiant Venus. The ceiling was painted for the Palazzo Contarini at Venice and may commemorate the birth of an heir. Venus extends her arm to Time, entrusting him with a child, perhaps her son, the infant Roman hero Aeneas.

GIOVANNI BATTISTA TIEPOLO *SS. Maximus and Oswald* Page 108

Tiepolo, one of the greatest decorative painters of the 18th century, was active not only in Venice, his native city, but throughout Northern Italy, in Spain (where he died in 1770), and from 1750 to 1753 in Würzburg, where he created his finest fresco schemes in the Prince Bishop's *Residenz*. Despite its scale, this small canvas conveys Tiepolo's mastery as a colourist and as a draughtsman, and his wonderfully inventive imagination. The subject has been deduced from its resemblance to an altarpiece in Padua of about 1742 dedicated to SS. Maximus and Oswald, from which both this sketch and another very similar one at Bergamo seem to derive. The whole scene, with its soaring arches and 16th-century costumes reminiscent of Veronese, is air-filled and animated by the brilliant silvery light. S. Maximus stands in bishop's robes, while at the right S. Oswald in armour looks upwards where a *putto* appears bearing a martyr's crown.

GIOVANNI BATTISTA PITTONI Venice 1687–1767 *The Nativity with God the Father and the Holy Ghost* Page 109

It was in Venice that Baroque painting saw its final flowering, in such virtuoso feats of colour and dynamic composition as appear in this canvas by Pittoni. The subject is unusual. Above the holy family appear God the Father and the Holy Ghost in an explosion of cherubs, angels and fluttering draperies. So much did a 19th-century owner disapprove of this arrangement that the upper part was painted out, only to be revealed on cleaning in 1959. But there is no discordance between the heavenly vision and the realistic details of the nativity scene beneath—the rustic manger and the peasant features and dress of S. Joseph. The whole painting is composed in terms of broad areas of colour. The light which falls diagonally across the picture casts deep resonant shadows and collects in a pool of radiance on the crib, the focus of the composition.

CANALETTO Venice 1697–1768 *Venice: The Grand Canal with S. Simeone Piccolo* Page 110

It required Canaletto's acute response to observed detail and his feeling for Venice itself to transform the topographical tradition of view-painting into an art-form of major stature. The son of a scene-painter and designer, Canaletto seems to have turned to view-painting after a visit to Rome in 1719. Throughout his life the city of Venice, with its unique combination of buildings and waterways offering splendid vistas of ancient ornamented palaces and churches reflected in limpid green canals, remained his chief inspiration. It is a subject precisely suited to his kind of talent, to his grasp of tangible forms, of masonry, boats and animated figures, and his ability to unify these shapes in luminous sunlit compositions. It seems that the Venetians found these views of their native city too obvious, as indeed in a masterful way they are, and Canaletto found his chief patrons among the English, visiting England himself on several occasions.

FRANCESCO GUARDI Venice 1712–1793 *View on the Venetian Lagoon with the Tower of Malghera* Page 110

A huge vaporous sky and extensive sheets of still water which echo the blue-grey tones of the clouds seem almost to engulf the scattered fragments of land and masonry in this view by Guardi. Although the Tower of Malghera appears in an etching by Canaletto, he was little interested in these remote and deserted expanses of the Venetian lagoon. In Guardi's painting, however, the subject is no more than a pretext for moody atmospheric effects, the tower no more than a visual motif around which the picture is composed. His method is not that of the conventional topographical view-painter. Breaking the horizon, with its block-like form summoned out of a few strokes of paint, the tower might just as well be a pure invention of the painter's imagination. Fishermen and boats are reduced to mere brushstrokes, a deft web of light and dark notes which evoke, without close description, the mood of these watery wastes.

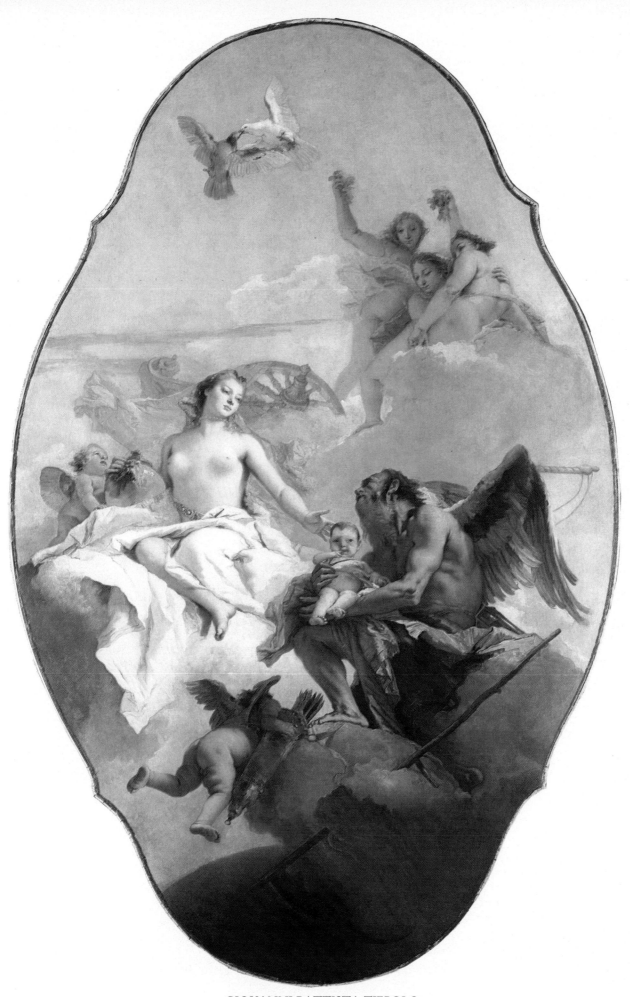

GIOVANNI BATTISTA TIEPOLO
An Allegory with Venus and Time
Canvas, 292 × 190 cm

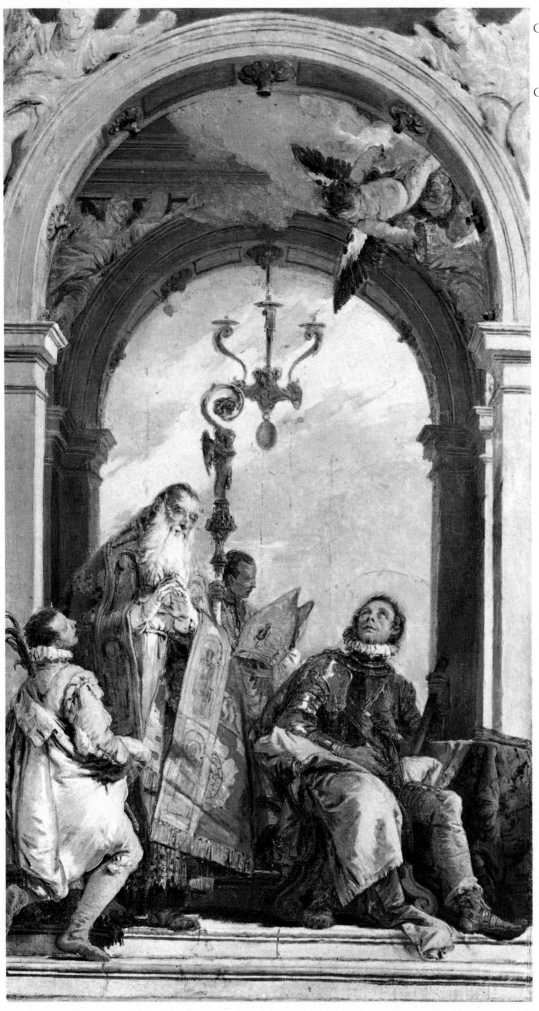

Left
GIOVANNI BATTISTA TIEPOLO
SS. Maximus and Oswald
Canvas, 58 × 32 cm

Right
GIOVANNI BATTISTA PITTONI
*The Nativity with God the Father
and the Holy Ghost*
Canvas, 222 × 153 cm

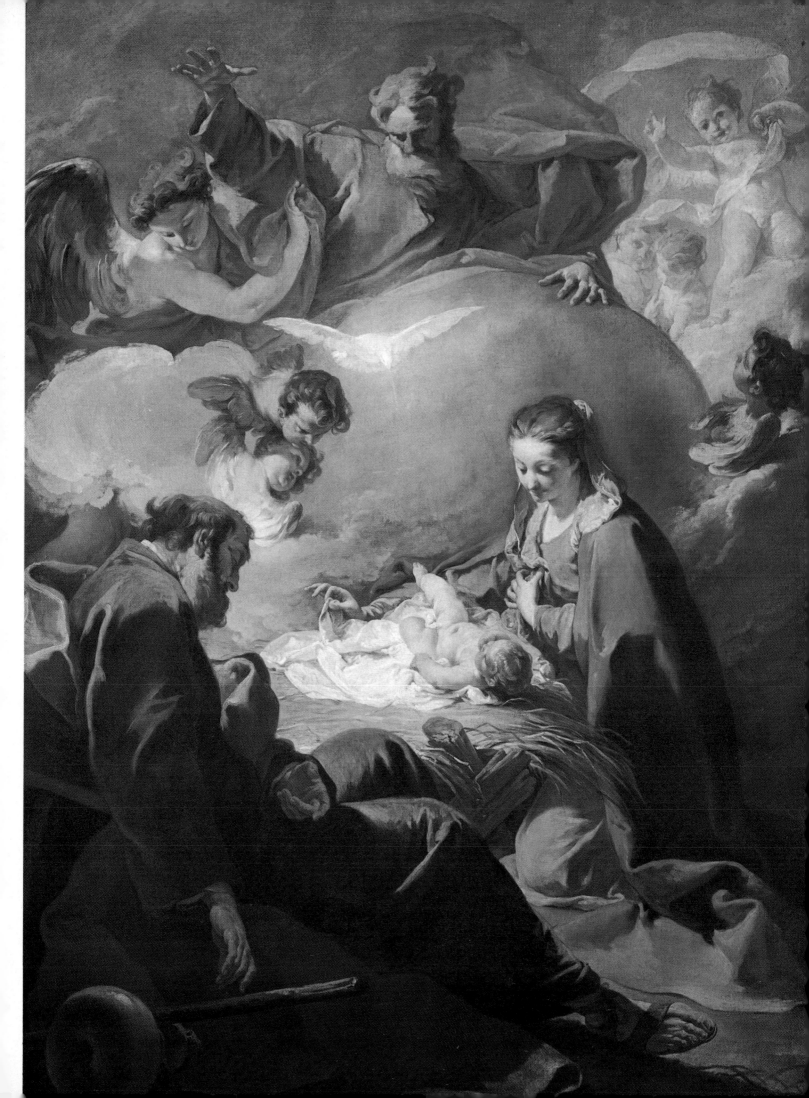

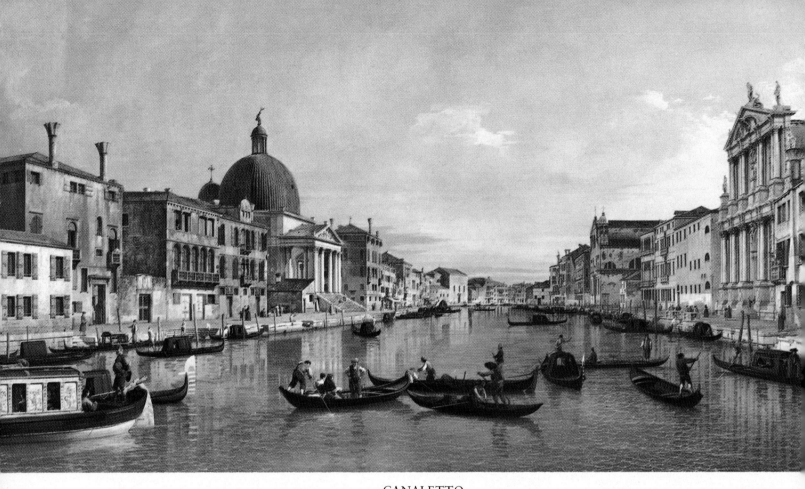

CANALETTO
Venice: The Grand Canal with S. Simeone Piccolo
Canvas, 124 × 204 cm

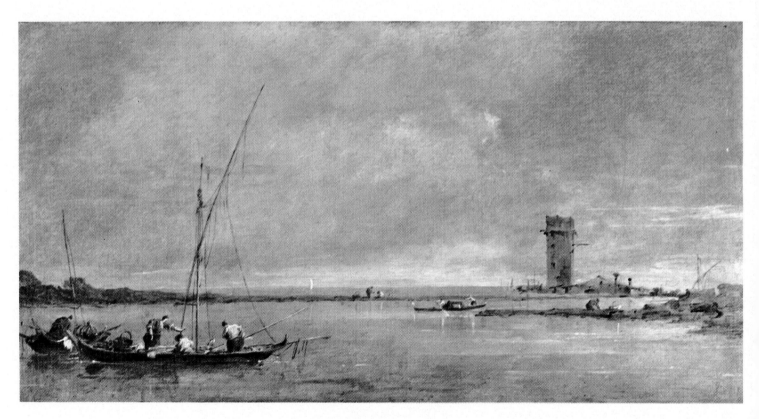

FRANCESCO GUARDI
View on the Venetian Lagoon with the Tower of Malghera
Wood, 21 × 41 cm

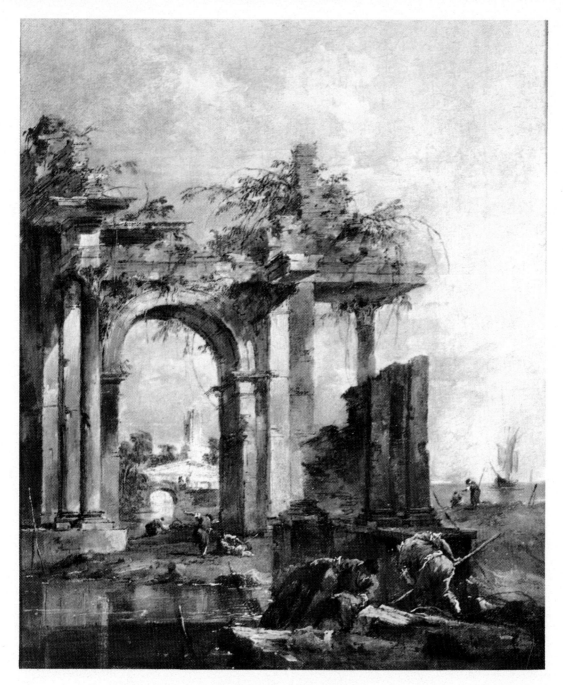

FRANCESCO GUARDI
A Caprice with Ruins on the Seashore
Canvas, 36 × 26 cm

FRANCESCO GUARDI *A Caprice with Ruins on the Seashore*
This architectural caprice is typical of many by Guardi dating from the late 1770s and shows his style at its most distinctive. The ruins of classical buildings of enormous scale are adopted as decorative features in compositions which commonly combine boats and elegantly posed supernumaries with views of lagoons. But the solid, tangible Venice of Canaletto has been fragmented by light. Here bent figures, perhaps delving for treasure, are dispersed about a colossal pillared arch which rises out of the water, sprouting delicate fronds of vegetation. The brilliant light transforms the masonry into a glittering pattern of tones, of dramatic contrasts and varied textures. The sketchy brushwork does not describe, but only hints at forms, indicating lights on costume and water with bright dashes of fluid pigment, creating an insistent, almost nervous flicker of light and movement.

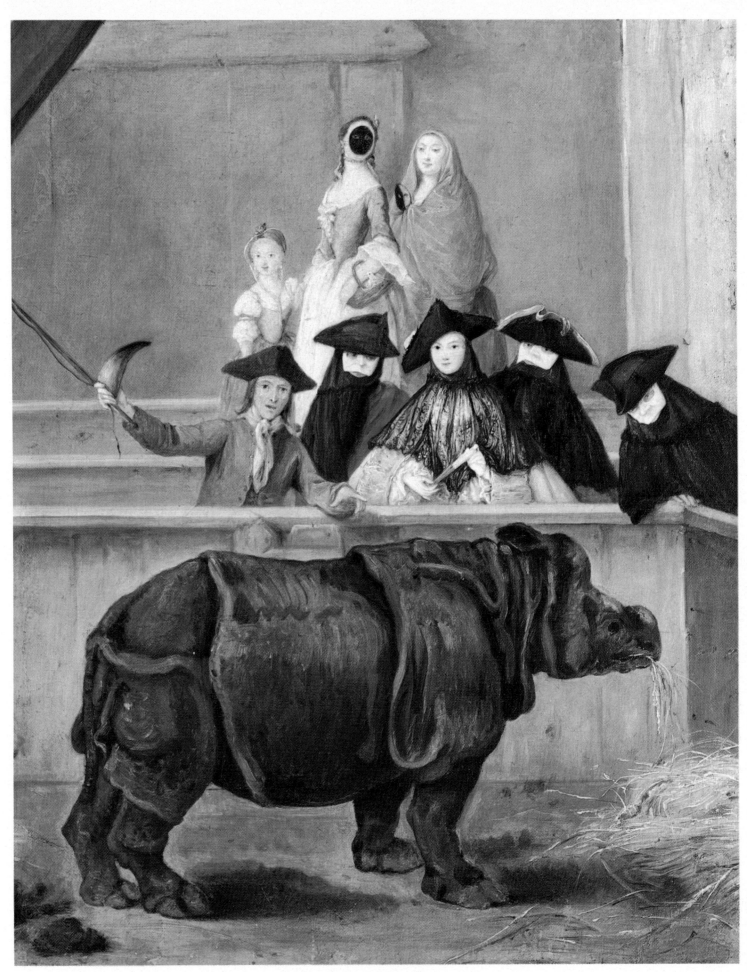

PIETRO LONGHI
Exhibition of a Rhinoceros at Venice
Canvas, 60 × 47 cm

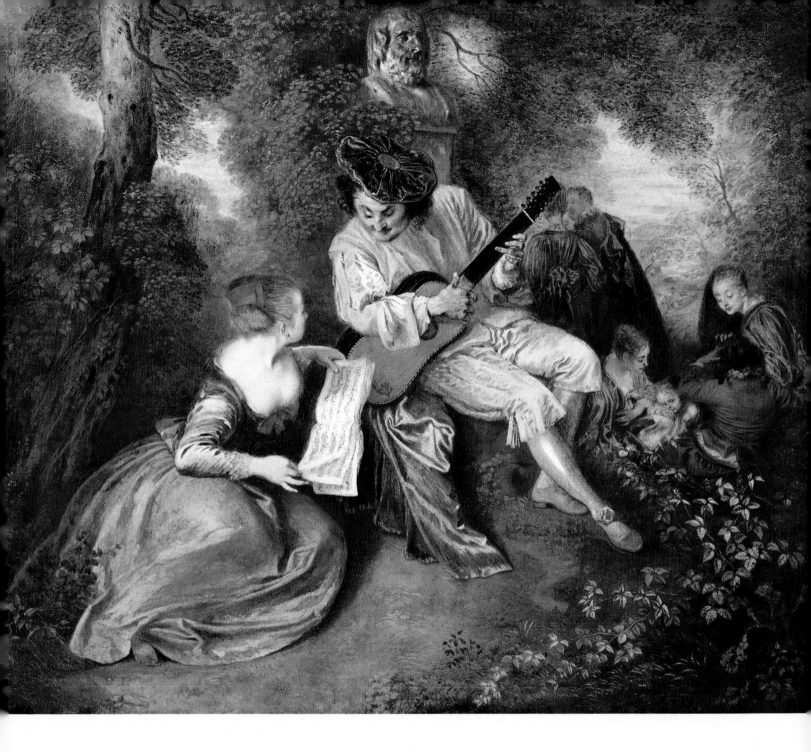

ANTOINE WATTEAU
La Gamme D'Amour
Canvas, 50 × 59 cm

PIETRO LONGHI Venice 1702–1785 *Exhibition of a Rhinoceros at Venice* Page 112
More interesting to Venetian patrons than Canaletto's views of the city were, it seems, Pietro
Longhi's scenes of social life. Somewhat awkward and naive, they record the pastimes of the
rich: visiting fortune-tellers, taking coffee, exchanging gossip, and here, dressed in festival cos-
tume, staring rather stupidly at a rhinoceros that was brought to Venice for the carnival of
1751, probably the first to appear in Europe for over 200 years. Surprisingly, Longhi seems to
have enjoyed little foreign patronage, perhaps on account of the nature of his subjects; they have
little to say outside the closed circle for which they were painted. Unlike Hogarth's scenes, they
are enlivened by neither satire nor comment, and remain a bland account of the frivolous
pursuits of a very narrow and privileged segment of Venetian society.

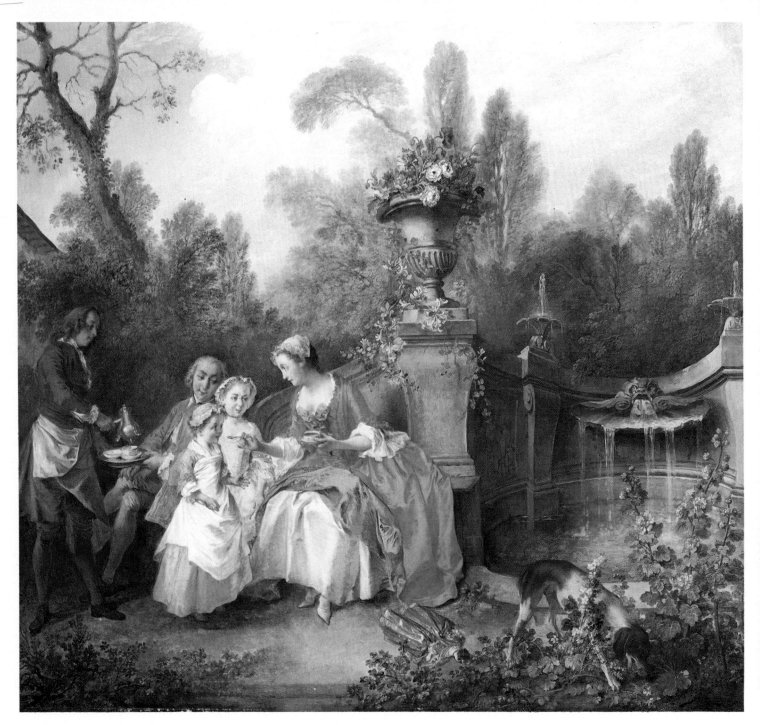

NICOLAS LANCRET
A Lady and Gentleman with Two Girls in a Garden
Canvas, 89 × 98 cm

ANTOINE WATTEAU Valenciennes 1684–Nogent 1721 *La Gamme D'Amour* Page 113
The emergence of Watteau and the *fête galante* during the early years of the 18th century in
France was to mark the triumph of Rubenism over the classical style of Poussin. Watteau
came from the east of France, from Valenciennes, a town which before his birth had been
Flemish, and in Paris he was inspired by Rubens's Marie de' Medici series. But his pictures are
small and the intimate genre character of his subjects bears more affinity with Dutch art. His
characters inhabit an undefined region somewhere between reality and fantasy. In this picture,
groups of lovers in fancy dress disperse themselves in a secluded woodland setting. An air of
mystery surrounds them, made potent by the dense foliage and shimmering light on their cos-
tumes. The silken textures, so reminiscent of Veronese, lend the scene an unearthly splendour
and sharpen the nervous lyricism of these finely poised, over-refined characters.

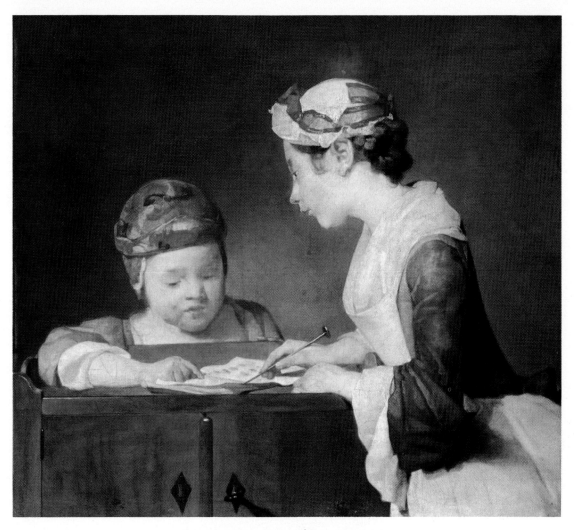

JEAN-BAPTISTE SIMÉON CHARDIN
The Young Schoolmistress
Canvas, 61 × 66 cm

NICOLAS LANCRET Paris 1690–1743 *A Lady and Gentleman with Two Girls in a Garden*
Page 114

Of the several artists influenced by Watteau, Lancret approaches most closely the seriousness and lyricism of his predecessor's work. Yet more so than Watteau, he actually reproduces the manners of contemporary society. The episode shown in this picture, which was exhibited at the Paris Salon of 1742, is keenly observed—a charming incident of domestic life grafted into a setting which is as fanciful as Watteau's idyllic woodland retreat. Thus genre is saved from banality by a liberal dose of fantasy. But the garden serves also to reinforce the underlying theme. Nature, which seems to run wild in the distant woods, is adorned by devices of man's making, by the ornamental Rococo fountain and the cultivated honeysuckle and hollyhocks. Similarly, the family group is natural and informal without being brutish. Human behaviour, Lancret hints, must obey conventions; a refinement of manners is necessary if Man's finest natural instincts are to operate successfully.

JEAN-BAPTISTE SIMÉON CHARDIN Paris 1699–1779 *The Young Schoolmistress*

The figure of Chardin stands above and apart from the French artists of his time. Into a period dominated by the extravagant and sentimental romances of Rococo art, he brought a seriousness and a truthfulness of vision which he applied to the most modest subjects—ordinary middleclass people, domestic interiors, and still lifes of fruit and pots and pans. In this he continues the tradition of Dutch 17th-century genre painting, but, like Vermeer, he eschews the sentimental and the trivial with an intellectual rigour which is as discriminating as it is discreet. The austerity of his compositions and the deliberacy of his brushwork (which shuns all flourishes and mannerisms) invest the simplest of subjects with a grandeur and moral dignity. The young girl instructing a child is not treated as a touching anecdote. These two children, anonymous as they are timeless, embody, and were recognized to embody, the 18th century's most serious beliefs about the importance of education and self-improvement.

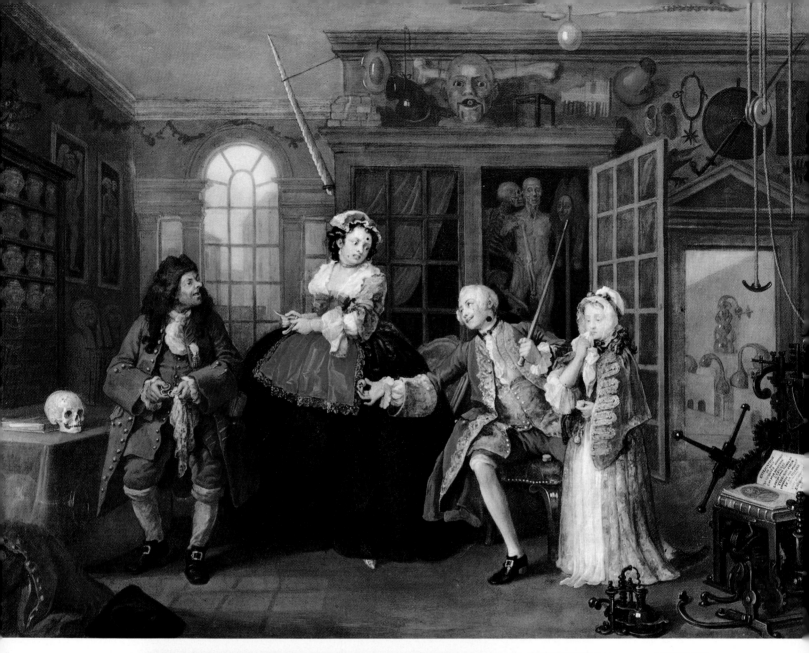

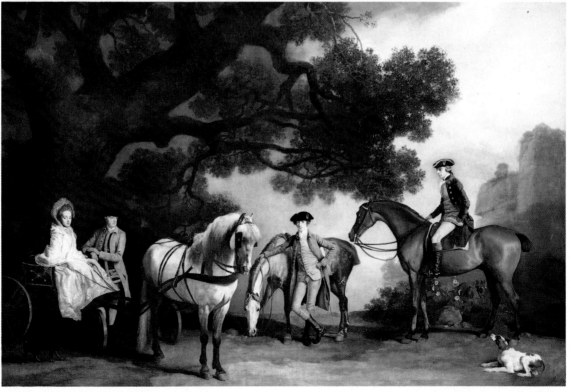

Left
WILLIAM HOGARTH
The Visit to the Quack Doctor
Canvas, 70 × 90 cm

Below left
GEORGE STUBBS
The Melbourne
and Milbanke Families
Canvas, 97 × 149 cm

Right
SIR JOSHUA REYNOLDS
General Sir Banastre Tarleton
Canvas, 236 × 145 cm

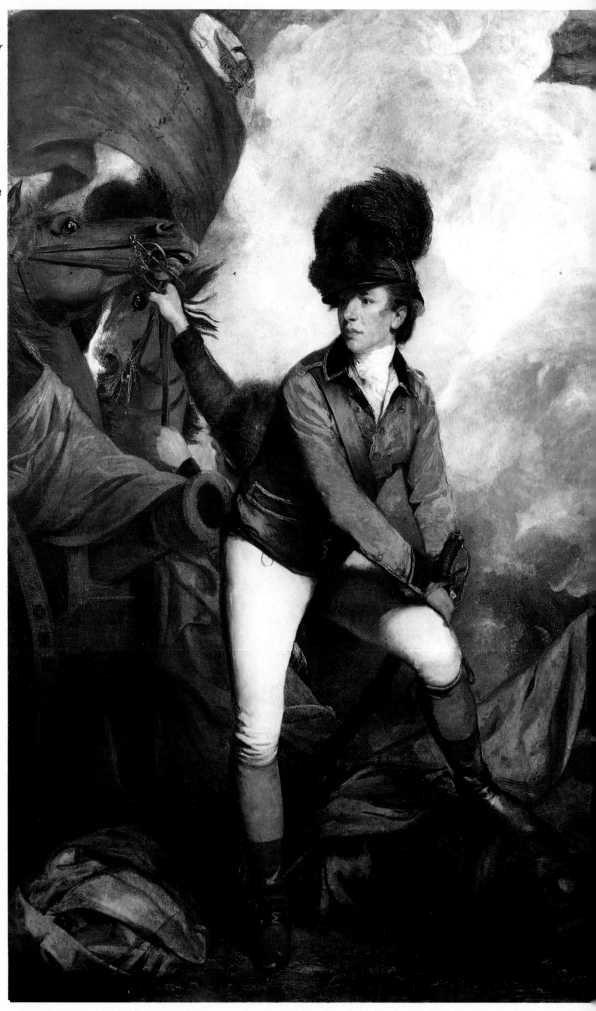

WILLIAM HOGARTH London 1697–1764 *The Visit to the Quack Doctor* Page 116

This picture is one of six in the National Gallery that make up Hogarth's series *Marriage à la Mode*. It is a story illustrating the consequences of dissolute living in high society. A match between a nobleman and an alderman's daughter, based on vanity and greed, finishes in adultery, the murder of the earl and the sucide of the countess. In this scene the husband visits a quack doctor, to seek, supposedly, a remedy for venereal disease, the result of his debauchery. The diseased skull and the skeleton making amorous advances to the anatomical figure serve to underline the hazards of loose living, while the flasks and strange contraptions that bedeck the room like instruments of torture reveal the mixture of superstition, ignorance and devilish ingenuity that makes up the doctor's skill. Hogarth adopted the serial format in order to develop the narrative of his satires in a more theatrical manner. By having the paintings engraved— as these were in 1745—he reached a wider audience and freed himself from the demands of normal patronage.

GEORGE STUBBS Liverpool 1724–London 1806 *The Melbourne and Milbanke Families*
 Page 116

Stubbs's fame rests on his paintings of horses, but he was by no means so limited a specialist. With a curiosity and inventiveness reminiscent of the Renaissance man, he compiled an anatomy of the horse, experimented with pigments and media, and developed new lithographic techniques. His animal paintings range from horses and dogs to such exotic fauna as leopards and monkeys. His curiosity extended to human society also. In this conversation-piece, people and horses are rendered with equal elegance and precision in a landscape setting, a reminder of the English aristocracy's attachment to the country. But this is not the actual landscape of rural England; it is a carefully constructed vista of sublime scenery. All anecdotal detail is removed so that the family group becomes emblematic of a whole social order.

SIR JOSHUA REYNOLDS Plympton 1723–London 1792 *General Sir Banastre Tarleton*
 Page 117

Banastre Tarleton is shown in heroic pose against a background of cannon-smoke, battle-standards and rearing horses. The portrait was painted in 1782, the year that the young lieutenant-colonel returned to England, renowned for his exploits in the American War of Independence. He wears the uniform of the troop known as Tarleton's Green Horse. Reynolds lacked the technical expertise so evident in the work of Gainsborough, his contemporary, but more than compensated for this failing with the stunning *bravura* of his compositions. He set himself the task of raising the status of painting in England, but remained tied by the demands of his patrons to portraiture, a genre regarded as inferior to history painting. Yet to his portraits he brought both a natural intelligence and an extensive knowledge of the Italian Old Masters.

THOMAS GAINSBOROUGH Sudbury 1727–London 1788 *The Morning Walk* Page 119

Gainsborough's first love was landscape, but like his contemporary Reynolds he was obliged to turn to portraiture to earn a living. Yet in this painting of William Hallet and his wife Elizabeth Stephen, executed about the time of their marriage in 1785, when they were both twenty-one, the couple are shown wandering through a rich woody landscape. The picture dates from Gainsborough's last years and shows his style at its most expansive. In contrast to the early double-portrait of Mr and Mrs Andrews (also in the National Gallery) with its Dutch-like precision of description, the subject has here been annexed by Gainsborough's imagination. These elegant figures, like the pastoral world they inhabit, appear to us rather as poetic inventions than as identifiable individuals. They are as insubstantial as the landscape itself, the soft, transparent texture of their clothes and hair—a miracle of brushwork—blending with the feathery foliage that envelopes them.

FRANCISCO DE GOYA Fuendetodos 1746–Bordeaux 1828 *The Picnic* Page 120

This painting, together with many others by Goya, belonged to the 9th Duke of Ossuna, his patron, yet is it likely that it was executed in the 1780s as a sketch for a series of cartoons for tapestries to decorate the bedchamber of the Infantas in the Palace of El Pardo. As in France, a taste arose at this time among the aristocracy for unsophisticated rural diversions and for dressing up in traditional costumes. In Goya's cartoons, carefree peasants amuse themselves with games, music and feasting in the open air. But while the light brushwork and brilliant colouring of these early works are perfectly suited to their decorative function, they already carry with them suggestions of the expressive power of Goya's later work. The group is gathered in the shade beneath a luminous sky. Intense notes of colour create an impression of gaiety and animation, so that although awkward and doll-like in their forms, these peasants emerge as real people caught up in spontaneous emotions.

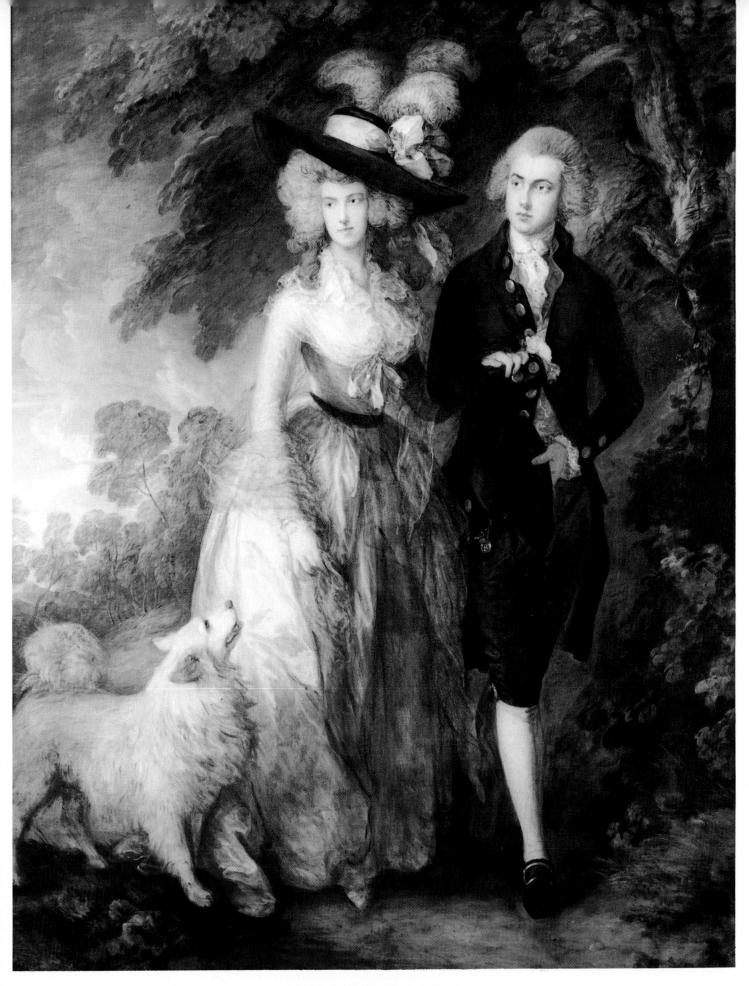

THOMAS GAINSBOROUGH
The Morning Walk
Canvas, 236 × 179 cm

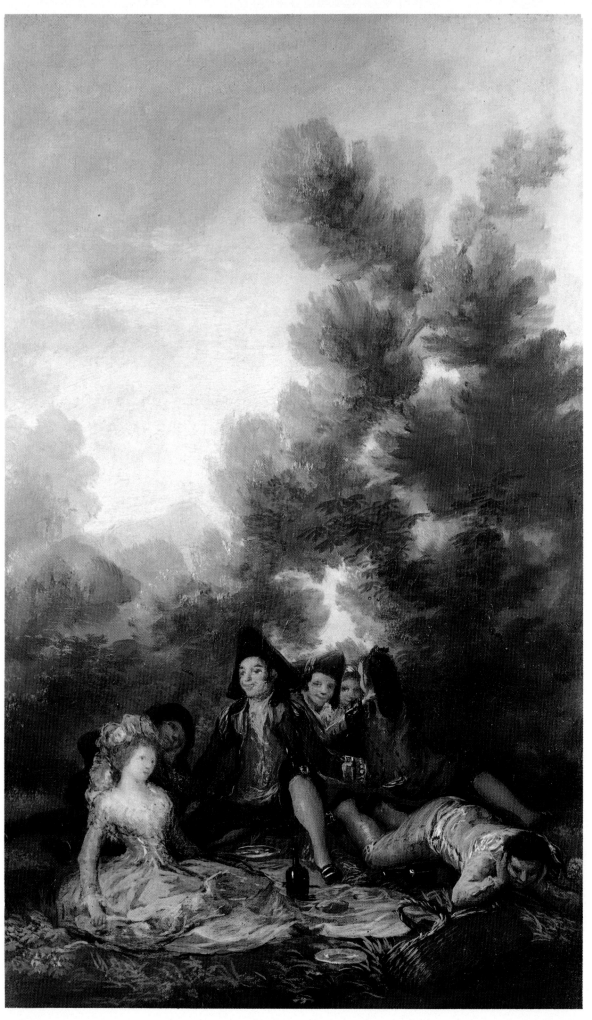

Left
FRANCISCO DE GOYA
The Picnic
Canvas, 41 × 25 cm

Right
FRANCISCO DE GOYA
Don Andrés del Peral
(detail)
Poplar, 95 × 65 cm

Far right
FRANCISCO DE GOYA
Doña Isabel de Porcel
(detail)
Canvas, 82 × 54 cm

FRANCISCO DE GOYA *Don Andrés del Peral*

Born in the middle of the 18th century in a country more backward and politically reactionary than the rest of Europe, Goya survived through periods of invasion and civil war to end his life deaf and an exile at Bordeaux in France. He was reared as an artist upon the work of provincial painters, under the influence of Giambattista and Domenico Tiepolo, and yet succeeded in adapting his art in response to changes of unprecedented violence. But his work shows him to have been a man of few preconceptions. If he was quick to grasp the breakdown of reason, the advent of despair, it was perhaps because his penetrating vision always allowed him to perceive reality clearly. As painter to the king he portrayed the stupid and degenerate royal family without flattery. In this portrait of about 1798 of Don Andrés del Peral, a gilder and painter to the Crown and thus his colleague at the court, no trite style smoothes over the hooked nose and twisted mouth. The painter has established direct contact with his sitter. Their eyes meet, and the luminous glow of light which glances over the shiny textures of the waistcoat and jacket seems to reveal the man himself in one ultimate exposure.

FRANCISCO DE GOYA *Dõna Isabel de Porcel*

This portrait of Isabel de Porcel and another of her husband, Antonio Porcel, were painted by Goya in gratitude for hospitality. As a painting it seems to reflect the warmth the artist must have felt towards the sitter. She is dressed in the fashionable costume of the *maja,* and the greenish black of her mantilla imparts a greater radiance to her face and breast. The broad rapid brushwork, thick and opaque in places, elsewhere scarcely covering the canvas, recalls the work of two other great artists of the 18th century, Gainsborough and Tiepolo, and in its uncompromising freedom anticipates Manet. The picture was probably executed at the Academy of San Fernando in 1805 and so dates from the period just preceding the French invasion of Spain, when, in pictures of the royal family, the aristocracy and his friends, Goya's portrait style reached a peak of expression and technical brilliance.

The Nineteenth Century

JOHN CONSTABLE East Bergholt 1776–1837 *Weymouth Bay* Page 123
The broad handling of paint, the striking simplicity of the design, and the elimination of distracting detail combine to give this small landscape a monumental grandeur. After his marriage on 2 October 1816 to Maria Bicknell, Constable and his bride spent several weeks at the vicarage of their friends, the Fishers, at Osmington near Weymouth. This picture is probably based on sketches made at that time and shows the uncompromising novelty of the artist's approach to landscape painting. Constable was not a precocious artist. He struggled to evolve his own style and was probably over forty when he produced this. But, perhaps for this reason, his interpretation of visual effects is uninhibited by the mannerisms of style which sometimes accompany technical virtuosity. Here both the sky and the landscape are built up in broad masses of light and shade, laid in with a freedom and confidence that are the result of long application.

JOHN CONSTABLE *Landscape: Noon ('The Hay Wain')* Page 123
Before 1821 Constable had succeeded, in sketches that are exceptionally free and rapid in execution, in escaping from the conventions of landscape painting and capturing the appearance of his local Suffolk countryside under different conditions of light and weather. In *The Hay Wain* he succeeds in applying this technique to a large, elaborate composition. The scene is still a real one. It shows the cottage of Constable's neighbour, Willy Lot, and the adjacent mill-pond. But the masses are consciously accumulated and balanced without the loss of that 'naturalness' that was Constable's aim. Time and fame have lessened the impact of the picture, but Constable is here among the first to treat the ordinary scenery of rural England on such a scale. There is no sublime panorama, no country house, no edifying incident from history or mythology to elevate the theme. The drama of light and shade on fields and trees is sufficient in itself.

JOSEPH MALLORD WILLIAM TURNER London 1775–1851 *The Fighting Téméraire tugged to her Last Berth* Page 124
One of the most famous of the pictures that Turner bequeathed to the nation on his death in 1851, this painting of 1838 shows *The Fighting Téméraire* being towed to Rotherhithe on the Thames to be broken up. The ship had fought in 1805 at the Battle of Trafalgar, and for Turner the subject becomes the occasion for a spectacular consummation, as a flaming sky signals the fate of this monument to an heroic age. Topped by the frail masts that were fitted for the final voyage, the ghostly white form of the ship is half-obscured by the squat black tug, belching fire and smoke, which has superseded it. And the river scene is transformed into an inferno. The light of the setting sun, fractured by the scattered clouds and reflected in the wide expanse of water, is broken into all the component colours of the spectrum, so that we seem to witness not an actual event but some cataclysmic vision.

JEAN-BAPTISTE-CAMILLE COROT Paris 1796–1875 *Avignon from the West* Pages 124–5
At a time when, to be considered as serious art, a landscape needed to be peopled with figures from the Bible or classical mythology, Corot was producing such lucid and unconventional landscapes as this view of Avignon, probably painted during a visit in July 1836. The large pictures he sent to the Paris Salon still clung to the subjects of 'historical' landscape, but his oil sketches, often brief and small in scale, demonstrate the clarity and immediacy of his response to nature. Later in his career he achieved fame with his poetic landscapes, gauzy twilight views of water and trees—the products of a sentimental imagination rather than a keen eye. The reverse is true of this picture. Totally unsentimental and un-Romantic, it resolves the varied forms of hills, trees and massed buildings into a structural and tonal harmony. Details disappear in the blazing sun. Only the skeleton of the landscape remains.

FERDINAND-VICTOR-EUGENE DELACROIX Paris 1798–1863 *Christ on the Cross*
 Page 125
Delacroix was renowned in his lifetime as an artistic rebel, the leader of the Romantics, the chief opponent of Classicism and the linear art of Ingres. Yet much of his work draws on traditional sources for its subjects, such as classical and medieval history, mythology and the Bible. But in this version of the Crucifixion, signed and dated 1853, as in many other works, he interprets his subject in a highly personal way. Delacroix held no firm religious beliefs, and this small and private work is, in effect, a record of human suffering, both of the reviled Christ and the anguished spectators round the cross. Naturalism is sacrificed to a heightened drama of effects. The figures stand bleakly against the stormy sky, their frenzied emotion conveyed not through conventional narrative means, but through stylized gestures, contorted rhythms and accents of colour.

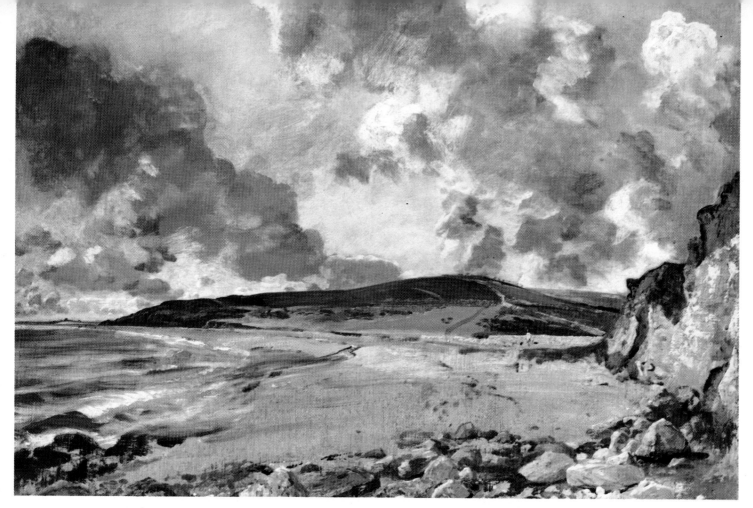

Above
JOHN CONSTABLE
Weymouth Bay
Canvas, 53 × 74 cm

Below
JOHN CONSTABLE
Landscape: Noon ('The Hay Wain')
Canvas, 130 × 185 cm

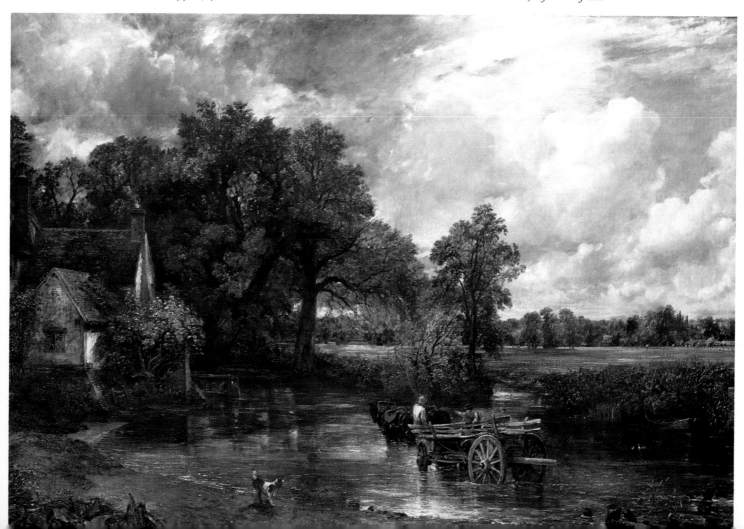

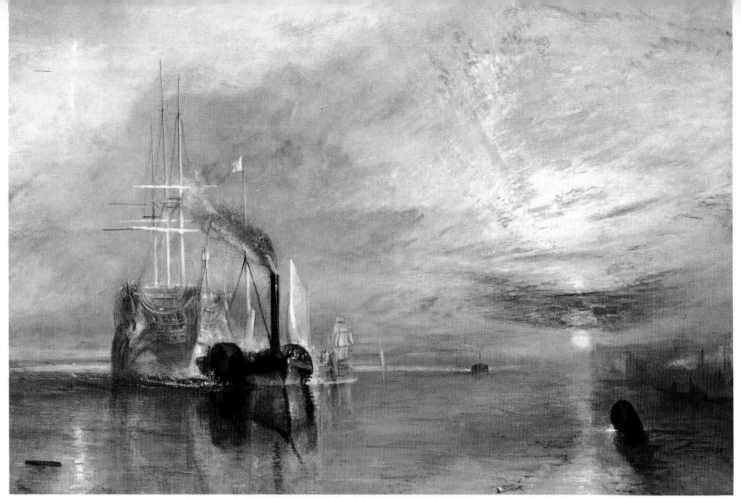

Left
JOSEPH MALLORD WILLIAM TURNER
The 'Fighting Téméraire' tugged to her Last Berth
Canvas, 90 × 121 cm

Below
JEAN-BAPTISTE-CAMILLE COROT
Avignon from the West
Canvas, 33 × 73 cm

Right
FERDINAND-VICTOR-EUGÈNE DELACROIX
Christ on the Cross
Canvas, 73 × 59 cm

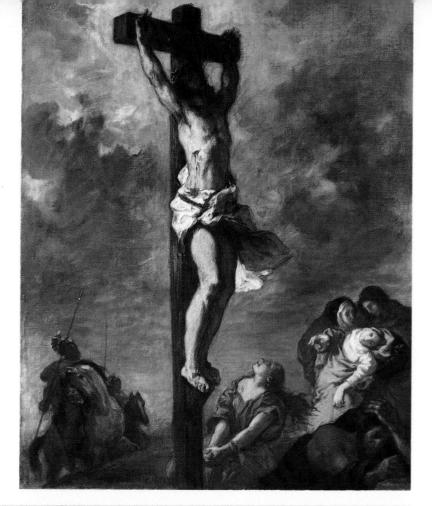

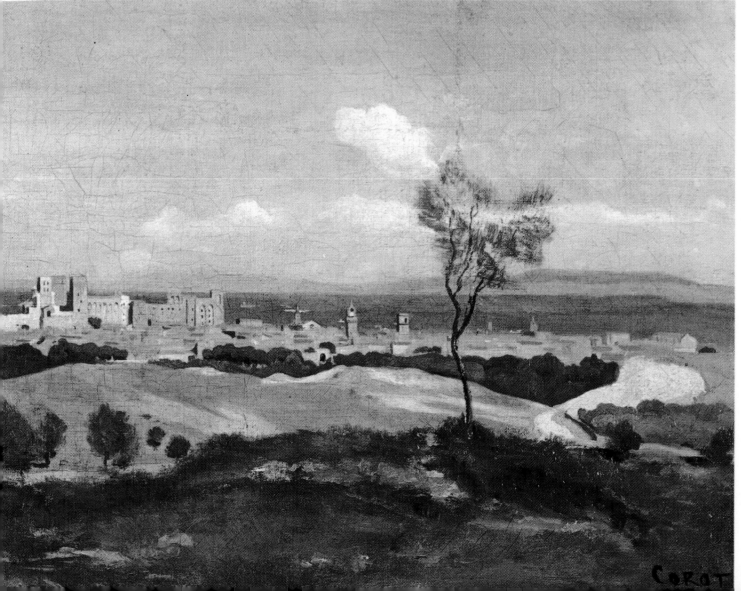

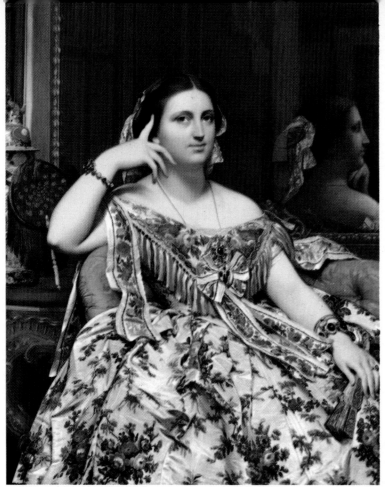

Left
JEAN-AUGUSTE-DOMINIQUE INGRES
Madame Moitessier seated
Canvas, 120 × 92 cm

Below
HONORÉ-VICTORIN DAUMIER
Don Quixote and Sancho Panza
Wood, 40 × 64 cm

Right
JEAN-DESIRE-GUSTAVE COURBET
Girls on the Banks of the Seine
Canvas, 96 × 130 cm

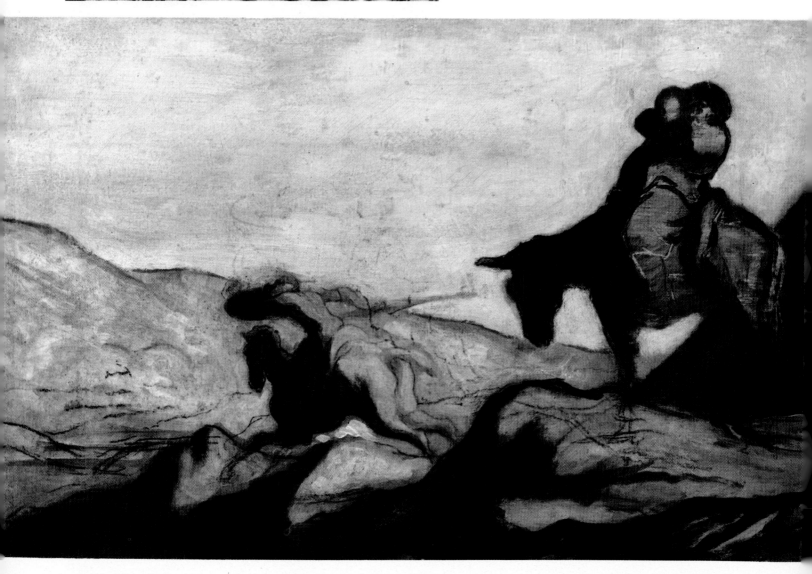

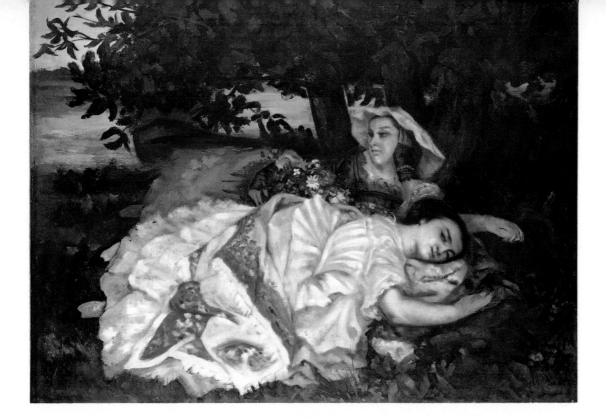

JEAN-AUGUSTE-DOMINIQUE INGRES Montauban 1780–Paris 1867 *Madame Moitessier seated* Page 126

A pupil of Jacques-Louis David, Ingres worked for many years in Rome, adopting Raphael and the Antique as his principal models. In this painting, the pose of the wealthy Madame Moitessier is derived from an antique wall-painting from Herculaneum. It is signed at the base of the mirror 'J. Ingres, 1856, aged 76', but he first began the picture twelve years previously and for a time included the sitter's young daughter Catherine. In 1849, on his wife's death, he abandoned it, and in 1851 painted a picture (now in the National Gallery of Art, Washington) of Madame Moitessier standing, in black. In 1853 he returned to the first picture, but in its final form the echoes of French 18th-century portraits are as strong as the Antique. Different styles are assimilated in an image which ultimately is modern. Madame Moitessier is a goddess of the drawing room. Sphinx-like, with polished boneless flesh, she sits self-assured amidst ornate second Empire furnishings in a fashionable dress of flowered Lyons silk.

HONORÉ-VICTORIN DAUMIER Marseilles 1808–Paris 1879 *Don Quixote and Sancho Panza* Page 126

Daumier's fame during his lifetime was based almost solely upon his caricatures, which were reproduced in huge numbers in French magazines. It was this reputation which prevented him from being accepted as a serious artist. But the poet Baudelaire, among others, argued eloquently on his behalf: 'Look through his works,' he wrote, 'and you will see parading before your eyes all that a great city contains of living monstrosities, in all their fantastic and thrilling reality'. The same acute awareness of the absurdities of human behaviour and the same sympathy for society's outcasts underlie his illustrations to *Don Quixote*. In this sketch, Cervantes's knight errant charges a flock of sheep. As Don Quixote is poised on the verge of insanity, so does this picture hover on the borders of fantasy. Horse and rider vibrate with the passion of Quixote's quest, swiftly suggested by the rhythmical undulations of Daumier's brush.

JEAN-DESIRE-GUSTAVE COURBET Ornans 1819–La Tour de Peilz (Switzerland) 1878 *Girls on the Banks of the Seine*

In his choice of subjects drawn from modern everyday existence, Courbet was reacting not only against the sterile academic painting of his day, but also against the gothic and oriental fictions of the Romantic school. On his note-paper he advertised himself as 'the master-painter without ideals or religion'. After a few brief excursions into Romantic subjects, he set himself the task of depicting only the things and events he witnessed around him. Neither fleeting effects of light nor subtle nuances of mood suited him, but facts—material objects which he fixed in solid vigorous paintwork with unequalled directness. Encouraged by his friend, the philosopher Pierre Joseph Proudhon, Courbet became committed to socialist ideas despite his unintellectual nature, and many of his pictures after 1848, including this composition sketch of Parisian prostitutes for the large picture in the Petit Palais, Paris, contain an element of social criticism.

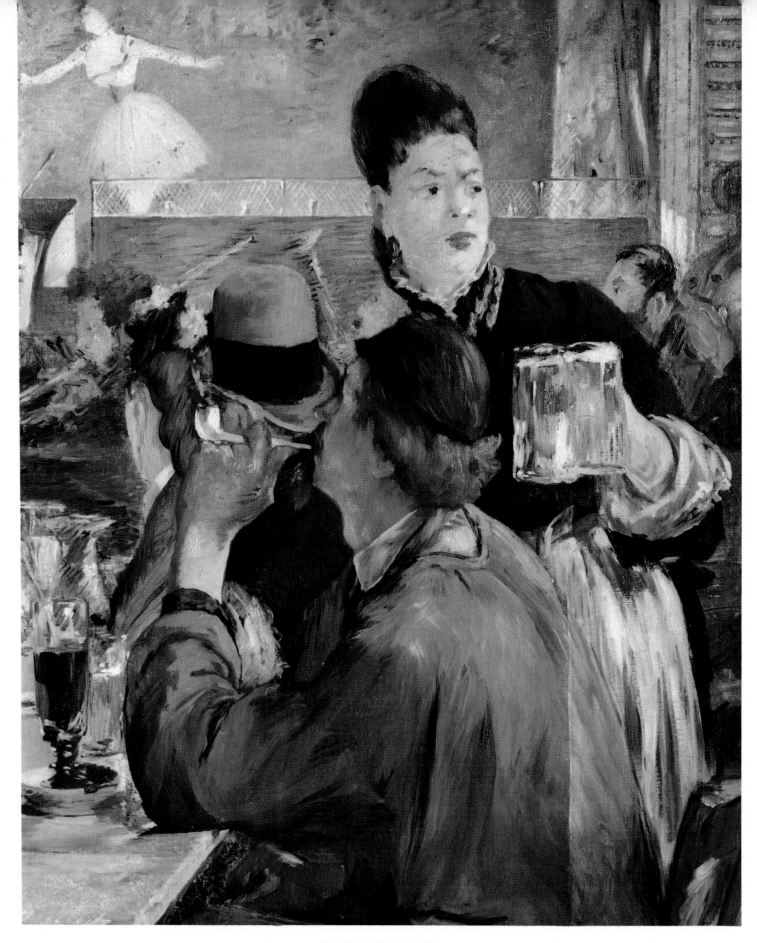

EDOUARD MANET
The Waitress ('La Servante de Bocks')
Canvas, 97 × 77 cm

Right
CAMILLE PISSARRO
The Côte des Boeufs at L'Hermitage, near Pontoise
Canvas, 114 × 87 cm

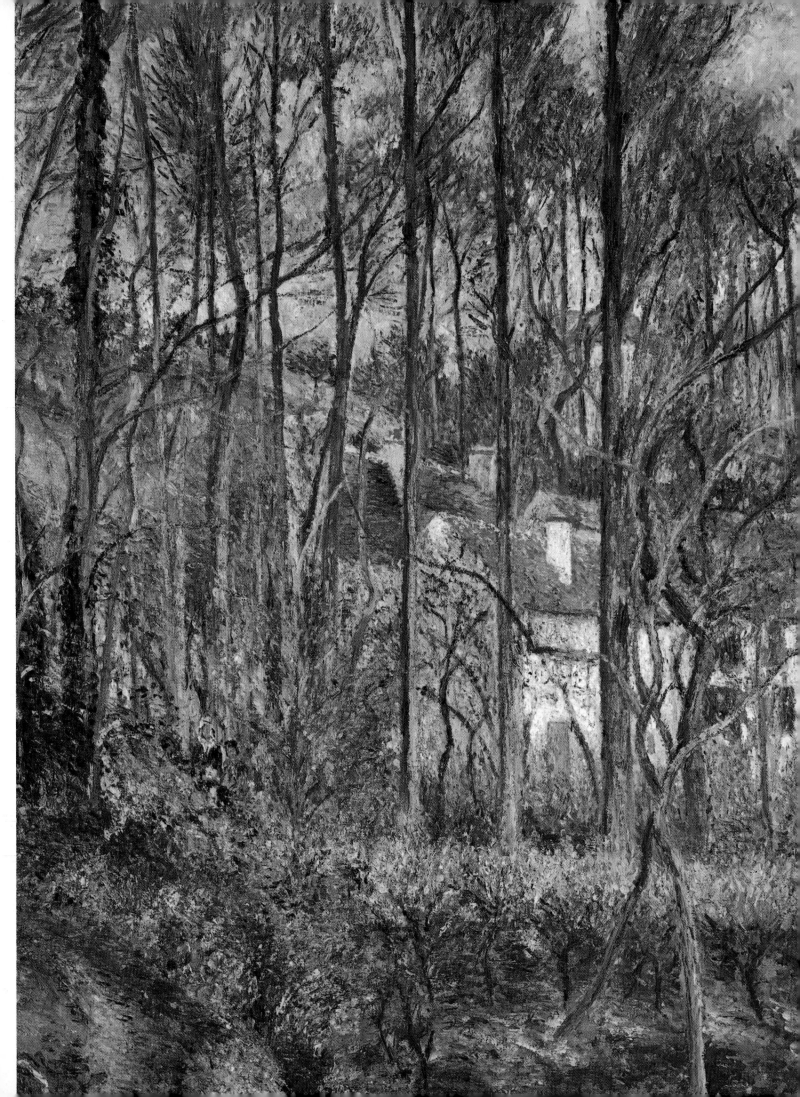

ÉDOUARD MANET Paris 1832–1883 *The Waitress ('La Servante de Bocks')* Page 128

In 1878 Manet began work on a large painting of the *Café-concert de Reischshoffen*. Before completing it he decided to divide the canvas, and the two parts survive in the painting in the Reinhart collection, Winterthur, known as '*Au Café*', and in this picture. The scene is set in the Brasserie de Reischshoffen, one of the brasseries with waitresses that were new to Paris in the 1870s, and Manet used a waitress and her 'gallant' as models for his principal figures. But the picture is a fragment in another sense also. Like a photograph, it extracts a single part from a scene of contemporary life. Although skilfully constructed, the composition remains informal, and Manet retains the suggestion of activity continuing on all sides. This sense of immediacy is reinforced by the loose brushwork and by the high-keyed broken colour which, late in his career, Manet adopted from his Impressionist friends Monet, Renoir, and Berthe Morisot.

CAMILLE PISSARRO Saint Thomas (Virgin Islands) 1830–Paris 1903 *The Côte des Boeufs at l'Hermitage, near Pontoise* Page 129

Pissarro was the most senior of the Impressionist group, yet he remained faithful to Impressionist ideas longer than any of his fellows, with the exception of Monet. Only for a brief while, under the influence of his young friend Seurat, did he make an excursion into the breakaway style of Pointillism. The pupil of Corot, he retained throughout his career a feeling for form and structure akin to his master's. He was almost exclusively a landscapist, and he consistently organized his material into balanced harmonious ensembles. In this painting of 1877, still wholly Impressionist in execution, the canvas is broken into a patchwork of irregular shapes by the tracery of branches, behind which red-roofed houses and a cloud-studded sky add notes of bright colour. It shows a scene in the vicinity of Pontoise, north of Paris, where Pissarro settled in 1870 and where Cézanne worked alongside him for a while and painted this same view. It was in Pissarro's paintings that he found the formal organization that was to become the basis of his own mature work.

CLAUDE MONET Paris 1840–Giverny 1926 *Lavacourt, Winter* Page 131

Dated 1881, this picture was long thought to show part of Vétheuil on the Seine, where Monet was then living. More recent evidence suggests that it in fact represents Lavacourt, a village on the other side of the river. But the location counts for little, for it is the play of sun and shadow on snow—which, like water, reflects and refracts coloured light—that becomes the true subject. The picture was painted at the moment when the Impressionist group, after a decade of coherent activity, began to split and pursue different paths. Monet alone continued to paint pictures based almost exclusively on the sensation of light, producing, in the years before his death in 1926, the series of huge canvases of water-lilies (one of which is in the National Gallery). It is perhaps in these latest works, where forms disintegrate in shimmering colour, that Impressionism finds its purist expression. Painting what he sees, not what the mind knows to be there, Monet abandons traditional means of composition and representation to use thick-coloured paint alone as a physical equivalent to his sensation of light.

PIERRE-AUGUSTE RENOIR Limoges 1841–Cagnes 1919 *The Umbrellas* Page 132

In 1881, dissatisfied with his work and with the Impressionist ideas which had formed its basis for over a decade, Renoir visited Italy. In Rome he saw Raphael's frescoes in the Vatican, and these made a huge impact on him. He probably began this painting, one of his most famous, shortly before he left France, but the major part of it was not painted until 1885 or 1886. It thus shows the very great transformation his art underwent during these years. The woman and the two girls on the right, dressed in the fashions of the early 1880s, are conceived in terms of merging colour and blurred contours. The soft textures of their dress actually disguise their forms. But the umbrellas and the woman on the left, dressed according to the styles of the mid '80s, are clearly defined with sharp contours. Renoir, for a time, sacrifices the more sensuous effects of paint and returns to a classical definition of form, based on line, in an attempt to chasten and reform his style.

GEORGES-PIERRE SEURAT Paris 1859–1891 *Bathers, Asnières* Page 133

Refused by the Paris Salon in 1884, this picture is the first of Seurat's large-scale compositions and shows him evolving a completely new style. Almost a generation younger than Monet and Renoir, Seurat, without discarding their brilliant palette, here strives to realize a more fixed and monumental vision of the contemporary world. It is not the fleeting, ever-changing effects of light which he attempts to capture in this view of the Seine at Asnières, an industrial suburb north-west of Paris. The dazzling midday-light serves rather to define forms and cast them in immobility. The reflections in the water and the shadows are as fixed as the figures, the distant tree masses as stable and sculptural as the bridge and the factories with their ranks of chimneys.

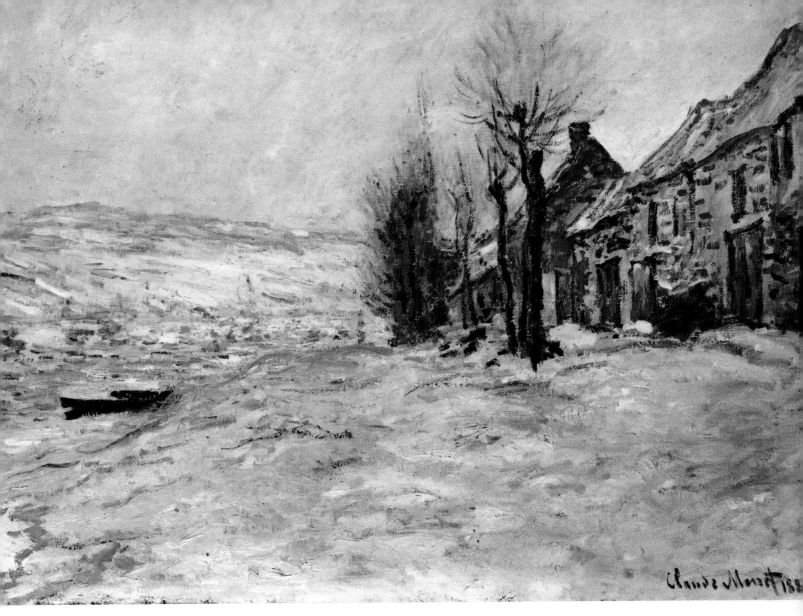

CLAUDE MONET
Lavacourt, Winter
Canvas, 59 × 80 cm

VINCENT VAN GOGH Groot Zundert 1853–Auvers 1890 *Sunflowers* Page 133
Nearly all the paintings for which Van Gogh is remembered were executed within a space of
four years—between 1886, when he first came to live in Paris, and 1890, when, at the age of
thirty-seven, he shot himself at Auvers-sur-Oise. In Paris, his brother Theo introduced him to the
work of the Impressionists. This seminal experience provided him with the means to represent
the southern landscape near Arles when he moved there in 1888, and to give expression to his
disturbed and tortured imagination. At Arles, where he became more frequently subject to fits
of insanity, his neighbours, the local countryside and the meagre furnishings of his house pro-
vided him with subjects for his paintings. Yet they are transformed by his treatment. His sun-
flowers, unlike Monet's irises and water-lilies, count as objects, but the artist's peculiar sensa-
tion, and the writhing impastoed texture of the paint, have infused them with an intense nervous
energy and embued them with an insidious life, a super-reality.

EDGAR DEGAS Paris 1834–1917 *Combing the Hair* Page 134
Although a member of their circle and involved in their struggle for recognition, Degas never
shared the aims of the Impressionists. A sophisticated aristocrat and an admirer of Ingres, he
had no interest in landscape painting and was little concerned with the problems of light which
occupied his fellow artists. His art is devoted instead almost exclusively to bodies in movement,
to the figures and gestures of ballerinas, of laundresses, of women working or washing or comb-
ing their hair. This picture, which corresponds closely to a pastel of about 1885, was painted
around 1892–5 at the time when his sight was failing. Consequently, although the design is still
tight, the treatment has become broader and more vigorous, and the colour, as it ceases to be
naturalistic, takes on an alarming expressionist power.

131

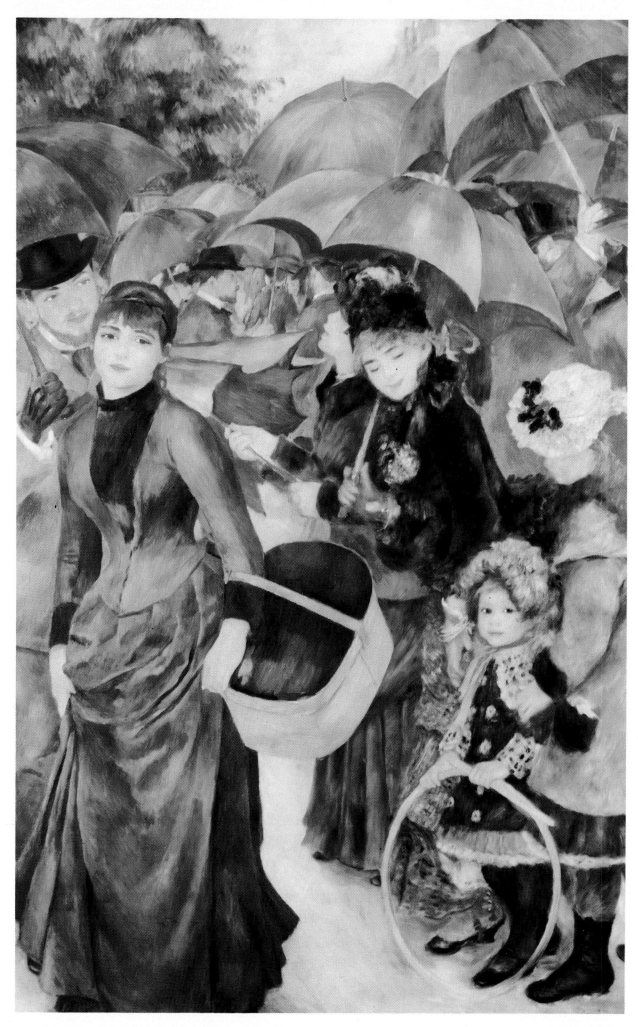

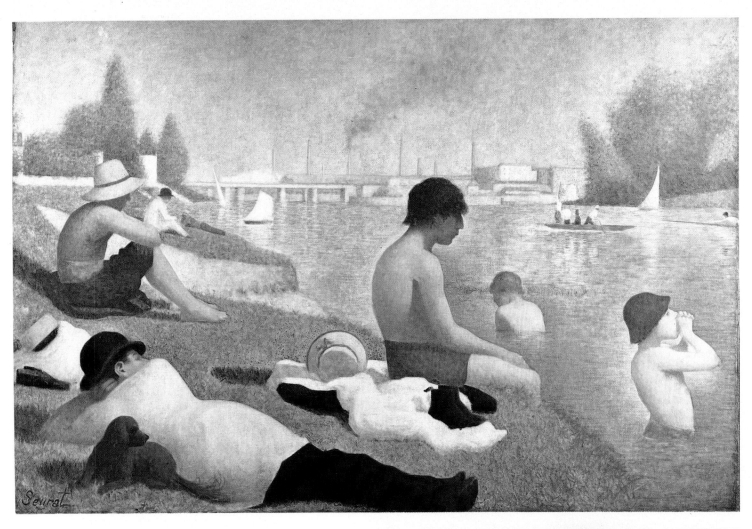

Above
GEORGES-PIERRE SEURAT
Bathers, Asnières
Canvas, 201 × 300 cm

Left
PIERRE-AUGUSTE RENOIR
The Umbrellas
Canvas, 180 × 114 cm

Right
VINCENT VAN GOGH
Sunflowers
Canvas, 92 × 73 cm

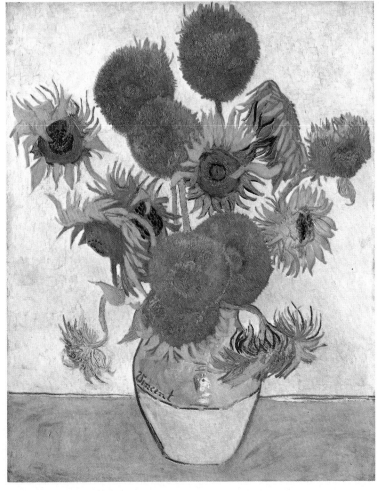

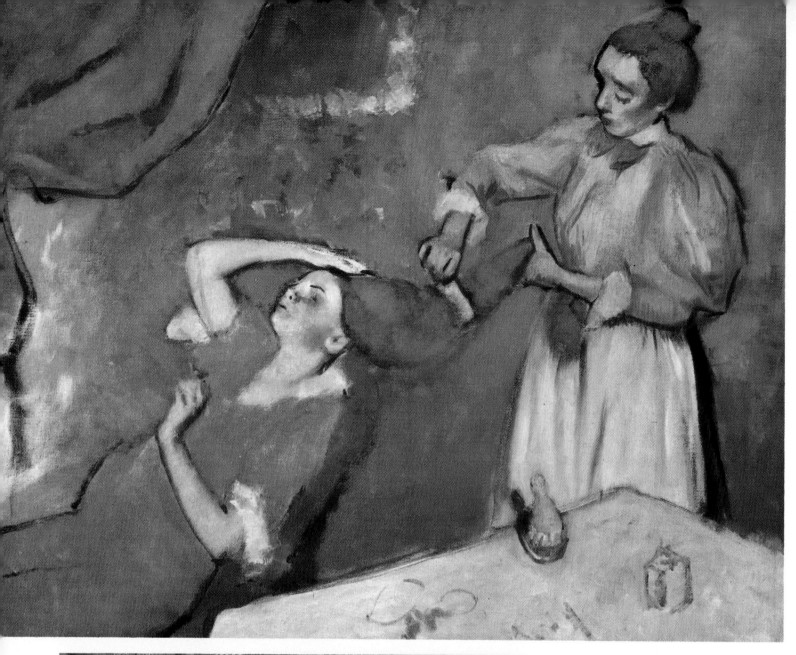

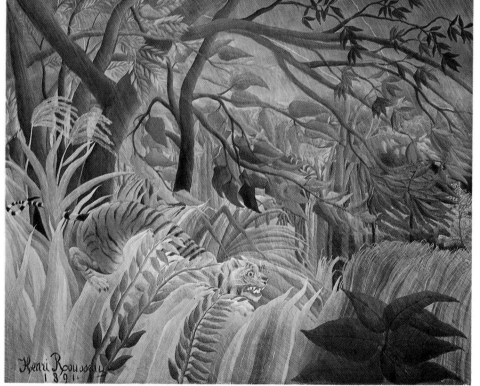

Above
EDGAR DEGAS
Combing the Hair
Canvas, 114 × 146 cm

Left
HENRI ROUSSEAU ('LE DOUANIER')
Tropical Storm with a Tiger
Canvas, 129 × 161 cm

Right
PAUL CÉZANNE
An Old Woman with a Rosary
Canvas, 80 × 65 cm

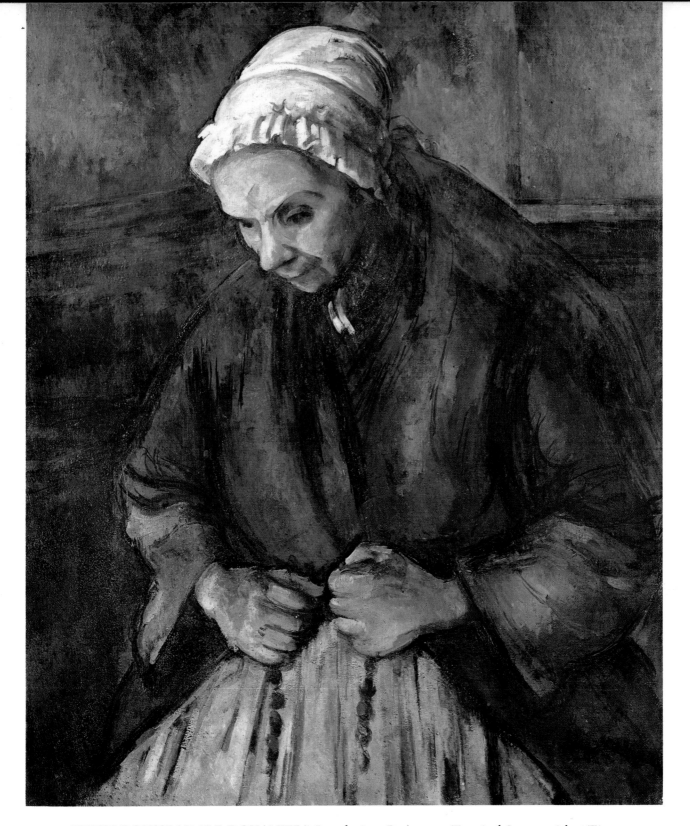

HENRI ROUSSEAU ('LE DOUANIER') Laval 1844–Paris 1910 *Tropical Storm with a Tiger*

Page 134

Henri Rousseau was forty when, in 1885, he retired from his post as a minor inspector at a toll-station on the outskirts of Paris to become a professional painter. In the following year he began to exhibit at the Salon des Indépendents, an annual exhibition organized in rebellion against the official Salon, and dominated by such artists as Seurat, Signac and Odilon Redon. Those who did not openly scoff at his efforts regarded his paintings as the work of a primitive, a 'Sunday artist', and condescendingly praised his naiveté. Not until this century has his skill as a painter been widely recognized. This picture was exhibited in 1891 under the title *Surpris!* and was the first of the exotic jungle pictures which he continued to produce until his death in 1910. In a letter of that year to the art critic André Dupont he wrote, 'I cannot now change my manner, which I have acquired as a result of obstinate toil', and despite the uninhibited, child-like involvement in his subject, his imagination is guided in this composition by a sophisticated feeling for picture structure and colour values.

135

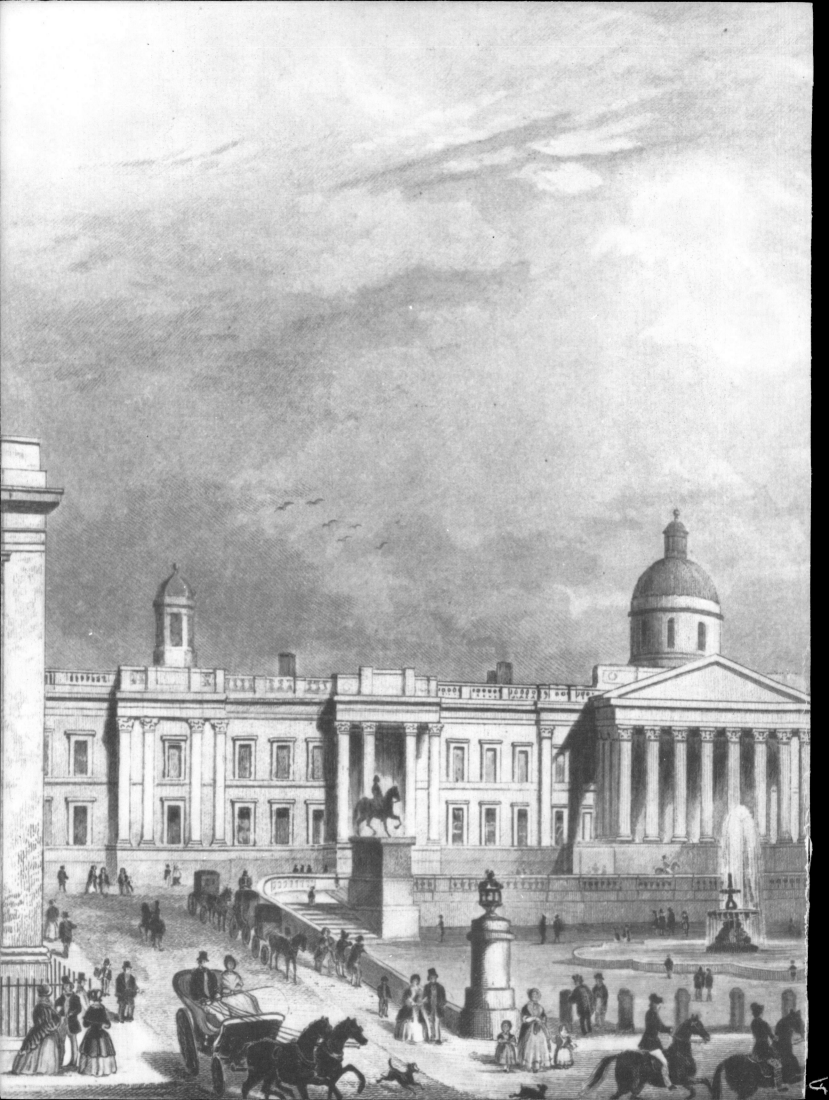